MW00772472

MILES BOOY studied film at the College of St Mark and St John in Plymouth and the University of East Anglia. He loves *Doctor Who*, Marvel Comics and science-fiction cinema, and studies them from both academic and fan perspectives. He is the author of *Love and Monsters: The Doctor Who Experience, 1979 to the Present* (2012) and a contributor to *The Cult TV Book* (2012), both from I.B. Tauris. He lives in Stafford with his wife and son.

'Miles Booy is an expert critic and his much-welcomed account of Chris Claremont's tenure on Marvel's *X-Men* will be essential reading for comic fans and historians alike. Booy succeeds in analysing the narratives and politics of comics with admirable scholarly detachment while never losing sight of the fun nature of his subject. This book is likely to be the definitive survey of Claremont's contribution to the Marvel universe.'

JAMES CHAPMAN
author of *British Comics: A Cultural History*

'An excellent and timely book about the unsung genius of Chris Claremont, the most under-appreciated comics writer, who nevertheless made a vast contribution to the super-hero genre. Booy gets deep into the work, and why Claremont is so influential.'

PAUL CORNELL
award-winning comics writer of *Wolverine, X-Men* and more

'*Marvel's Mutants* provides the sort of literary analysis of the X-Men that we've been waiting for. This is not more of the same, endless discussions of the X-Men's politics. Rather, Miles Booy excavates and illuminates the subtle but often forgotten themes and tropes – joy and hunger, civilisation and savagery, humanity and machinery – that truly gripped the attention of long-time writer Chris Claremont. This is a compelling, novel, and necessary reconsideration of the foundational period of the X-Men.'

NEIL SHYMINSKY
pop cultural commentator and Program Co-ordinator, Cambrian College

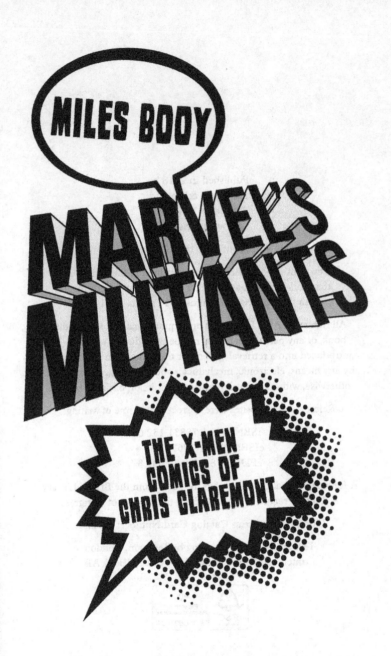

MILES BOOY

MARVEL'S MUTANTS

THE X-MEN
COMICS OF
CHRIS CLAREMONT

I.B. TAURIS
LONDON · NEW YORK

Published in 2018 by
I.B.Tauris & Co. Ltd
London • New York
www.ibtauris.com

Copyright © 2018 Miles Booy

The right of Miles Booy to be identified as the author of
this work has been asserted by the author in accordance
with the Copyright, Designs and Patents Act 1988.

All rights reserved. Except for brief quotations in a review, this
book, or any part thereof, may not be reproduced, stored in or
introduced into a retrieval system, or transmitted, in any form or
by any means, electronic, mechanical, photocopying, recording or
otherwise, without the prior written permission of the publisher.

References to websites were correct at the time of writing.

ISBN: 978 1 78831 152 6
eISBN: 978 1 78672 331 4
ePDF: 978 1 78673 331 3

A full CIP record for this book is available from the British Library
A full CIP record is available from the Library of Congress

Library of Congress Catalog Card Number: available

Text design and typesetting by Tetragon, London
Printed and bound in Sweden by ScandBook AB

MIX
Paper from
responsible sources
FSC® C007584

'*I want to fight. And I want just as much to give in.*'

ILLYANA RASPUTIN
Magik #4 (March 1984)

'*We are born biological beings, but we must become existential individuals by accepting responsibility for our actions.*'

THOMAS R. FLYNN
Existentialism: A Very Short Introduction

CONTENTS

CONTENTS

ACKNOWLEDGEMENTS
AND HOUSEKEEPING

The comic which is this study's central text underwent a name change. Originally entitled *X-Men* in the 1960s, it became *The Uncanny X-Men* with #114 (October 1978). For brevity's sake, this is abbreviated to *X-Men* in my discussion. Such an abbreviation was traditionally used in fan discourse and, indeed, Marvel's own publicity materials, so this should be simple enough – except that *X-Men* (that one hyphenated word without elaboration or description) is also the name of a film (Bryan Singer, 2000) and of a second comic, launched in October 1991. For the purposes of this book, the italicised term *X-Men* refers to the comic begun in 1963 and written by Chris Claremont from 1976 to 1991. Where any other work of that name is being referred to, I have made it clear. Where the word is used without italics, it refers to the characters, not the published comic. All comic titles are italicised.

The story contained in every issue of *X-Men* had a title which was usually given on the opening page, though delaying it a page or two was not unknown. These titles, where given, are in single quotation marks (e.g. 'The Submergence of Japan'), although in referring to a given comic I have normally cited the issue number rather than the story title. Sometimes an umbrella title would link several issues (e.g. 'The Fall of the Mutants'), usually as part of a marketing initiative, and these and any other variations from the normal pattern are noted along the way. Fans often made a point of referring to the characters by their human birth names (e.g. Scott Summers, Logan, etc.) as part of their claim that Claremont wrote three-dimensional human beings (as discussed in Chapter I). By contrast, I have primarily referred to them by their super-hero code names (Wolverine, Storm, etc.) as that is how they are best known, especially by those who lack decades of immersion

in X-lore. The exception is Kitty Pryde, who has always been more frequently referred to by that name than any of her various code names. As regards the storylines themselves, I have generally assumed that readers have some familiarity with the comic during this period but need reminding of the details. Every chapter begins with a passage which outlines the major storylines and industrial developments in the period under discussion. Whatever degree of familiarity readers bring to this book, they should be able to orientate themselves there.

Throughout this book, I have given the date of each comic as it is cited or discussed. This date refers to the one on the front (the 'cover date'), unless explicitly stated. It should be noted, however, that outside of news periodicals (which are more time-specific), American practice has been to place dates on the covers which were two or three months ahead of their actual publication date, thus allowing the issue to remain 'current' on the news stands for longer. During the period under discussion, an issue of *X-Men* bearing the cover date 'December 1980' would actually have been published in September of that year. This explains why *X-Men* #143 (March 1981) is a Christmas story – it was on American news stands for Christmas. The title of the three-part 'Fall of the Mutants' story (#225–7) is a pun, but one which only works if you understand that the issues were on sale in America during the autumn of 1987 despite cover dates early in 1988.

Marvel comics have their own stylistic conventions. Where I quote the dialogue or explanatory panels, most of these have been carried over. In a strange grammatical move, for instance, Marvel use two hyphens where the normal usage would be a single dash (e.g. 'But within the club is an inner circle open only to a select few -- an inner circle who see the club as an avenue to achieving power' (#130, February 1980)). I have carried this over into my quotations from the text. Conversely, all lettering – be it in dialogue bubbles or captions – is written in the comics in upper case letters (e.g. 'SUDDENLY'), but I have not rendered all quotations in this manner. Anyone who wants to see how odd it looks when a book quotes comics in this way is directed to Grant Morrison's volume *Supergods*.[1]

Lastly, within the US, comics are known as 'comic books', and this is routinely abbreviated to 'books' (or 'book' singular, as in 'I started to write the book...'). This might well reflect the industry's need for respect, its claim to be a properly literary experience. I wouldn't dispute that, but since my bibliophily still outweighs my comic fandom – and because I'm British, not American – I'm not keen on the use of the word in this manner. However, readability takes priority over personal preferences. To avoid over-repetition of the British term, I therefore use the words 'book' and 'comic' interchangeably. After all, in the world of comics, we're all American now.

This book is solely based on public sources, primarily the comics, their letters pages and the fan magazines which surrounded them, including contemporary interviews with those working at Marvel during the period in question. Those interviews were widely discussed and influenced fan interpretation. At times I have drawn on knowledge of the company's internal politics – which was not, I believe, made public at the time – but have endeavoured to keep this to a minimum. In 2011, Claremont gifted his prodigious archives (correspondence, story drafts, etc.) to Columbia University. I have not sought as part of this project to view those documents.

The development of Claremont's writing was influenced by many wider industrial factors, and context is provided as required. For those requiring a broader view of where *X-Men* sat in the wider world of comics, Sean Howe's *Marvel Comics: The Untold Story* is a good company history, while the revised second edition of Gerard Jones and Will Jacobs' *The Comic Book Heroes* is a wider account of developments in the mainstream of American comics from the mid-1950s to the 1990s.[2]

Kai Bowden allowed me to borrow comics from his collection – thanks, Kai. I asked several questions about *X-Men* continuity on the forum boards at www.unstablemolecules.com, and I'm thankful for the responses which allowed me to track down obscure references. A number of people commented upon this project at various stages and I'm thankful for their comments and enthusiasm: Jon Arnold, Barnaby Salton, Neil Shyminsky, Tim Small and Robert

Thomas. Sarah Terry's keen copy-editing protected me from a thousand embarrassments. Philippa Brewster commissioned this book for I.B.Tauris, and Alex Billington and David Campbell saw it carefully through production.

David Booy helped me research the appendix and trace the differences between the original comics and their reprinting in *Classic X-Men*. He compiled the bibliography, caught at least one error in the text and is always good value on the subject of Marvel. Superson, take a bow. My wife, Samantha, graciously put up with it all.

INTRODUCTION

In 1991, the comics world was shocked to hear that Chris Claremont was ceasing to write *The Uncanny X-Men*. At a time when Marvel's writers would routinely spend less than two years on a given assignment, Claremont's 17 years on the comic had embraced nearly 200 issues as well as many spin-off titles. His association with the comic was so large, and the sense that he was the ruler of this franchise was reflected in the way that *The Comics Journal*, a prominent magazine of commentary constantly pushing for higher standards across the industry and more ambitious creative goals, described him on its front cover as having been 'deposed'.[1] He had won a wealth of fan awards, evolved the themes of prejudice which we now associate with the franchise and turned *X-Men* into America's bestselling comic. That might seem like achievement enough, but our postmillennial perspective reveals what no one in 1991 could possibly have known: that Claremont's stories of the complicated lives of mutant heroes in the Marvel Universe would be the basis for a global media franchise.

Although comics fandom saves its highest praise for artists, or even those multitalented individuals who both write and draw, Claremont had long been recognised as an auteur, a writer who returned endlessly to his favoured themes. In its August 1982 issue *The Comics Journal* had argued that 'Chris Claremont's *X-Men* [...] combines rousing superhero adventure with such thematic concerns as the division of the soul between good and evil or reason and savagery, and the relations between men and women.'[2] Later, perhaps inevitably, came the charges of repetition: 'It may be true that Claremont has never fallen into the usual clichés of comics. Instead, he's created his own clichés and used them over and over and over again.'[3] Beyond his recurrent themes, Claremont's reputation as a

distinctive writer was based on his use of language, again distinctive. In the twenty-first century his favoured phrases ('I possess you, body and soul', 'No quarter asked, none given') are referred to by fans as Claremontisms, and the quickest Google search produces many lists. None of this is to deny that Claremont worked collaboratively with artists and editors, some of whom resented the praise heaped upon him, feeling that their own contributions to the plot and the storytelling were being overlooked. Although I have striven for understanding in this area, a book which makes Claremont its focus seems likely to repeat this fault, and I apologise in advance to slighted collaborators.

There were limitations to Claremont's auteurism. He was not an artistic genius, but neither was he the hack that those who refused to love *X-Men* in the 1980s sometimes claimed. The quality and success of his other assignments for Marvel varied. He could make a poisoned chalice like *Marvel Team-Up* readable in the late 1970s, but couldn't save *Spider-Woman* from cancellation in 1983.[4] If he was hugely influential, it was partly because he was heading in the same direction that the industry, and pop culture more widely, was taking anyway. He adapted to developments around him, renewing *X-Men* by constant infusions of new influences. Of course, what it means to be an author, to write with a distinct voice within an industrialised medium, is open to debate. Shifts in company practice which enabled or thwarted Claremont's ambitions are discussed in the main text. For now, suffice to say that his writing fits well with what is perhaps the most famous of all claims for authorship within a collaborative medium, the one which I have already invoked with my use of the term 'auteurism'.

The auteur theory was developed in France in the 1950s to explore the idea that certain directors brought a consistent series of thematic or stylistic concerns to the films that they created with others. The term is now used more loosely – directors have been described as auteurs on the basis of a single film if it seems stylistically distinct enough – but the original theorists insisted upon traceable recurrences across many texts. Once embraced by comics critics and historians, the term auteur was used primarily to denote those multitalented individuals who both wrote and drew the comics

they worked on. Despite this, Claremont (who was never an artist in the sense of someone who produced pictures) was viewed in a similar light in the 1980s. This was recognised both within Marvel Comics (in 1979, Rick Marschall, discussing the editorial position he had just left with the company, referred to Claremont as being among the shrinking number of writers at the company who had 'an individual vision'.[5]) and without. Claremont became an auteur by simply outlasting the artists and editors assigned to X-Men. As they came and went, he continued to make his own concerns central. For all that this lent recognition to his oft-deployed stylistic tics, however, Claremont's employers were constantly making demands, requiring that the success of X-Men be expanded with spin-off titles and big developments which they, not he, would define. Claremont, finally, was a talented professional working in an industry, frequently rolling up his sleeves to rethink the narrative as his employers threw him creative speedballs he often didn't much like. The chapters of this book are the story of that 17-year run, and are arranged broadly chronologically. Before turning to that, the rest of the Introduction will briefly discuss the state of the series and Marvel Comics in general up to the point Claremont became writer on X-Men.

THE UNCANNY X-MEN

The comic which we now call *The Uncanny X-Men* was created in 1963 by Stan Lee and Jack Kirby for the newly emergent Marvel Comics. That company was a rebranded form of Timely Comics which, only a handful of years earlier, had been struggling in the marketplace. Superheroes themselves had been popular in the war years, selling well to GIs, but had lost favour in peacetime. Timely had switched to other genres: westerns, romance, war, crime and stories of nurses and models. Horror had been a popular genre until a spasm of public concern in the mid-to-late 1950s destroyed a number of companies, curtailed the activities of others and led the industry to adopt self-regulation in the form of the Comics Code.[6]

In the 1950s and 1960s, many comics were anthology titles organised around genres rather than recurring characters. Thus, many of the Marvel heroes who are so familiar today debuted not in comics bearing their own names but in comics with broader titles: Spider-Man first appeared in a comic called *Amazing Fantasy*, Iron Man in *Tales of Suspense* and Thor in *Journey Into Mystery*. The company was owned by publisher Martin Goodman, and run by Stanley Lieber under the pen name of Stan Lee. As the company stumbled from crisis to crisis with the booming and busting of the comics market, Lee was on the verge of leaving in the early 1960s, feeling that there was no space for the type of writing he wished to pursue. This period of disillusion coincided with the revival in fortunes of the superhero genre at rival DC Comics.[7] When Goodman told him to come up with some superheroes for Timely, Lee, feeling he had nothing to lose, wrote the kind of stories he wanted to, and, starting with the first issue of *Fantastic Four* (November 1961), found himself with profitable comics on his hands. With the third issue of *FF*, the company was rebranded as Marvel Comics.

Lee acted as writer, art director and editor on most of Marvel's comics throughout the 1960s, an immense workload which was only made possible by his preferred method of writing: he would work out a story with the comic's artist, provide them with a plot synopsis based on this story and write dialogue for the pages of art which would subsequently be produced.[8] This is now known as the 'Marvel Method'. One consequence of working in such a manner was that the credited writer deferred much of the storytelling, the panel-by-panel unfolding of the narrative, to the artist. Consequently, the exact division of labour on any given Marvel comic is difficult to discern. This was a matter of little or no importance when the heroes were created. Back then, they were seen as a bandwagon that Timely/Marvel was jumping upon to avert short-term collapse, and people had no doubt the fad would pass. The question of authorship, however, became increasingly urgent as the fame and commercial value of the characters grew. The most influential of Marvel's artists at the time were Steve Ditko (with whom Lee created Spider-Man) and Jack Kirby.

The superhero comics which Lee oversaw could largely be divided into two camps: books featuring individual heroes, and ones about teams of heroes. The first of these categories featured characters who were prone to self-doubt and who felt marginalised in their private lives. Peter Parker (Spider-Man) was a nerd, Matt Murdock (Daredevil) was blind, Thor was a god whom nobody worshipped any more and his secret identity, Don Blake, was mildly disabled. Steve Rogers (Captain America) was a man who'd been cryogenically frozen in the final stages of the war and thawed out twenty years later, a man two decades out of step with modern society. This sense of social exclusion would be escalated by the burden of the mighty secret which they kept, the way it compromised their relationships. Since the heroes needed to earn a living, their comics were filled with a supporting cast of classmates or work colleagues. Unlike DC characters, who lived in fantasy cities like Metropolis or Gotham City, Marvel's heroes lived in defined areas of the real world (usually a borough of New York), and the comics would incorporate the character of that neighbourhood into the story. By contrast, books about teams of heroes – *The Avengers*, *Fantastic Four* – often featured protagonists who lived public lives as professional world-savers and, backed by private fortunes, operated out of dedicated hi-tech premises. They did not have normal jobs, so interacted mainly with each other or with other superpowered individuals. Even romantic relationships tended to be with members of this community, or possibly with the pretty, young nieces of known supervillains. The scale of enemy needed to test an entire team of heroes was necessarily large, so threats were often global. As with the setting of a dedicated superhero environment, this meant that the specifics of location had to be downplayed. 'Your friendly neighbourhood Spider-Man' could spend his time protecting Manhattan, but the Fantastic Four and the Avengers would vanish for great runs of issues on to foreign soil, or into outer space and alternative dimensions.

Operating at the borders of these two definitions was the comic then simply called *X-Men*. Lee had proposed to call it *The Mutants*, but publisher Goodman thought the word esoteric and asked for a different title. Thus was *X-Men* born. The comic struggled to find a readership for most of the 1960s and underwent several changes

in the period. Lee was sporadically interested in pursuing the idea that mutants were an ostracised group who must keep their powers secret, but when Roy Thomas became writer with #20 he dispensed with such concerns, treating the title as a more traditional superhero comic.

The comic's fortunes changed in 1969, when Neal Adams became *X-Men*'s new artist and co-plotter (as so often, the exact division of the storytelling is disputed by writer and artist) and the comic became something it had never been before: innovative and compelling. That Adams' pictures drew on pop art and photorealist techniques would have been enough to set them apart from the norm, but what really caught the eye was his page layout. The look of a Marvel comic had been strongly regulated until that point. Each page would consist of several panels (normally two rows of two or two rows of three), each rectangular in shape, taller than they were wide, and each strongly separated from those panels on either side by a slim band of white (known within the publishing industry as the gutter). Adams disregarded this. Composing his pages for maximum impact, he would arrange panels diagonally across the page or inside other pictures, sometimes dispensing with the gutter altogether. He would juxtapose scale, placing a long shot of the action next to an extreme close-up, and elements of one panel would intrude into other pictures. This was comics as kinetic joyride.

Among those who were amazed by Adams' artwork – and he is cited as an influence by an entire generation of comics professionals – were workers within the industry itself, including the young Chris Claremont. Although he was born in England in 1950, Claremont's family had moved to America three years later and he had grown up on Long Island, New York, reading science fiction. Like many Marvel staffers he had vivid memories of comics as a child, though since his grandmother would send him packets of English comics such as *The Eagle* this meant different memories (and arguably a different sensibility) from his peers. He was a student working as a gofer at Marvel during the January/February break from his studies in Political Theory at Bard College in Annandale-on-Hudson ('some 50 miles (as the proverbial crow flies) north-west of the X-Men's mansion/headquarters'[9]). His duties were not

creative – photocopying, replying to fan mail – but he did handle art during the production process, and he was thrilled by the kinetic layouts which Adams was sending to the Marvel offices. Moreover, his position allowed him to sit in on plotting sessions with Thomas and Adams. While they were looking for a conclusion to a story in which the X-Men battled the Sentinels, giant robots programmed to capture and exterminate mutants, Claremont observed that the ultimate source of mutation was the sun, and thus inspired the conclusion of #59 (when the Sentinels would leave the earth to challenge that source head-on). It was an inauspicious beginning for a young man who at that point had no aim to write; acting was his ambition.

By the mid-1980s, when fandom had grown in numbers and sophistication, and fans wanted books which experimented with the medium's formal properties, comics like this would power the industry. An artist who composed page layouts in new ways would be, in the argot of the times, a 'hot artist' working on a 'hot book'. As Adams worked away in 1969–70, however, this market was barely formed, and his artistry could not save the comic. With #66 (March 1970), *X-Men* was cancelled. There would be no more issues.

Or would there? As sales figures were finalised – months after the event, as was the norm at the time – the comic had apparently undergone an upturn in sales. Even these improved figures couldn't justify the expense of new stories and artwork, but the comic reappeared in December 1970 with #67, reprinting old stories which Marvel already owned and was under no contractual obligation to pay royalties to reuse.

Claremont returned to Bard College, graduating in 1972. He failed to make a career as an actor, but, having kept in contact with Marvel, took up a post as an assistant editor within the company in 1973. The position enabled him to take on last-minute writing jobs when regular writers missed deadlines. *Daredevil* #102 (August 1973) is his first credited writing assignment, a competent but routine story of a supervillain kidnapping a young girl in order to force her scientist father to build weapons technology for him. The following year he was assigned to the kung fu comic *Iron Fist*. There he would enthusiastically collaborate with an emerging artist, John

Byrne. Like Claremont, Byrne had been born in England in 1950 – in West Bromwich, in the Midlands – before his family moved to Canada when he was eight.

Claremont and Byrne were building up credits, breaking into the industry, but it was an industry in crisis. Emblematic of comics' precarious existence was the 'DC implosion' of 1978 when the company cancelled 17 titles – 40 per cent of its comics – in one day. Companies used sales of 100,000 per issue as the point where a comic was viable, but veterans could remember when they had sold five times that. Sales were crucial because, unlike prestigious magazines, comics attracted only small advertising revenues. Though Marvels carried a dozen or so pages of ads every issue, they were for nickel-and-dime products – baked Twinkie bars, toy soldiers, X-ray spectacles and other items for pre-teen boys – with low profit margins. With Stan Lee perhaps seeing another bust in the offing, Marvel was sporadically experimenting with magazine formats which had better production, more content for adults and a higher mark-up, but these experiments found little success.

Into this fading market, *X-Men* was relaunched. Roy Thomas had become editor-in-chief and, having written the comic for much of the 1960s, wished to bring it back. Elsewhere in the company there was a suggestion that, with foreign markets increasingly reprinting Marvel's American-made material, a team of superheroes drawn from those countries where the company was present or into which it wished to expand might be a good idea. In a similar vein, Thomas was already thinking of creating a Canadian character based on the wolverine, a stocky and solitary carnivore which resembles a small bear. Known to have killed creatures much larger than itself, the wolverine has ferociousness and strength beyond what might be expected of a creature of its size. When Thomas left the company, these projects were inherited by his successor, Len Wein, who introduced Wolverine as a protagonist in *The Incredible Hulk* (#180 and 181, October and November 1974) before he would be launched as part of the new X-Men the following year. When the comic appeared, the international dimension, such an important impetus, was retained – but the notion of tying this concept directly to marketing ambitions had

been lost. Marvel wasn't going to be expanding into Colossus' homeland of Russia anytime soon, and Storm's Kenya wasn't a major demographic either.

Wein would write *X-Men* too, at least initially. He was editor-in-chief at Marvel, but in the mid-1970s the holder of that position was expected to carry a heavy writing load as well. Legend says that it was while working on the first story (a double-sized issue, *Giant Size X-Men* #1), he was struggling for a resolution to the plot when lightning struck twice and Claremont, sitting in on the plotting meeting as Wein's assistant, suggested that the villain, a living island, could be defeated by using the magnetic powers of bit-part character Polaris to briefly sever the gravity fields holding the island in place, thus causing it to be thrown into space. When Wein found that his many other duties meant he didn't have time to write the subsequent ongoing *X-Men* comic, he was happy to hand the job to Claremont. If Wein had been resigning from writing a prestigious monthly title, there might have been competition from senior writers, but no one objected to a new, young writer picking up this low-priority assignment because of a couple of happened-to-be-there plot assists and his expressed enthusiasm for the project. After *Giant-Size* #1, the stories of the new team would continue in the regular comic, displacing the reprints from #94 (August 1975) onwards, and Claremont would write it. With his writing career taking off, he resigned his position as assistant to the editor-in-chief.

If Claremont wanted to express his world view through *X-Men*, an industrial product produced to tight monthly deadlines, there were precedents to follow. Stan Lee had not been averse to moralising on the tolerance of others, but he had kept to a mainstream message and had written – indeed, co-created – such a large range of comics that his talent was not associated with any single one of them. The company's expansion in the early 1970s had seen a new generation of auteurs who wedded their concerns to specific comics. Writer/artist Jim Starlin used Marvel's science-fiction hero Captain Marvel to write tales where increased 'cosmic awareness' was a thinly disguised allegory for chemical experimentation, and the series *Warlock*, where the title character fought an authoritarian

future church. Another writer, Steve Gerber, found that his down-beat view of society and satire on human foibles was best captured in comics with non-human protagonists such as the empathic swamp monster Man-Thing or Howard the Duck. The former is a man-turned-monster drawn repeatedly to strong human emotions which he can barely understand and the latter a refugee from another world where apes have remained apes and ducks have evolved as the planet's most intelligent life form. The incomprehension expressed by these characters when faced with human cultural norms allowed Gerber to point up the absurdity and cultural specificity of much that 1970s America took for granted. These comics are sometimes depicted as brave threats to Marvel's middle-of-the-road apoliticism. Strictly speaking, this may be true, but Starlin's anti-authority kicks and Gerber's post-1960s hangover were hardly commercially brave decisions. Given a readership made up largely of young men, these writers' concerns aligned well with those of Marvel's audience. They did, however, keep the company relevant to its audience as society changed.

Their audience-friendly nature aside, the mid-1970s auteurs also experienced a large degree of creative freedom. Marvel's use of a single editor-in-chief meant that the postholder had no time to micromanage individual comics. The context for Len Wein's quitting the writing of *X-Men* was that he had 54 magazines to oversee. Claremont would later say of that period that

> from 94 to 100 the book [*X-Men*] existed in an editorial structure which was essentially laissez-faire. For better or worse we could do what we wanted. With a little guidance but not the extremely aggressive, interfering, arbitrary structure that you have today. Editors were much less likely to put their stamp on a book. They were much more likely to trust the writer and artist.[10]

The laissez-faire approach of *X-Men*'s early days would not last, as Claremont makes clear. In 1978 a new editor-in-chief, Jim Shooter, aware of the failings of the system which he had inherited, appointed a number of editors, each with a stable of books to oversee. They would supervise the everyday work on the titles, giving Shooter himself

time to work on larger questions of corporate and aesthetic policy. A number of top writers and artists left the company in disagreement with the new policies, but several of the longer-running auteur comics continued. Marv Wolfman and artists Gene Colan and Tom Palmer brought a rich characterisation to the title character of *Tomb of Dracula* (1972–9) and Doug Moench worked with various artists from 1974 to 1983 to turn *Master of Kung Fu* from a quick cash-in on the martial arts craze into an extended study of why a pacific man might be drawn endlessly into violent combat. It is traditional to see the auteurist period at Marvel as a distinctly 1970s phenomenon, as the era which precedes Claremont's *X-Men* (and it is certainly the case that *X-Men* became most completely a self-conscious auteur piece in the 1980s), but several of these comics – *Dracula, Kung Fu, Howard* – were still running when Claremont began writing about mutants, and he was aware of them as a potential model for his own writing, telling *The Comics Journal* in 1979 that

> Every good writer has in him a book that is special – to Doug, it's *Master of Kung Fu*. For me it's *X-Men*. For Bill [Mantlo] it's *Micronauts*. For Roy [Thomas], it's *Conan*. For Marv, it was *Dracula*. And that book, because the writer puts a lot of himself or herself into it, becomes ipso facto a serious book.[11]

Claremont proved to be more the auteur than the others he named. They limited themselves to one personal book, but his themes and characters travelled with him from one assignment to the next. When he had left *Iron Fist* in the late 1970s, one of its supporting characters, Colleen Wing, was pulled into *X-Men* as a possible romantic interest for Cyclops. When he was writing *Man-Thing* and *Spider-Woman* in the early 1980s, those characters too crossed into *X-Men*. Many of the villains that he created for *Marvel Team-Up* (Arcade, D'Spayre) would eventually face the X-Men. A number of the 1970s auteur comics had been set at the fringes of the Marvel Universe (*Master of Kung Fu* was based in England, the *Micronauts* lived in an alternative universe and the overt supernaturalism of *Dracula* was best kept one step removed from the more rational New York heroics), but Claremont's stories were set in and around

New York. His concerns and characters could easily cross from one comic to another.

But if Claremont was an auteur, what was his foremost theme?

CLAREMONT'S FAVOURITE THEME: THE DIVIDED SELF

While developing the 'mutant prejudice' theme which came to define *X-Men* for so many people, Claremont pursued his own favoured artistic obsession: the existence of a dark side to human identity which might consume or unbalance the rational, stable self. In the context of superpowered mutants who wield immense powers, the stakes of a conflict between primal, socially irresponsible desires and serving the greater good would be extremely high. This theme was explored firstly through the character of Wolverine, who is depicted as a man only just able to keep his violent impulses at bay, then, in 1980, through the 'Dark Phoenix' storyline which cemented *X-Men*'s position as the discerning reader's comic of choice. By 1985 the theme was so common that Claremont would have it put to him by *The Comics Journal* that 'if there's one criticism that's beginning to be voiced now about the X-Men, it's that there have been so many times the story of being [*sic*] changed into the dark side of themselves,' a charge he largely evaded, talking about the repetitious nature of any serial narrative over ten years.[12]

Implicit in the stories of superpowered beings in conflict with their own urges was a view of human nature, and about what it means to be heroic and to be (for a superhero, at least) well balanced. It is well expressed by Storm in #214 (February 1987), who, having just seen off the influence of Malice (a psychic entity who bends people to her own will by magnifying their dark side), speaks of 'knowledge and mastery of the self' as the route to the desired state of being. 'The *shadow-side* of my self -- our darker nature -- is what sustains you and gives you power over us,' she tells the psychic entity. 'But it is also what makes me *leader* of the X-Men.' Storm thus has acknowledged and integrated her darker qualities into a stable and socially responsible self. If this book

becomes repetitive – in the way that auteur studies can – it is
because we shall trace the struggle to attain such a balance through
several generations of new, young recruits to the team. They find
it tough, for in *X-Men*, self-knowledge is always occluded. While
Storm might talk of knowing herself, the previous issue had found
the newest member, Psylocke, reflecting with typical Claremontian
self-consciousness on her teammate Doug Ramsey, 'He... loves
me. More deeply and truly than he knows. And how do *I* feel?' It
is a paradox common in *X-Men* that telepathic characters can read
the intentions and feelings of others more clearly than their own.
This necessarily made *X-Men* a very different proposition than a
comic like, for example, *The Amazing Spider-Man*, where characters
might be physically transformed or temporarily mentally possessed
but inherent identity and self-knowledge remained unproblematic.
X-Men bred a generation of teenage ontologists and metaphysicians.

Claremont conceived this battle between good and darkness in
religious terms and psychoanalytic ones. The former provided a
vocabulary of temptation, of powers being physical delights which
erode the soul (a key word, discussed in Chapter IV). The ideas and
vocabulary used here (soul, evil, sorceress, Limbo) are not exclu-
sively Christian, but Claremont's usage is mostly compatible with
it. Although it was praised for its internationalism, the comic was
populated with characters from Christian countries (although it was
presumably just a coincidence that those characters introduced in
Giant-Size X-Men #1 who were from non-Christian countries were
the ones to be swiftly written out; Sunfire returns to Japan in #94
(August 1975), and the Native American Thunderbird is blown up
an issue later). In 1983, Claremont's ideas about characterisation
began explicitly to include the question of the X-Men's religious
beliefs. Characters began to think through the issue of a good/evil
division within themselves in explicitly Christian terms, particularly
in the spin-off comic *The New Mutants*, where correspondence from
Christian readers became a recurrent feature of the letters page.
The use of biblical vocabulary shifted over time. When Claremont
began to write *X-Men* in 1975 it could be assumed that a main-
stream American adventure narrative – especially one to be read by
children, if not exclusively so – would base its assumptions about

good and evil on Christian ideas, explicitly or otherwise. By the time he left the comic, the social situation was much more conflicted about such assumptions. Writing in 2003, Claremont described his view of Christianity as that of an outsider, but acknowledged that he had read the Bible in its entirety as a college student and did so again, more than once, in the early 1980s.[13]

Although he does not use the terms, Claremont's conception of the human psyche – as opposed to its spirit or soul – was drawn from Sigmund Freud's tripartite division of the mind into id, ego and superego. These are terms which Freud introduced in the 1920s, expanding upon his earlier division between conscious and subconscious processes. In this model, the id (Latin for 'it') is the instinctive part of the human personality. It acts according to the pleasure principle, demanding instant gratification of its needs. It is present from birth, and, indeed, infants are a mass of pure id; they scream for food when requiring it and defecate as they wish/ need to. As people mature, so the demands of the id are modified by the development of the ego (Latin for 'I'). The ego organises the id's demands, balancing them against the realities of the wider world. It learns concepts like deferred gratification and deploys them so that the id's needs can be met within the wider social environment. This is a product of the socialisation process, and without it individuals could not function within a society run on social interactions and timetabled commitments. Beyond this is the superego, the conscience which sets moral boundaries on action. Partly conscious, partly subconscious, the moral understandings of the superego generate guilt after actions it feels are inappropriate. Some individuals, of course, select more demanding moral codes than others. A vegetarian who on principle denies themselves the pleasures of bacon has a strongly developed superego, as does a religious believer abstaining from the sexual gratification that their body/id requires. I don't choose these examples at random. Both sexuality and the consumption of food are common metaphors in Claremont's work, even if the former was at first largely a subtext in a comic designed to be read (if not exclusively) by children.

Freud's ideas have been questioned, but it is not necessary for us to debate their merit, merely to understand that they were

influential across society, not least on Chris Claremont. Indeed, his interest in the subject only escalated a stream of psychological themes which were common across Marvel's comics. Although the term itself hardly features, superegos manifest themselves so often in superhero comics that they become generic conventions. A person suddenly granted great power needs to decide what to do with it, and the moment of moral choice is often played out in the first issue. In *Fantastic Four* #1 (November 1961), one of the team members, The Thing, says, 'We've gotta *use* that power to help mankind, right?' Most famously of all, in Spider-Man's first appearance (*Amazing Fantasy* #15 (1962), and included in the films and TV series made since), Peter Parker at first elects to use his unusual gifts for self-enrichment, foreseeing a career in wrestling or entertainment. When a crook runs past him, rather than apprehend the man, as he easily could, he simply laughs at the pursuers. Soon afterwards, the same villain shoots Peter's beloved Uncle Ben. The final panel shows Spidey walking through the city at night, the caption reading, 'And a lean, silent figure slowly fades into the gathering darkness, aware at last that in this world, with great power there must also come -- great responsibility!' It's a pithy rephrasing of an original source which is still argued about today.[14] The same quotation is used in *X-Men* #188 (December 1984) and #236 (late October 1988). Peter Parker's choice to use his powers for a noble end, and the warning of the consequences when he didn't, are restated every few years both to acquaint new readers with Spider-Man's motivations and because a medium so often accused of corrupting its young readers requires regular ethical pronouncements as evidence of its morality. Marvel's comics could easily become an exchange of punches between equivalent superpowered people, so strong moral demarcations were (and remain) required. Characteristically, Claremont's variations on the theme were less pithy and emphasised the suffering which high moral ideals entailed: 'We call ourselves *heroes*, girl,' says Wolverine in #207 (July 1986). 'That means we have to stand for something, no matter how hard or how much it hurts.' One of *X-Men*'s innovations was the recurrent use of characters for whom the moment of electing to use their powers for good was not something which became set in

stone once it was made but which needed to be repeatedly restated in the face of other temptations. This became a hallmark of Chris Claremont's writing work – perhaps *the* hallmark, as we shall see.[15]

Where the superego and the id had come into conflict in 1960s Marvel Comics (and in adventure fiction generally) the forces of the id were normally externalised as supervillains, who invariably appear as some dark inversion of the hero. Thus, while super-scientist Reed Richards ran the Fantastic Four in the spirit of technocratic open-ness (the team never covered their faces or hid their birth names, but lived publicly at a known address in New York as professional superheroes), their arch-enemy Doctor Doom mixed science with black sorcery, was never seen without his mask and tyrannically ruled the central European country of Latveria from a medieval castle, keeping the populace in a condition approaching agrarian serfdom. While Reed was rational in combat, Doom frequently lapsed into jealousy and vanity, negative character traits which would often prove his downfall. The X-Men would have several such foes, each of them different as the themes of the comic changed and what it meant to be an X-Man shifted. Claremont also created villains whose very names encapsulated the way in which they preyed on negative human emotions, amplifying them in human hosts/foes. Malice (first appearance: *X-Men* #210, October 1986) and D'Spayre (first appearing in the Claremont-written *Marvel Team-Up* #68, April 1978) are examples, and the stories featuring them are clearly metaphorical. *X-Men* #144 (April 1981), for instance, is explicitly about how Cyclops does not give into despair (D'Spayre). These were villains who could never be fully expunged, for the heroes were fighting ongoing traits of human behaviour. 'So long as there is hope, it must be balanced... by despair,' Spider-Man is told in *Marvel Team-Up* #68, in a line repeated later in *X-Men* #144, 'We can reduce him for a time. But while there is life itself, he will exist.'

More than these villains, however, Claremont's recurrent trope was to refuse externalisation, and instead have the X-Men repeat-edly fight negative forces within themselves. He made the theme his own, but we should note that his predecessor, Len Wein, bequeathed him a conception of Wolverine which was a classic conflict between superego and id:

I always saw Wolverine as psychotic. That's what wolverines are; they're crazy. His natural tendency, every instinct in his body, says that if you say 'Good morning' to him in a tone of voice he doesn't like, he will rip your throat out. But it's his restraint, where the claws would go for your throat and then stop, that makes him a hero – his own inner battle with himself to restrain the monster in him [...] A hero is a guy whose instinct is to kill you but doesn't because he knows it's wrong.[16]

Psychology, instinct and religion/spirituality: which of these systems framed the debates about human nature varied from story to story. The 'Dark Phoenix' arc is primarily told in terms of id and ego. Claremont later used the character of a teenage sorceress, Illyana Rasputin, as his foremost vehicle for the theme, and the supernaturalism surrounding the character meant that these stories leaned towards religious imagery. It is easy to read either stream of imagery as a metaphor for the other, and other vocabularies were sporadically present; we shall discuss these as appropriate.

The clash between ego and id was the dominant theme in *X-Men* comics of the late 1970s and 1980. Chapter I analyses these issues, where villains are most often defined by their appetites and heroism is recurrently defined as the control of self – particularly important when one wields superheroic powers. Wolverine and Phoenix are characters central to this theme. As a superheroine, the latter was also seen within comics fandom as representative of the strong female characters which Claremont consistently wrote, a welcome contrast with the more demure women common in comics of the time. Fan appreciations of Claremont's work – and the stylistic features of his writing which made him popular – are also discussed in this chapter.

As would be expected when the theme is the complexities of human nature, natural settings abounded in X-Men comics of the 1970s. These were replaced in the early and mid-1980s with urban settings, initially those associated with political power (Washington DC, the Pentagon, etc.) but later by more everyday settings, notably the streets of large cities populated by workers and shoppers who make their own commentary on the action. These themes are explored in Chapters II and III. These chapters also chart the

ways in which Marvel sought to capitalise on the success of *X-Men*. The chief strategy to exploit the brand was in the creation of spin-off comics, and Chapter IV deals with the first of these, *The New Mutants*, which Claremont wrote for 54 issues in the early and mid-1980s. Chapter V details the final five years of Claremont's time as writer on *X-Men*, a time when he was increasingly under pressure to write to agendas dictated by the company. The book, then, is broadly chronological, and each chapter highlights a theme which is dominant or emerging during the period under discussion. That said, *X-Men* never developed one topic to the exclusion of all others, so commentary on other subjects is provided to give a more accurate picture of the comic's development.

CLAREMONT'S CHARACTERS

Giant-Size X-Men #1 (May 1975) to *The Uncanny X-Men* #140 (December 1980)

Central X-Men in this period: Professor X (Charles Francis Xavier – telepath and teacher of the mutants), Cyclops (Scott Summers – fires energy beams from his eyes), Phoenix (Jean Grey – telepath), Wolverine ('Logan' – enhanced senses, healing ability. The latter allowed him to survive the replacement of his natural skeleton with a new one made of unbreakable adamantium, including a set of three metal claws on each hand), Storm (Ororo Munroe – weather control), Nightcrawler (Kurt Wagner – a teleporter and circus-trained acrobat who looks like a demon), Colossus (Piotr/Peter Rasputin – can turn into a superstrong man of steel) and Banshee (Sean Cassidy – wielder of a sonic scream which allows him to fly).

When it was relaunched in 1975, *The Uncanny X-Men* was a low priority for Marvel. While the company expected marginal sales (it was initially released only every other month, half the release rate of a more successful comic), Chris Claremont and artist Dave Cockrum plotted a lengthy story of a cosmic war, acting as if the comic's future was assured. After initial success, Claremont would make these extended narratives the comic's default storytelling mode. While shorter stories of three or four issues were played out he would introduce enigmatic scenes, the relevance of which would only become apparent months or years later. In 1978, the comic was promoted to a monthly release, by which point Cockrum had left and been replaced by John Byrne. Byrne was a faster and prettier artist. He never found a straight line he couldn't curve aesthetically or a face muscle he couldn't soften. By 1979 he was fandom's favourite artist, and *X-Men* was sweeping the board at all fan-voted awards. The X-Men fight multiple villains, but the period in question is dominated by two lengthy sagas. The first involves the Beast, a member of the 60s team, briefly returned, and Phoenix becoming split off from the rest of the team after a battle in Antarctica.

They mistakenly believe their teammates dead and report this to Xavier, causing him to close down the school before the rest of the team finally reach home via Japan, Canada and a tropical paradise referred to as the Savage Land. The other, longer still, is the evolution of Jean Grey. Originally a low-level telepath and telekinetic called Marvel Girl, she sacrifices herself in #100, only to be reborn via cosmic radiation as Phoenix, one of the most powerful characters in the whole Marvel Universe. However, Jean proves incapable of controlling the primal force now within her and – with the intervention of a villain called Mastermind, who works a psychic seduction on Jean to loosen her moral inhibitions – she becomes Dark Phoenix, a being whose cosmic hunger makes her consume a distant star, destroying the entire populace of a planet which it supports. Claremont and Byrne intended that the resolution would involve Jean being stripped of her powers, having to make it in the world for the first time ever as a normal non-powered humanoid. Marvel's editor-in-chief, Jim Shooter, felt that this was insufficient punishment for the genocide which she had caused, and the final five pages of #137 (September 1980) were rewritten and redrawn. When it saw publication, fans were shocked to find that Jean had sacrificed her life, committing suicide rather than remain a potential risk to all around her.

Len Wein wrote *Giant Size X-Men* #1, in which the new team is assembled and the old members leave, and the plot for #94 and #95 (August and October 1975) of the revived *X-Men* comic before the time pressures of being Marvel's editor-in-chief forced him to hand the writing of the latter to Chris Claremont. Wein has not discussed any long-term plans he might have had for the comic, and, indeed, the multiple demands upon him at the time make it unlikely he had made many. We know that he intended Colossus, the strongman, to be the star of the comic and that Wolverine's powers were initially conceived of in terms of strength.[1] The plot for the two issues involves the X-Men saving an American military base from B-grade Marvel villain Count Nefaria, a mission bequeathed to them by Marvel's most powerful team of heroes, the Avengers, who are otherwise engaged. We could speculate that Wein intended a traditional superhero comic in which the X-Men would venture forth from their mansion home to fight supervillains, possibly at the request of quasi-government institutions, but we don't really

know whether this was the case; there is too little evidence, and the plot discussed above might be more a nod to the past (it echoes a similar bare-under-attack story from *X-Men*'s very first issue in 1963) than any indication of future directions.

Whatever Wein would have done, history placed the writing of *X-Men* in the hands of Chris Claremont. He and artist Dave Cockrum (Cockrum was artist up to and including #107, in October 1977) instantly made their mark. These are not the *X-Men* issues of legend, and certainly not the bestselling, but they had a distinct and likeable style. A lengthy story about a fugitive princess from another planet fused traditional superheroics with science-fiction imagery, giving the comic a distinct visual identity from Marvel's more earthbound comics. The multinational cast meant that foreign words (*tovarisch, boyo, mein Gott*) recurrently peppered the dialogue in a way quite unlike any other Marvel comics. There were in-your-face self-reflexive cameos. In #98 (April 1976), Stan Lee and Jack Kirby pass the X-Men in New York, reflecting that there was less kissing in the book in their day, while #105 (June 1977) depicts Claremont and Cockrum plotting the very fight scene (Phoenix vs. Firelord) which rages around them. Other humour played itself out around Nightcrawler. The most self-consciously funny of all the characters, he talks of derring-do and smilingly cites old films, fancying himself a swashbuckler. A recurring joke runs through the early issues, for whenever the X-Men commandeer or hire a vehicle it is destroyed, and only Nightcrawler notices this recurrent misfortune. Readers were addressed directly as fans with allusions to Marvel's own history (the *tac tacatac* sound effect denoting cosmic rays in #100 repeats the one used in the very first issue of *Fantastic Four*, 15 years earlier), the competition's comics (in #107, the X-Men fight the Imperial Guard, the members of which replicate DC's *Legion of Superheroes*) and other iconic science fiction (#105 has a page-long homage to *Star Trek*, complete with 'Ship's Log: Imperial Date 2131.6...'). This whimsy played out extra-textually too, since the letters page was allegedly edited by an armadillo. The comic's sense of reality could be stretched, in #101–3 (October 1976 to February 1977), to include the Leprechauns who live in Banshee's Irish castle. When

Cockrum drew a steam train in contemporary Britain, it might have been a patronising American view of the low-tech 'old world' back east (and was criticised as such on the letters page), but it did not stand out in the context of the X-Men's stylised world, which mixed science-fiction futurism with archaic romanticism, often in the same panel. Moira MacTaggert is a world-renowned geneticist and has won a Nobel Prize for her work on mutation, but her hi-tech mutant research centre is the lone building on a desolate Scottish island. The Starjammers are space adventurers with advanced technology, but they style themselves in the manner of sixteenth-century pirates.

Much of this playfulness did not outlast the comic's becoming more self-consciously serious once its profile rose and Cockrum was replaced by John Byrne. Where Cockrum liked big gestures, Byrne gave the characters a subtler body language, and his pictures were realist – the train which he drew at Edinburgh station in #119 (March 1978) is modern right down to the British Rail logo. Among the other signs of increased seriousness was a tendency for discussions between characters to embrace popular philosophical issues. Thus, in #122 (June 1979), Storm visits Harlem and is treated to a discourse on juvenile delinquents:

They got no homes, no decent schoolin', no money, no jobs -- no *hope*! So they shoot up skag [...] an' they live in a society more concerned about cagin' 13-year-olds for life than tryin' to give 'em a decent chance.

In #137 (September 1980), Nightcrawler, pondering Dark Phoenix's destruction of the D'Bari homeworld, reflects that 'As a child, in the circus, I knew people who had survived the *Holocaust* -- the Nazi death camps. I still cannot forgive the butchers responsible for those artrocities [*sic*]. How then can I forgive Jean?!' Two issues later (#139, November 1980), he questions God's motives in Jean Grey's having to die ('How -- how could you have been so... cruel?') and in #140 (December 1980), Wolverine would reflect on how the governments that he has worked for licensed him to kill and upon his own moral code:

A man comes at me with his fists, I'll meet him with fists. But if he pulls a gun -- or threatens people I'm protectin' -- then I got no sympathy for him [...] I never used my claws on someone who hadn't tried to kill me first.

Nightcrawler replies, 'What you say is reasonable, logical, justifiable. But does that make it *right*?' The comic is saying nothing new on any of these occasions – these are all well-established positions in familiar debates – but the letters pages suggest that some readers found them novel, even thought-provoking, and the constant appearance of these debates was part of *X-Men*'s sheen of moral sophistication. The lecture on drug policy is unrepresentative in its didacticism, however; more representative are the examples concerning forgiveness, God's unfairness and Wolverine's use of force, all of which end in a question. These are unanswerable questions, of course, not least because another issue of *X-Men* has to come out the following month, and another the month after that, so in moral debate as in everything else it thrives on irresolution.

With the comic moving in such self-consciously serious waters, jokey cameos became more discreet, the characters involved no longer being given dialogue to draw attention to themselves. Batman villain the Joker, present at a New York disco in #130 (February 1980), is obvious, but it takes far sharper eyes to spot Popeye amidst a collection of galactic dignitaries in #125 (September 1979) (page 10, panel 5, since you ask). Other features from the comic's earliest days would become part of its long-term make-up. The foreign vocabulary remained, and *X-Men* made references to high art part of its repertoire. A quote from *Hamlet* opens #97 (February 1976), and in #123 (July 1979) Banshee reads *Finnegans Wake* while his teammates visit a ballet performance at the Lincoln Center in New York. This later became a recurrent motif, since #145 (May 1981) and #177 (January 1984) feature similar trips. Indeed, when the X-Men take in younger members in the 1980s, ballet is part of the curriculum, a way of learning better control of one's body.

Readers responded in kind to the literary ambience. A correspondent in #110 (April 1978) likened *X-Men* to the work of Russian novelists, while another, in #115 (November 1978), discussed the

comic in relation to Franz Kafka. Self-expression itself became a theme based around Colossus, the young Russian who always felt he didn't have the words to express his feelings and took to drawing as an artistic outlet. Christmas, too, would become a feature. The season appears more recurrently in *X-Men* than in other Marvel comics, including #98 (April 1976), #119 (March 1978), #143 (March 1981), #192 (April 1985), #205 (May 1986) and #230 (June 1988), as well as #14 (April 1984) of a later spin-off, *The New Mutants*.

More attractive to readers than these motifs – or, at least, more commented upon by them – were Claremont's deeper themes and complex plot arrangements. By #98 (April 1976), Claremont's third issue plotting the comic, there are three storylines running through the book, two of which would be revealed to be linked months later, and a fourth begins an issue later. And by #105 (June 1977), the lack of resolution was the subject of letters-page humour: 'Chris and Dave swear on their lives that every loose end in this book'll be cleared up by the turn of the century.' Planning the comic a long time in advance, Claremont would drop hints about future plot lines, preparing the ground with appetising teasers. These would become retrospectively odd if the plot, when it finally arrived a year or more later, had been modified away from what was originally hinted. #110 (April 1978), for example, contains a moment when the thoughts of Moira MacTaggert 'twist back to days long past -- to the dreams she'd shared with Charles Xavier... to the nightmare they had become. But that, unfortunately, is a story for another time.' The intention was later to reveal that Xavier and MacTaggert had had a child who was a monstrous mutant called Proteus, but by the time the story saw print nearly two years later scruples had been raised about heroes like Xavier having children out of wedlock, and the child was granted a different father.

Although Xavier was saved the strain of battling his own son (at least for the time being), such personal stakes and intimate connections to the action became a hallmark of the comic. Despite the costumes, code names and superpowered fights, the X-Men aren't really superheroes. They do not patrol the city looking for muggings-in-progress to stop (like Spider-Man), and nor are they a team to which the US government turns when global apocalypse

threatens (that would be the Avengers or the Fantastic Four). Len Wein might have had something like the second scenario in mind, but Claremont invested the team with a different, more personal mission. In the 1980s, that mission would be modified. It would become referred to as 'Xavier's dream' and involve humanity and mutants living in peace together. In the mid-1970s, however, some sporadic and inconsistent references to anti-mutant protests aside, that issue didn't really arise. As is pointed out in #96 (December 1975), there are only a handful of mutants known to exist in the Marvel Universe, so simple maths shows that that they constitute no threat and large-scale integration isn't an issue; the X-Men's mission at this time is to fight evil mutants, and this point is made many times. 'Proteus is the kind of mutant Professor Xavier created the X-Men to protect humanity against,' says Cyclops in #127 (November 1979), one mention among many.

The result was a comic with a distinctly different narrative from other Marvel comics. The X-Men don't live in New York (where a hugely disproportionate amount of superhero activity takes place), but remain at Xavier's private school 50 miles to the north, honing their skills while awaiting the next emergency. They don't look for trouble, but are instead repeatedly attacked in or around their home turf: by the demon Kierrok in #96 (December 1975); Eric the Red or his surrogates (#97, February 1976; #104, April 1977); the Sentinels (#98, April 1976); Black Tom Cassidy and the Juggernaut (#101, October 1976), who then hire Arcade for #123's (July 1979) attack); Vindicator/Alpha Flight (#109, February 1978; #122, June 1979); Warhawk (#110, April 1978); and Mesmero and Magneto (both #111, June 1978). Even before *X-Men* became known for stories about prejudice against mutants, the team lived in a near-constant state of siege. Some of these attacks are personal: Black Tom Cassidy is Banshee's cousin, Juggernaut is Xavier's stepbrother, Alpha Flight is the Canadian superhero team which Wolverine quits to join the X-Men. These tangled relationships generate plot lines even when the team seek to avoid trouble, as well as accounting for some of the emotional intensity for which the comic soon found itself renowned in fan circles. This latter point was also encouraged (though Claremont seems to have needed little encouragement) by

their status as students. The X-Men are quite self-consciously in the process of self-actualisation, and the decision to make several of them older than Len Wein had originally envisaged (he'd seen them as teenagers) did nothing to change this.

Beyond these motifs and tropes, however, Claremont was developing a deeper theme for the comic: the characters' relation to their own nature, and the thin line which separated human from animal.

THE NATURE OF THE BEAST

Since Claremont returned consistently to the question of human nature, natural (rather than cultural) settings were the obvious visual accompaniment. While other heroes fought on the mean streets of New York, the X-Men would visit the Savage Land (a tropical paradise hidden beneath Antarctica, where people live a pre-industrial existence and dinosaurs still roam – #114–16, October–December 1978), the Canadian forests (#139–40, November–December 1980, as well as *The Incredible Hulk* #180–1, October–November 1974, where Wolverine had been first introduced) and Polemachus (an alternate dimension where the warlike populace live feudal lives and ride dinosaurs – *X-Men Annual* #3, 1970) while frequently relaxing or honing their skills in the woodlands around Xavier's mansion. Even when not treading such obviously metaphoric terrain, their adventures often took place on rugged and isolated outposts: Muir Island, off Scotland's western coast (#104, April 1977; #125–6, September–October 1979), Banshee's Irish castle (#101–3), Antarctica (#112–13, August–September 1978) or outer space (#99–100, June–August 1976; #106–8, August–December 1977; #137, September 1980).

The break-out characters in these stories were, understandably, those most defined by their closeness to nature and by the extremity of their own natural personalities: Storm and Wolverine. Where the latter is defined primarily by his masculine ferocity, the former is characterised, in this period, by her feminine grace. Both commune regularly with nature – Wolverine with animals, Storm with plants. When Xavier recruits her, Storm is worshipped as a weather goddess,

bringing the rains to an African plain so that the locals can grow food. Once she moves to the X-mansion, she is given a room in the attic, where she grows plants. All the team have such rooms, but Storm's is the most strongly characterised. In #109 (February 1978), after the team return home after time in deep space, we learn that 'though Moira MacTaggert has cared for Ororo's plants as *best* she could... it's obvious that they've *missed* her.' Storm talks to her plants and they to her: 'Her tone is gentle, bantering, as she moves among the plants, greeting each one, talking to them as she would to people and listening intently to each answer.'

Where Storm is associated with plants, Wolverine seeks animals. He takes his code name from one, and until #120 (April 1979) it is the only name readers know him by. His costume exposes his arms, and once Byrne replaced Cockrum as artist, those arms, previously bare, were drawn with masses of thick, animalistic hair. While Storm relaxes with the others in #109, Logan seeks solitude in the woodlands, testing his skills by tracking deer and approaching them undetected by their senses. Six issues later, in #105 (June 1977), he addresses a sabre-toothed tiger as he would a person and it understands his sophisticated instructions given over three panels. 'I like gardens, and their solitude,' he says in #118 (February 1979). This closeness to nature is the basis of a bond which forms between Wolverine and Storm. Even at the beginning, when they have had little shared experience, Wolverine defers to Storm in unique ways. He does not respect Cyclops' leadership of the team – the tension between them runs through the first four years of the comic – and in an early argument (#97, February 1976) he threatens to 'cut you [Cyclops] wide open for that,' only to back off when told by Storm that 'You will do nothing, Wolverine -- not now, not ever... or you will answer to *me*.'

The nature which Wolverine communes with is that most associated with his own primal urges. All the scenes where he talks to animals are clear metaphors for that. The nature which Storm is connected to, by contrast, is the world outside of herself. Dave Cockrum expressed the idea that her eye colour changed with her mood and that the sky changed colour with them, but acknowledged that this had never been successfully managed in the comic.[2] The

character's early life is retold in #102 (December 1976), showing how she grew up in Cairo, but then felt something

> pulling [her] *south*, away from Egypt and the *Sahara*. You walked
> for a *year*, two thousand miles from Cairo to the *Serengati* [*sic*]
> *Plain*. And though you'd *never* seen the veldt before, you knew
> you had come *home*.

The juxtaposition here is explicitly between the desert around Cairo and the lushness of the Serengeti Plain, and although there would be later attempts to add mysticism to this incredible trek, at this point it was understood purely in terms of nature calling out. Storm was 'home' on the Serengeti because it had plant life in a way that the Sahara didn't. This closeness to the state of nature is not purely the result of her mutation. When Manhattan is magically transformed into a barbarian kingdom in *X-Men* #190 (February 1985), she alone of all the island's inhabitants, though she has been stripped of her powers some issues previously, can sense 'a fundamental wrongness [which] she does not understand and cannot explain'. Her power, of course, is weather control, something also apparent in other protagonists (Arkon throws lightning bolts in *X-Men Annual* #3 (1970), Alpha Flight summon up a storm in #120, April 1979), so, like any good melodrama, *X-Men* takes place against a backdrop of billowing clouds and torrential downpours: 'the worst Atlantic gale in living memory' (#103, February 1977), 'the raging fury of one of the worst winter gales to hit the Drake Passage, south of Cape Horn, in over a hundred years' (#116, December 1978), 'weather such as this planet has not seen since its infancy' (#147, July 1981), 'the nastiest Antarctic blizzard any of them has seen' (*Marvel Fanfare* #3, July 1982).

When the weather is not pounding the X-Men into submission and they find the time to relax, a Storm who is at one with nature – and accessing her own, deeper self – is depicted in a bikini, or similar arrangement, particularly once John Byrne becomes artist. In #109 (February 1978) she chafes at the necessity of wearing even this on a group outing to a nearby lake: 'It is only for the professor's sake that I endure this land's strange taboos.' In #116 (December

1978), the bikini again connotes a state of restfulness in the natural environment of the Savage Land. By contrast, in #120 (April 1979), when the X-Men are hunted through the Canadian city of Calgary they purchase new clothes from a department store to disguise their distinctive appearance, and Storm feels 'smothered' by her stylish ensemble.

While there may be good thematic reasons for dressing Ororo in a bikini at times, these (along with occasional moments when she generates a personal cloud and takes a naked shower in its rainfall, only her long hair wrapping around her body to protect her modesty from the reader's gaze) are moments when she is explicitly sexualised, often clearly as the object of the male gaze. In #114 (October 1978), the team are resting in a tribal village in the Savage Land, licking their wounds after a battle with Magneto and making plans to return to civilisation. The 'bikini scene' begins with Banshee musing on the fate of other X-Men, falsely believed dead in the battle, and he walks through the village, talking to Cyclops about the rest they need before seeking a route home. He heads to another hut, reflecting that the Savage Land 'is a *nice* place to visit, but it isn't *Sean Cassidy's* idea o'...' The concluding word of the sentence, 'Paradise', is not contained in this panel, but carried over to the next, a close-up on Sean's surprised face. In a second speech bubble, he asks 'Ororo?', and the next panel, the tallest on the page, is a portrait of the bikini'd Storm. 'Hello, Sean,' she says, 'Chief Tongah's wife *gave* me these robes. Do you *like* them?' It is a classic shot/reverse shot sequence: a small panel of the man looking and a larger display of the woman he is stunned by.

As might be expected when characters are understood in this way, the Savage Land is a location where both Storm and Wolverine come to the fore. Storm contrasts this natural environment with society ('This land is so *unlike* New York. [...] There -- even on a *good* day -- the sky smells to me like an *open sewer*. Scott says that is because of *progress*'), while Wolverine finds himself face-to-face with carnivorous dinosaurs. Logan's violence and the visceral nature of his weapons would become a concern for senior Marvel editors, who were unsettled by the idea of him slashing people to ribbons. Monsters feature prominently in *X-Men* not just because they

are exactly the sort of 'nature free of all humanity' that the comic makes so much thematic play with (see below), but more practically because it allows Wolverine to enter a 'berserker rage' in the way which readers wished to see without harming 'people'. He first does so against a winged demon, Kierrok, in #96 (December 1975). The other X-Men are shocked by his ferocity and his explanation would define the character for decades to come:

> *Ten years* o' psycho-training. O' hypnotism. O' *drug therapy*. Ten years o' *prayin'*... an' I *cut* him to *pieces* without a *thought*. *Nothing changes*, Prof -- I thought I'd learned to *control* myself -- I guess I was *wrong* -- an ya wanta know somethin' *funny* -- I'm *glad*!

As a demon from the time before man, Kierrok is exempt from moral prohibitions on killing, as are the dinosaurs of the Savage Land. Wolverine regards attacking a pterodactyl-like creature and slashing it to pieces as doing 'what comes naturally' and, standing amidst the creature's remains, can reflect, 'It's been a *long* time since I've been able to *cut loose* like this -- and I intend to make the *most* of it.' The first flashpoint of Wolverine's career as a killer (in as much as its morality and character implications caused significant fan debate) occurs two issues later (#116, December 1978), when he strikes down a human guard, apparently killing him. 'He's like the great *cats* on the veldt,' reflects Storm. 'When he strikes, there is no *mercy* in him.' Decades later, in 2013, a less inhibited Marvel would render the metaphor apparent with a comic, *Savage Wolverine*, which opened by featuring Logan's adventures in the Savage Land.

Wolverine was not initially the most popular character in *X-Men*, and among his detractors was artist Dave Cockrum, who favoured other members of the team. He became more prominent once John Byrne became artist. Byrne's own youth north of the border ensured that he would favour the team's one Canadian character. Claremont and Byrne put together the character's origin and drip-fed it into *X-Men*. Once he became the most popular character, *X-Men* would be caught in a complex relationship with Wolverine's berserker rages. Marvel couldn't possibly endorse them, but the full unleashing of his violent nature was exactly what some fans

wanted to see, and #133 (May 1980) was the first of many covers over the years to promise those fans exactly that: 'Wolverine Lashes Out', reads the excitable cover copy, alongside an image of Logan's claws knocking five armed security guards flying. Striking a balance between family-friendly content and the more violent tastes of its young male readers would be a challenge for Marvel editors in the 1970s and 1980s. The narrative compromise would often be stories where the X-Men were so completely beaten and imprisoned by powerful foes that only the eruption of Logan's innate nature could save them – his violence was thus rendered as an unfortunate narrative necessity.

X-Men #111 (June 1978) is an example of this sort of story, one of several issues where Wolverine appears naked (or nearly naked). He is the only male member of the team to be regularly stripped. However, if Storm's body is displayed for its beauty and her bikini sequences denote a character at rest, when Logan is naked it is always a tense moment, a visual metaphor in a plot line about his being stripped of his humanity. His clothes, those prime markers of the difference between humans and animals, are removed or shredded by those who would revert him to his primal nature. In this issue, all of the X-Men have been regressed to crude caricatures of themselves by the hypnotist Mesmero and displayed as fairground freaks. An ex-member of the team, the Beast, tracks them to the carnival and attempts a rescue. He is, however, captured by a group of the fayre's manual labourers. Byrne's art doesn't labour the violence – although the caption says that the fight lasts several minutes, it only gets a single panel – but it is clearly brutal, as the men are armed with clubs and other wooden implements. Wolverine, who is chained to a wall nearby, watches, but no one pays him attention because he has been completely reduced to a '*man-beast* from the Yukon'. As the Beast is dragged away, Logan's response, 'nnnNNOOO...!', is more an animal's howl than a word, but he responds on a more visceral level: 'The fight has sparked a *response* deep within him, a primal, elemental *need* that's been at the *core* of Wolverine's being all his *life*.' That primal response gives him the strength to break free of both his hypnotic conditioning and the chains which bind him. In this story, Wolverine's berserker

nature erupts unbidden, a product of a loss of control imposed by an exterior force. In the 1980s a different approach would be taken. The comic would consistently place Wolverine in situations where he felt he had no other choice but to consciously and deliberately unleash his animal nature (to 'harness the power of my rage -- make it work for me', as he puts it in #146, June 1981) and hope he can retain control.

The battle in *X-Men*, in this period of the comic, is routinely to find the balance between nature/human nature and the conscious, moral processes of the mind. With the Savage Land reflecting the psyches of several of the heroes, it is unsurprising that when the X-Men travel there the plot concerns a threat to the Savage Land's ecology. In this story (issues 114–16), the natural processes of the land are threatened by the massive intrusion of technology in the form of a hi-tech city which has 'upset the delicate ecological balance that, throughout the aeons, had kept the Antarctic icecap at bay'. As so often in post-1960s eco-fables, the opposition is between a liberating state of nature and the degradations of technology. The villain is a villain precisely because he cannot find balance: 'Instead of living in harmony with nature, this Garokk is breaking it to his will,' declares Storm in #116. In this instance, it is an excess of rationality and civilisation (represented by the advanced technology of the city) which is the threat. More often, the battle is excessive primal nature run wild. This presents itself in the form of monsters which are understood here to be those with no higher mental functions to control basic desires or who have consciously chosen to become slaves to their appetites. 'We will go hungry no longer,' booms Krakoa, the Living Island from *Giant-Size X-Men* #1 (May 1975), a Wein-scripted line which would find frequent echoes in Claremont's writing down the years.

A creature in constant hunger may be treated as a monster or as a sympathetic being with a complex and unfortunate problem. *X-Men* can take either view, but the need for villains – and for something recognisably non-human so that Wolverine can dig his claws in – has meant that some have been monstrous. One such example is Proteus. Conceived during the marital rape of Moira McTaggert, he is a mutant with the ability to reshape reality, a mutant who

needs to consume humans in order to maintain his corporeal form. The X-Men fight him in #125–8 (September–December 1979). Seemingly denied a physical form of his own (the details of how Moira gave birth to such a being are understandably glossed over), the character could plausibly be treated sympathetically as a man forever excluded from real existence. However, the comic does not take this direction. Instead, the violence of his conception has become Proteus' destiny, and he simply takes what he wants without regard for others. 'I... *hunger!*' he says, and 'Human! I... *need...*you!' (both #125), and 'Once more... I hunger' (#126). He is described as 'ravenous' in #128, and Cyclops describes humanity as simply Proteus' 'food'. The character is one of many Claremont villains who speaks this way, and even when this process of consuming people is not literal it can be figurative, such as in #129 (January 1980) when the newly emerging mutant Kitty Pryde reflects of Emma Frost, the White Queen of the sinister Hellfire Club, that 'She looked at me like I was something good to eat.'

At the other, sympathetic end of the spectrum is Karl Lykos, a being whose mutation is such that he must absorb the energy of other people to survive, but who is transformed into a winged beast, Sauron, if he takes too much. Lykos had been created in the late 1960s as a way of producing a vampiric character at a time when the literal representation of vampires was prohibited by the Comics Code. When he reappears in the late 1970s, Lykos is heroic precisely because he has fled the civilisation to which he is a threat, and, having found himself in the Savage Land, has found a balance there: 'I still needed *life-energy* to survive, but I took it only from the *lesser animals* around me. I became *one* with the land, a man finally at *peace* with himself' (#115, November 1978). The language and imagery of addiction hangs around these characters: they cannot help themselves, but put up the best battle they can against their impulses to consume.

There is a clear Freudian dynamic in much of this: the conflict between the moralising superego and the uncivilised id. We see it in Wolverine's struggles for self-control, Proteus' indifference to this struggle and, more metaphorically, in the opposition between the hi-tech city and the natural ecology of the Savage Land. One

of the oddest twists in the history of *X-Men* production is that this vocabulary was explicitly introduced in #106 (August 1977), the throwaway story 'Dark Shroud of the Past'. The story was actually written by Bill Mantlo, often regarded as Marvel's speediest writer, and commissioned upon the comic's resurrection in 1975 as a 'fill-in', a story to be left on the shelf to be used if/when Claremont and Cockrum missed a deadline. Mantlo wrote the story to Len Wein's character specifications, so when it finally saw print two years later, Claremont necessarily rewrote the dialogue to take account of the significant changes which had occurred. In the story, the old X-Men appear in the mansion and attack the new team, accusing them of being unworthy of the role, before being revealed as phantoms drawn from the repressed part of Xavier's mind: 'That was my... *evil* self, X-Men. The Charles Xavier who would use his powers for personal gain and *conquest* -- the *Mr. Hyde* to my Dr. Jekyll. Usually, I have *no trouble* keeping that part of my psyche in *check*.' This is a forgettable story, but it is notable for being the first use of the explicitly psychoanalytic vocabulary which Claremont would use to greater effect later on. It presents Xavier's life, as so many other mutants' lives will be shown, as a struggle to keep in check forces which would otherwise destroy him.

This Freudian vocabulary became the basis for how Claremont explored what it meant to be human. A fully functioning human has a conscious mind, rational and capable of taking moral decisions, but that mind is under pressure from more primal forces which might swamp it, reverting the human back to a near-animal status. The foremost exploration of this theme was the story which rocked comics fandom in 1980, which crystallised the narrative form that exploration of the theme would take and which would consistently haunt the comic until Claremont left it: the saga of the Phoenix, the 'child of light and darkness' (to quote #136, August 1980).

DARK PHOENIX

In the 1960s, the original X-Men frequently wished to be rid of their powers. They viewed them as a curse which set them apart

from other people, as they demanded self-control and gave little in return. Something of this persists into the new X-Men through the character of Cyclops, the only remaining member of the old team. He still feels cursed because his power – beams of energy streaming from his eyes – cannot be switched off and he is required to wear a red visor (or, later, a more stylish pair of ruby spectacles) at all times to stop them constantly causing damage. The rest of the team are freer to activate their powers as and when they need them. Be it Storm flying and commanding the weather, Wolverine revelling in a fight or Nightcrawler flamboyantly showing off, the new team enjoy their powers. When those abilities are taken from them by blocking technology, they feel a loss; the fullest expression of their identities is tied to the physical use of their powers. The use of the X-Men as metaphors for sexual identities would take years to develop, but this is surely the basis of that reading.

Like all natural forces in Claremont, the joy these powers bring must be balanced against their potential for destruction. In #96 (December 1975) Cyclops, angry with guilt over the death of his teammate Thunderbird on the new team's second mission, lashes out with his eyebeams at the trees in the woods surrounding Xavier's estate:

> He's *never* cut loose like this before -- *without* thought or care or *restraint*... The *power* flows through him like a *thing alive* -- and for those few moments there is *hatred* in him, yes, but there is *glory* too -- an *unholy* glory, a need, a... *hunger*.

As we have seen, the villains in *X-Men* are often those who give in to this hunger. What makes a hero is precisely that they do not, and Scott's anger soon passes. As 'Dark Shroud of the Past' showed, even Xavier, who – being older, bald, wielding advanced mental powers, and wheelchair-bound – is often coded as a rational, less emotionally excitable specimen of humanity, had a dark side which he needed to keep under control.

The story which most completely explores these themes, 'Dark Phoenix' (#135–7, July–September 1980), is one of the most frequently reprinted comic strips of our time and the high point of

the Claremont/Byrne *X-Men*. The story's twists are both touching (it is implied that Scott and Jean consummate their love) and shocking (Jean destroys a sun, killing five billion people). Familiar faces are economically assembled (ex-team members Angel, Beast and Professor Xavier's alien love interest Lilandra are all present for the finale) and Byrne captures them beautifully as Claremont forces each to look to their conscience ('I once thought I would defy the *Devil* himself for Jean. Now... I'm not so sure'). Vibrant new villains appear, while an old one is hidden in plain sight. The epitome of Claremont's strategy of long-term plotting, Jean's explicit seduction by evil begins in #122 (June 1979) and concludes over a year later, a transition built around the question marks which have been present over her powers ever since her rebirth in #101 (October 1976).

Len Wein had written Jean out of the comic, and she had departed with the original team in #94 (August 1975). That Claremont brought her back three issues later should surprise no one; after all, she and Cyclops formed the book's central romantic relationship. Every Marvel comic had one of these, and they were an important (if often implicit) component in the company's argument that it told stories about real characters, and were a way of retaining the interest of teenage readers who might otherwise have left comics behind. In #101, Jean is reborn, and her powers are enormously enhanced under circumstances so narratively ambiguous that nearly a decade later the company was able to completely rewrite the accepted understanding of the event. Her transformation occurs when she is caught in cosmic radiation while piloting a space shuttle to Earth through a solar storm. (Naturally, it is 'the worst *solar storm* in living memory'). Having crashed into Jamaica Bay, off the coast of New York, she erupts from the water in a new, dramatic costume, declaring 'I am fire! And *life incarnate*! Now and forever -- I am Phoenix!' She then promptly collapses, so the extent of her new powers does not become clear until four issues later, when she battles Firelord, a major Marvel villain. The use of her powers is accompanied by the manifestation of a fiery bird, the Phoenix Force. Her battle with Firelord is merely a prelude to the events of #107–8 (October–December 1977) when she reactivates a stargate

('My... God. Jean used to be the *weakest* X-Man. Now she powers up an *inter-stellar transporter* without batting an *eyelash...*', #105, June 1977), 'snares' a meteor from a distance of a thousand kilometres and brings it smashing down on to a foe, and, in the culmination of the space-war epic which had been running for 18 months, she enters a mystic crystal and (in a sequence where sci-fi imagery meshes with Jewish mysticism) re-energises the fundamental latticework of the universe, thus staving off its destruction at the hands of a neutron star. I won't recite the extensive captions which Claremont added to the artwork to explain this almighty episode, but it plays heavily on Jean's temporary loss of her own sense of self as she merges with both the Phoenix Force and the universe itself. This elevation of Jean's powers went hand-in-hand with the rethinking of her non-superhero life. Although returned to the comic, she did not live in the seclusion of Xavier's mansion but instead retained an apartment in New York, shared with Misty Knight, a regular in another Claremont/Byrne comic, *Iron Fist*.[3]

This revamping of Jean's character was part of Claremont's tendency to write female characters that were as strong and as powerful as the male ones. In keeping with this, Claremont rejected the common tradition of giving hero(ine)s gender-specific code names (Spider-Man, Wonder Woman, etc.), preferring instead to follow the alternative practice of using gender-neutral identities. Jean, announcing herself as Phoenix, throws off her previous infantilising code name of 'Marvel Girl', a development which was applauded across fandom. 'Well, it took comicdom all of half a decade to do it, but you at Marvel have finally come up with a super-heroine. I mean, a real superheroine,' gushed the letters page of #109 (February 1978). Through *X-Men* and other comics, Claremont gained a reputation in the late 1970s for writing female characters that were as rounded and as competent in battle as their male counterparts. In *Iron Fist*, he and John Byrne had developed the supporting characters, Misty Knight and Colleen Wing, as running a hard-fighting detective agency. Mary Jo Duffy, a regular correspondent to Marvel in the mid-to-late 1970s, and only a couple of years away from taking up a writing/editorial position at the company, expressed the mood in her letter printed in *Iron Fist* #12 (April 1977): 'Chris, no

man has ever characterized women as clearly and realistically as you do. Colleen and Misty are both wonderful characters, for their faults and weaknesses as well as their strength and individuality.'[4] Claremont's reputation for writing women in this way would be contested in some corners, but he would never lose it, and books with female leads (*Ms Marvel*, *Spider-Woman*) would be assigned to him to work his magic on.

Jean soon finds herself ambivalent about her new powers and the changes to her psychology which take place as she uses them. Wolverine quickly recognises that this new Jean reaches primal depths that the others do not. Having freed himself from Mesmero's hypnotism at the circus in #111 (June 1978, discussed earlier in this chapter), he understands that Jean is the one X-Man whom he might awaken the same way, thinking, 'I broke *outta* my hypnotic trance by reactin' t' things on a gut, *instinctive* level [...] Now I gotta make Jeannie do the *same*.' The plan works, though Jean almost kills him as he awakens her real self and powers. Wolverine chooses to awaken Jean in this way because he senses something of his own primal fire in her. The comic returns occasionally to the idea that Wolverine is in love with Jean and seeks to steal her away from the more self-controlled Cyclops. This romantic rivalry can be read retrospectively as reflecting the battle between her id and superego, though this is insufficiently developed as a theme during this period.

From the start, Claremont developed specific descriptions to describe the reborn Jean. 'Her attack is savage, surprising both of them with its primal fury,' a caption reads as she battles Firelord in #105 (June 1977), and when required to make a tactical withdrawal, she reflects that '*part* of me still wants to get *Firelord* -- to... *kill him*! My power -- it's hitting me like a *drug*. I've never felt such... *ecstacy* [*sic*]!' *Primal* is the word most frequently associated with Jean's use of her powers, 'like a drug' the most common metaphor and *ecstasy* a common description of her feelings, here intended to resonate with all its overtones of trance-like states and religious or emotional/sexual frenzy. She 'feels power -- *her power* -- thrill through her soul... part of her *glorying* in it, part of her *terrified*' (#108, December 1977). Another frequent metaphor for Jean's transcendence is singing. When she uses her power to psychically

draw from her friends the emotional support she needs to literally save the universe she 'feels her power, the power of her friends, *sing* within her' (#108); 'Her power is a *song* within her, filling her with a primal glory, an unhuman *joy* that she's beginning to enjoy more and *more*' (#112, August 1978); 'Her power a symphony within her... a song of joy that builds too quickly in its crescendo' (#128, December 1979).

There is idealism in the language here. No other Claremont addict reaches for such intangibles as *glory* or *song*. They crave *pleasure*, *energy* or *power* – sensations to titillate the physical self or forces to manipulate the material world. Jean alone is reaching for something as immaterial as music and as transcendent as glory. I have used the word *balance* to describe what the Claremontian hero(ine) struggles to achieve. The word which unites that concept with the song metaphor is *harmony*, and it is used by Claremont in #136 (August 1980) as a retrospective description of Jean's greatest moment – saving the universe in #108 – and as the indicator of everything which she has subsequently lost. *Glory* and *joy* are words less commonly used now than they were in the past. Though they have secular uses, they appear less often in modern usage, and carry connotations beyond the material. Webster's online dictionary includes 'the presence of the Divine Being' among the meanings of glory, and joy often carries a spiritual meaning beyond such passing moods as happiness or physical delights such as pleasure. Though these secular concepts are also present, the religious vocabulary is meaningful here because all these stories of unnatural hunger are, at heart, temptation narratives. This religiosity sometimes becomes blatant, as when Jean saves the universe and the X-Men are briefly characterised in terms of the Tiphereth, part of the Kabbalah's tree of life (#108), or in Claremont's recurrent use of the word 'soul' to denote one's most authentic identity (which I will discuss in Chapter IV).

Under other circumstances, Jean might find the balance required of all Claremontian heroes, and we can only imagine what a glorious song would result. However, a convoluted 'thought you were dead' plot line isolates her from the rest of the team (#114–25, October 1978–September 1979) and she falls, instead, under the influence

of Mastermind. This evil mutant, who appeared in 1960s issues of the comic, uses his powers of illusion to create a new identity for himself as Jason Wyngarde, a handsome eighteenth-century aristocrat. By creating illusions in Jean's mind that they are lovers, and that she herself is an eighteenth-century figure, he dismantles her moral scruples and leads her to join him in the Inner Circle of the Hellfire Club. This is the power-obsessed mutant core of an exclusive club for the United States' – later, the world's – rich and influential. At this point in its development (1979–80), the Club's taste for the clothing of two centuries earlier simply looked like a nod to the infamous club of the same name which flourished in eighteenth-century England, but Claremont would develop a new emphasis some years later. The Club would later express themselves as an id which wishes to be free of the moral restraints and legal safety nets of modern society, as in this declaration by its leader Sebastian Shaw in *New Mutants* #51 (May 1987):

There is a *reason* for our garb, Magneto. It symbolises a rejection of the strictures and false morality of this modern age... and our allegiance to the ways of a rougher, more vital era -- when a man, or woman, was limited solely by his wits, his strength, his courage, his ambition. Nothing was beyond the reach of those willing to pay the price.

This wider, cultural view was a few years in the future, however. In 1979, the issues were presented in personal terms. 'I'm merely giving her a taste of some of her innermost -- forbidden -- needs and desires,' Mastermind reflects in #129 (January 1980). 'Within her angel's soul -- as in all our souls -- lurks a devil, a yang counter-part to the surface yin. All I'm doing is freeing that negative part of her "*self*" from its moral cage.' That freeing manifests itself in ways which look, to adult minds (particularly those 40 years on), staggeringly mundane, and those anticipating images of depravity will be disappointed. The high level of ascetic self-denial required of superheroes means that even the most innocent use of powers to make one's own life easier is regarded as a major transgression. Thus, Jean's descent into evil is marked mostly by her using her powers

to change clothes instantly. She does it twice in #125 (September 1979), the second time shifting to a low-cut top, provoking Havok (Scott Summers' brother, Alex) to reflect, 'She's showing off -- using her telekinetic talent to manipulate her body's metabolic levels and counteract the cold. She seems to be flaunting her powers more and more these days -- that's not like Jean at all.' When she pulls the same stunt in front of Scott himself, in #132 (April 1980), his thoughts are similarly troubled: 'She did it again, changed from costume to street clothes by telekinetically rearranging the molecules of her outfit. Why do I find that so disconcerting? Why shouldn't Jean use her psi-powers to make her life easier?'

Why not, indeed? Except that the rule which operated in 1979/80 was that heroes did not do that. Powers were only exercised in the course of defending humanity; superegos demanded that the casual use of those same powers to ease one's own workload was wrong. With Jean's instant costume changes, the issues openly articulated are the avoidance of the labour which mundane tasks require ('easier') and the arrogance implied in the charge of 'showing off' – of demanding that one become the focus of attention for those immediately present. There is also a sexiness about some of the clothing which Jean chooses to shift into (a low-cut yellow top and a bikini-style affair), which we are invited to interpret as a sign of loosening morals. These tropes of easiness and sexuality are repeated throughout the issues of Jean's seduction. #130 (February 1980) finds her picking up stray thoughts from a downmarket disco: 'Some of the images I'm receiving are so... vile. But, I can handle that. Part of me almost finds those thoughts... *attractive*.' An issue later she again takes the easy way out by tampering with the mind of Kitty Pryde's father in order to save the X-Men from embarrassing questions about their presence in a malt shop when it was destroyed. 'That used to be anathema to her,' reflects Cyclops (#131, March 1980). The comic is playing fast and loose with its ethical Rubicons here – Xavier had several times done the same in the past for identical reasons – although it is a foreshadowing of the stance taken in the 1980s, when, in the face of telepathic villains with no scruples about mental manipulation, it would become a repeatedly stated line which the X-Men's telepathic characters do

not cross. Mental manipulation might be the least of Jean's crimes in #131, when she also kills a villain, Emma Frost, the Hellfire Club's White Queen. Although there is no body shown (a loophole which the comic would later exploit to bring her back), the implication is clear. In a duel that is fought on the psychic plane rather than the physical, Jean fights more ferociously than ever ('Her power is a song within her... a passion beyond human comprehension. She is more alive than she has ever been -- as she smashes through the White Queen's psychic defences with contemptuous ease') and in desperation her opponent brings the whole building down around them. Cyclops interprets this, an issue later, as the Queen's suicide, although Jean could easily have chosen to extend the psychic shield which protects herself and Storm to save her foe as well. The issue after this (#133), her seduction complete, Jean joins the Inner Circle as the Black Queen, a clear replacement for the dead woman. In her new role she is granted a skimpy new costume and a flirtatious way with the Inner Circle's male members: 'Mastermind's given her the instincts of a minx,' Cyclops reflects.[5]

Mastermind's grip over Jean collapses when he apparently slays Scott in front of her eyes, a step too far which reawakens her normal personality. Even here, however, as she turns the situation around, she retains a sad self-consciousness. 'You're a woman after my own heart,' Wolverine commends her in #134 (June 1980). 'I know. I wish I wasn't,' she responds. 'The repressed dark side of my soul' is ascendant, says Jean, and, as they flee the building, 'her song of power builds to its inevitable crescendo.' Her costume turns from green to blood red, she is transformed into Dark Phoenix, and metaphors of passion come thick and fast in the writing. 'Jean's enjoying this!' thinks Scott in #135. 'Using her power is turning her on -- acting like the ultimate physical/emotional stimulant!' Storm looks to her friend for some of the love which radiated from her when she saved the universe, but now she senses 'pain, great sadness -- and an awful, all-consuming *lust*'. Wolverine is again characterised as the only one who truly understands the passions which rip through Jean, and regretfully unsheathes his claws to deliver a killer blow: 'Ev'ryone else is holdin' back [...] I got no choice. I gotta end this -- now! *Permanently*!' (#136, August 1980).

Like any Claremontian villain who has given themselves over to their appetites, Jean becomes defined by her hunger, and having beaten even Wolverine, she heads into deep space, a journey which exhausts even her powers. 'I'm ravenous. Before I go on, I need sustenance. This star should do nicely.' As she consumes the star, condemning the inhabitants of one of its orbiting planets to death, 'she craves the ultimate sensation.' As any adult will recognise, all of this is the language of sexual desire. That allegory was not openly written into the comic because of the young audience, but Claremont was happy to articulate it in interviews aimed at older readers: 'To use a somewhat gross term, it was the quest for the cosmic orgasm. Her feeding... on the star was an act of love, of self-love, of masturbation probably.'[6] Hunger metaphors are common in *X-Men* (and readers may even grow tired of them by this book's end), although those of childhood only recur at this point in the series, despite this stage of life being an image of beings in whom the restraining superego has not yet reached full formation. This is the central theme of #136, 'Child of Light and Darkness', which suggests that the Phoenix Force is something mankind is not yet old enough to assimilate and handle wisely. Galactic Empress Lilandra calls Jean 'the child'. 'Knowledge without wisdom -- age without maturity,' is Xavier's sad judgement.

What happened next is well known to comics fans and professionals alike. Marvel's editor-in-chief Jim Shooter, employing a hands-off policy regarding comics in development, only saw Jean's act of cosmic genocide as the issue went into production. Too late to stop it seeing print, he queried how the story was to be resolved in the following issue. Claremont and Byrne intended that Jean would be apprehended and advanced alien science used to remove the Phoenix power from her body, molecule by molecule. She would be rendered literally powerless for the first time, and she would have to learn to live in the world without the telepathy and telekinesis which she had previously known. This would lead to a major moment of moral decision when, in a dramatic 150th issue, she would be offered the ultimate temptation, the return of the Phoenix powers. Shooter vetoed this, feeling that the punishment was unequal to the crime – that merely taking Jean's powers away

was an insufficient price to pay for someone who had killed five billion people – and that Marvel should not endorse this moral position. With the print deadline looming, the revision devised by Claremont, Byrne, Shooter and incoming editor Louise Jones concluded with Jean feeling the rising of the Phoenix Force within her and, worried that she would take more innocent lives, using alien weapons to take her own life.

Although it was forced upon him, this resolution is written in a typically Claremontian manner. As the climax approaches, Cyclops urges self-control: 'You have an intellect, Jean, a will, a soul -- *use them!* Fight this dark side of yourself!' The demand that Claremont places upon all the X-Men is that they retain self-control in the face of overwhelming desires. That is Wolverine's daily struggle, and it is what villains such as Proteus fail to do. For Jean, however, it is simply too much to ask: 'I'd have to stay completely in control of myself every second of every day for the rest of my immortal life.' (That Jean, having resurrected herself once already, might well live forever – barring catastrophic circumstances – is a point not discussed anywhere else, and its addition here does make her burden sound larger.) As her normal self battles to stay in control, she activates alien weaponry to obliterate herself. Some commentators, picking up on Shooter's concerns with the moral positions which Marvel was seen to be endorsing, reflected that the comic ended up condoning an act of suicide. *X-Men*, both in its story pages and letters column, preferred the word *sacrifice*.

Another writer, having completed 'Dark Phoenix', might well have looked for a different theme. Claremont, however, returned to it almost immediately in #139 and #140 (November and December 1980). Perhaps intended as an optimistic alternative to Jean Grey's fate, this story specifically concerns the progress which Wolverine has made in taming appetites and animal nature. The character had been first introduced in *The Incredible Hulk*, where as a Canadian agent he had been sent to handle the title character, who had bounded across the border from the US and got entangled in a battle with a mythical woodland beast, the Wendigo. After this story, Logan had next appeared when he quit the Canadian service to join the X-Men,

and the Canadians had twice dispatched other superpowered agents to try to bring him back.

In *X-Men* #139 Wolverine appears for the first time in a new costume, changing his traditional bright yellow for clothes of brown and orange. There is no explicit link made between his adopting a new look and the themes of the story, but it is hard, once these themes become apparent, not to infer a symbolic shift away from his previous persona. He deflects the question of why he has changed with a flippant 'Why not?', before announcing that he is going to finally resolve his issues with the Canadian government. He and Nightcrawler head north, his reunion with old friends resulting in the first use of his name – Logan – in front of an X-Man. Readers had been privy to this information for almost two years, but Nightcrawler is the first X-Man to learn it, and from this point on it is used freely by the team. Alpha Flight, the hero team Wolverine left, are busy in the forests, and when Wolverine realises that their mysterious antagonist is the Wendigo he offers his help, reflecting that 'I come up here to tie up some of the loose ends in my life, and wind up face-to-face with the *biggest* loose end of 'em all!'

The Wendigo is a transformed human being, one whom the heroes seek to return to its proper form. It could be written sympathetically, but the comic prefers to treat the character as a monster, and thus fair game for Logan's claws. The use of a young mother and her baby, prisoners in the Wendigo's lair, being kept for when it needs fresh meat, is perhaps a narrative device to allow this. The magic spell which sustains the Wendigo also heals its wounds almost instantly, so the battle exhausts Logan without reaching a conclusion. Alpha Flight step in, deploying Snowbird (Anne McKenzie), a heroine who can turn herself into any animal she wishes. This power comes with the traditional Claremontian risk: 'I assume the persona of whatever creature I become. If I am consumed by bloodlust, I could become as terrible a threat to my friends as Wendigo himself.' A true Canadian, Snowbird transforms into a real wolverine, the ferocious creature of which Logan is only 'the closest avatar'. We do not see the resulting savagery – Byrne prefers to show us the shock on her comrades' faces, including Logan, who can only ask, 'Annie... what have you done?!'

McKenzie is indeed consumed by her bloodlust and sits, baring her fangs at all who approach. Alpha Flight's resident Native American, Shaman, steps forward to cast the spell of transformation which will free the man inside the Wendigo, asserting that he can recall Annie Mckenzie as well. Wolverine stops Shaman, deploying instead his own ability to speak to animals to recall Mckenzie to her human state. His stated reason is that this would be too much for Shaman, and that having redeemed Annie he might have too little magical energy left to transform the Wendigo. In the mid-1980s, the comic would fully develop a theme of resisting magical solutions in preference to victories achieved through psychic or ethical exertion, but that vocabulary was not in place at the time this story was written. To readers with retrospective knowledge, it might seem to underpin Wolverine's strategy, but this is never stated, possibly because the scene is not ultimately about Annie's choice to return to human form, but about Wolverine's capacity to see her triumphantly through the process. He uses his previously seen ability to talk to animals, but also draws on the unlikely example of Cyclops: 'I've gotta reach Annie with words -- an' emotions -- just like Scott reached Jean Grey when she'd been consumed by *Dark Phoenix*.' The words he uses are not shown. The apparently lengthy dialogue is not directly quoted but mentioned in a caption, and once Annie is herself again, Logan offers the comfort that 'You've gone through the valley, faced the worst parts of yourself, and triumphed. It'll never be as rough again.'

The story acts as a marker of Logan's own progress: his capacity to talk Annie back from a brink that he himself has faced and triumphed over. He combines his classic traits as a creature of nature with verbal skills copied from the example of Cyclops, the leader he has never previously respected, and gets to voice what will become the house moral: that once a person has faced their demons down once, further confrontations will be easier. Reflecting his own maturing into a being with greater self-control, one who will routinely aid other people through the dark moments that he has himself faced, the story equips him with a new costume and inaugurates both the common use of his human name and the practice of flashbacks to his time as a Canadian agent. Jean Grey

couldn't control her passions, but this story – treat it as a coda to 'Dark Phoenix' – shows how Logan has.

WRITING THE CHARACTERS

Some readers of *X-Men* were willing to interpret the characters in terms of a larger picture of humanity, producing analyses not unlike that which I have pursued in this chapter, as evidenced by a number of letters printed in the comic, for example:

> Chris Claremont is showing us the conflict between the light and the dark within the psyche of Jean Grey. This conflict is but an example of what each of us must deal with in order to acquire any sort of psychological and philosophical maturity. The conflict personified by Jean Grey is a sad comment on the nature of this human world of ours... (#136, August 1980)

> To me, Cyclops reflects the order and discipline that we all consider as one of our better virtues. In contrast, Wolverine and most recently Jean Grey as Phoenix represent our inherent anger and ferocity as individuals. (#140, December 1980)

For the majority of readers, however, it was more important to read the characters not as emblems of a theme but as coherent bundles of individual traits which made *X-Men* a study in human emotion and interaction. The below examples are representative of what was printed on the letters page:

> Thanks for Jean Grey, for Sean Cassidy, for Lilandra Nerimani [*sic*], for Kurt Wagner, for Scott Summers, for Charles Xavier, for Hank McCoy and all the rest. Thank you for giving us people, instead of just another bunch of superheroes. I love them all. (#119, March 1979)

> Claremont's brilliant characterisations have ensured that we know the X-Men after these past two years and we care about them.

Claremont hasn't just shown us what the X-Men do, he has let us share it with them. (#115, November 1978)

Even criticism could be couched in such terms. 'The characterization had completely crowded out the normal dialogue,' complained one correspondent in #130 (February 1980). Note also the way that fans would routinely refer to the characters by their human identities rather than their superhero code names.

While the letters page, edited by Marvel staff (often Claremont himself responded to readers), might be expected to portray the comic in a positive light, these comments nevertheless reflected the general mood of fandom on this issue. Those who dissented from this view knew that they were fighting against the grain of fan opinion. Such dissent could be commonly found in the major fanzine of the period, *The Comics Journal*. Produced to a quality which matched non-glossy professional magazines, the *Journal* and its publisher, Gary Groth, campaigned to have comics viewed on a par with all other art forms. As such, the magazine sought to recognise quality or innovative work, and became increasingly scathing of anything which it found formulaic or unambitious while championing those works which it felt artistically utilised the relation of word to image in comics.[7] With Marvel and DC – and hence superheroes – dominating the American comic book industry, they would inevitably become the focus of much of the *Journal*'s attention, but a clear gap was emerging between the magazine's staff, who were increasingly critical of the mainstream industry's aesthetic standards and working practices, and much of the readership, for whom Marvel and DC more or less *were* comics. As the most acclaimed comic of the period, *X-Men* was always going to be central to such debates. A negative review in 1979 took issue with a number of Claremont's favoured devices, arguing,

All of the X-Men are so tediously agonized that revealing their 'personalities' is accomplished primarily through the characters talking to themselves. Claremont's characters do a great deal of soul-searching [...] *X-Men* 119 contained a letter praising the characters as 'real' people (as do almost all issues of the book).

Well, if exaggerated neuroses and hand-wringing can pass for 'real' in the world of comic books, then perhaps they are [...] inserting cute foreign words into their mouths and phobias into caricatured habits does not give them authenticity [...] *The X-Men* is little more than *All My Children* or *The Doctors* with fancy superhero costumes and super-villains.[8]

The disparaging comparison to the culturally denigrated form of the soap opera and the accusation of characters' 'hand-wringing' were criticisms which Claremont's overt emotionalism made easy. Doubts about one's ability to fully contribute to (or lead) the team, concern for other members, questioning the morality of pragmatic actions and indecision over romantic feelings were common across the team. Storm had claustrophobia to contend with, and Colossus bouts of homesickness.

All of these agonies were expressed through words. Whatever facial expressions or body language his artists gave him, Claremont's characters expressed themselves in language. 'I mourned for Hank,' a confused Cyclops tells Storm in #114 (October 1978), 'but -- for Jean there's *nothing* there. After the shuttle flight, nothing had changed between us, yet *everything* had. She wasn't the girl I'd *loved* anymore.' When there was no one to talk to, characters could talk to themselves, Claremont could populate a panel with thought bubbles reeking of self-doubt, or he could simply use captions to describe emotional turmoil. In #114 Jean takes a two-panel walk to Professor Xavier's study to deliver the (incorrect) news of the X-Men's demise. Other writers would let the pictures of her lonely walk speak for themselves, but Claremont was not that sort of author. In six captions split over two panels, he would take readers into her mind:

She makes no *sound* as she moves through the house, and with each step *memories* swirl around her... the day she *arrived* and met *Scott Summers* for the first time... the life she *shared* with the X-Men, *old* and *new*. She never thought the house could feel so *empty*. She *aches* inside, a knot *tightening* around her heart with every passing *second*. And yet, her face is *calm*, her hand steady.

Much of Claremont's wordage attempted to capture interior states, and fans applauded that. However, the extensive word count could obscure meanings conveyed by the art. Discussing the details of a sequence in #148 (August 1981), Dave Cockrum would reflect, 'Chris is going to have to cover it mostly in copy.'9 For this reason, by the early 1980s, fans concerned with the aesthetic questions of the comics form – of the fusion of word with picture and the alleged primacy of the latter in a visual medium – would question Claremont's way of writing. He himself was always happy to discuss issues of characterisation in interviews with the comics press. 'I have a tendency, for better or ill, not to show everything,' he offered by way of explanation for some oddities. His interviewer on this occasion suggested that a line in #100 (August 1976), about a deep friendship having formed between Jean and Storm, was an example of this, the relationship in question having not been visible to readers, and Claremont elaborated, 'That was something that was intended to be established in #97 at the airport [...] I didn't set it up and in hindsight I should have set it up.'10 Claremont's many interviews to the fan press and his willingness to answer every question asked of him about missing motivation, sudden friendships or the way he had originally planned sequences meant that two versions of *X-Men* circulated within fandom: the one which actually saw print and another which existed inside the author's head and which he would elaborate on without hesitation. He would contextualise the state of the finished product within the collective nature of Marvel's production process. When an artist working from his plot understood the story differently from Claremont, meanings would be obscured. Talking of Wolverine's killing of a guard in the Savage Land (#116, December 1978), he explained that his original plot line established that

[i]t was a wartime situation. You have Storm, Wolverine and Nightcrawler on the ground. You had the guard. You had an airborne patrol of pterodactyl riders a hundred feet overhead. The slightest outcry would have brought them down and would have defeated the X-Men. The man had to be taken out swiftly, silently and permanently [...] John [Byrne] chose not to do it

that way. He did not establish the threat – the pterodactyl riders flying guard patrols, we had no time to change it.[11]

Those who wish to see this as excuse-making for confused work may do so, although the problem might be understood as a potential pitfall inherent in the Marvel way of working. One such disjunction between the writer and artist finally led to Byrne leaving the comic. *X-Men* #140 (December 1980) begins with Colossus in the grounds of Xavier's mansion while Wolverine and Nightcrawler are away in Canada. Specifically, Colossus is pulling a tree stump from the ground. Byrne would make it clear during subsequent interviews and convention appearances that he regarded this as minor work for a hero who punches his way through walls. This is clearly what the picture shows: there is no tension in the man's body, no strain on his face; indeed, there is the hint of a smile. The stump itself is clearly coming free. Speed lines drawn around it show just how quickly it is moving as Colossus pulls. The picture shows that Peter, who grew up in an agrarian collective in the Soviet Union, is enjoying a little light gardening. However, having received the pencils, Claremont chose to add dialogue and captions which described the scene quite differently. In Claremont's view, this was no easy work, but a 'duel' with Colossus, presumably straining, declaring, 'By Lenin, either my heart will burst and my steel body crack -- or I will pull you *free*!' Byrne's easy time in the field is rewritten as hard work, physical agony and, perhaps, as self-testing. Byrne had drawn none of this, and, concerned that his visual ideas would continue to be overwritten by Claremont's prose, he left for *Fantastic Four*, where, as both writer and artist, he could retain more control.[12]

Byrne was leaving a comic which, by 1980, had completely sealed its position as the most acclaimed in America. A fan club of several hundred readers from around the world was run out of a private home in Bridgewater, England, unofficial but recognised enough by Marvel that advance artwork was previewed there and senior editors interviewed. Its influence can be found across the industry in the early 1980s. DC began *The New Teen Titans* and revamped *The Legion of Superheroes*, producing its own bestsellers. The former was, like *X-Men*, the revival of a past comic which had never gained

acclaim, and mixed members of the old team with dynamic new arrivals. Its editor Len Wein (who had written *Giant-Size X-Men* #1), writer Marv Wolfman (Wein's successor as Marvel's editor-in-chief, and thus de facto editor of *X-Men* #95–100, October 1975–August 1976) and artist George Perez (who'd drawn *X-Men Annual* #3 in 1970) filled the comic with powerful superheroines, long-term character arcs and a blend of superheroics and science fiction that seemed familiar to comic fans. Perez, like Byrne, was not a great experimenter with the grid system, which both men left intact, and his images were just as easy on the eye, stylised, rounded and pretty. Like Byrne, he was fast, rarely a man to miss deadlines, and this, combined with his and Wolfman's long-term commitment to the project, granted *Titans* the same continuity of style which marked *X-Men* in the late 1970s. *The Legion of Superheroes*, which had always juggled a regular cast of twenty or more, brought the relationships between them to the fore. Decades later, *Legion* writer Paul Levitz would reflect that these comics saw DC attempting to 'get more in sync with the emerging world of comic shops dominated by Marvel'.[13] That emphasis on comic shops was one sign that fan consumption was disassociating itself from the wider culture. Another was the fact that while wider culture associated Marvel and DC with characters who worked alone (Batman, Superman, Spider-Man, the Hulk), team-based books were dominant among sales to comics fans.

<p style="text-align:center">★</p>

This, then, was *The Uncanny X-Men* in 1980: king of the comic-book world as everyone understood it. But 1981 would change that understanding, and *The Uncanny X-Men* would transform itself to keep up.

II

HISTORY AND FUTURES PAST

The Uncanny X-Men #141 (January 1981) to #168 (April 1983)

Central X-Men in this period: Professor X (Charles Francis Xavier – telepath and teacher of the mutants), Cyclops (Scott Summers – fires energy beams from his eyes), Wolverine ('Logan' – enhanced senses, healing ability), Storm (Ororo Munroe – weather control), Nightcrawler (Kurt Wagner – a teleporter and circus-trained acrobat who looks like a demon), Colossus (Piotr/Peter Rasputin – can turn into a superstrong man of steel) and Sprite/Ariel (Kitty Pryde – a 13-year-old girl who can turn intangible, allowing her to pass through physical barriers).

John Byrne left *X-Men*, frustrated by some of Claremont's ideas and keen to establish himself as a writer–artist in his own right. The series' original artist, Dave Cockrum, returned, and though his art failed to excite fandom as Byrne had done, sales of *X-Men* continued to climb. Guest appearances by Doctor Doom, the Man-Thing and Spider-Woman reconnected *X-Men* with the wider Marvel Universe, though the inclusion of the last two probably owed much to the fact that Claremont was scripting them simultaneously with *X-Men*. He could not, however, save these other comics from cancellation, so his superstar status had its limits. Cockrum's return brought with it the reappearance of the Starjammers and significant stories set in outer space. In the wake of Jean Grey's death, Cyclops took a leave of absence, but returned to the team in #150 (October 1981). Kitty Pryde joined and the number of mutants in the Marvel Universe began to expand. The major event of this period was the development of a 'possible future' scenario. This depicted a not-too-distant future America where mutants were registered, tagged and often killed merely for existing. The story, 'Days of Future Past', drew on the imagery of the Holocaust, and in #150 Magneto was revealed as a survivor of Auschwitz. *X-Men* had found a big theme, one which would define the comic for decades to come. The first plans for an X-Men film

were publicly discussed during this period, with Claremont and other Marvel staff taking meetings with production company Nelvana, but nothing would come of them at this time.

X-Men #141 begins with Kitty Pryde running through a desolate urban wasteland. It is a distinct break with the natural spaces which had been associated with the comic for so long. With Wolverine having made progress in controlling his rage and Jean Grey departed, the comic was moving into new areas. There would be much about the control of passionate urges in the stories to come, but from now on they would share space with new themes. From this issue until #168, *X-Men* is dominated by fantasy spaces (alien planets, the mystic dimension of Limbo, Magneto's mysterious island with its buildings left by a lost civilisation, the castles of Doctor Doom and Dracula, a literal Fairy Tale) and by the corridors of political power (Washington meeting rooms, the Pentagon, a private New England school). The desolate New York through which Kitty runs manages to be both a fantasy space (because it is the year 2013 and the streets are patrolled by giant robots, the Sentinels, who have taken over the country) and an index of politics (because this is what America becomes when executive policy goes horribly wrong). The Sentinels have taken control of America, and, seeking to expand their control/ extermination of mutants across the globe, are ready to move against the rest of the world. Other nations promise nuclear retaliation, so the world sits on the brink of destruction. Cover dated January 1981, the issue went on sale in America during November 1980 (election month), and the present-day portion of the story is set on 'the final Friday of one of the closest, hardest-fought presidential elections in recent memory'. The future events which it creates turn on the consequences of the assassination of an American senator, Robert Kelly, by a reformed Brotherhood of Evil Mutants, which allows a rabid anti-mutant candidate to win the next election in 1984, famously the year of George Orwell's future dystopia. Claremont had written nothing like this in the comic before, but these themes become recurrent after this issue. The story itself cuts between 1980, the comic's present, and 2013. In the future, things become

progressively worse as the remaining mutants are killed in a failed attempt to stop the Sentinels moving against the rest of the world. Presumably, nuclear Armageddon will follow. In the present-day portion of the story, the X-Men succeed in stopping Kelly's assassination, thus potentially avoiding the dystopian future – although there are, of course, any number of other ways in which the persecution of mutants may come to pass. Indeed, the story ends with an epilogue set in a darkened room in the White House, where the government's attitude towards mutants is shown to have hardened as a result of the incident. The story concludes, then, on a tone which will become familiar in future years: cautious optimism tempered by shadows hanging over an unknown future.

The future dystopia takes its imagery from Nazi Germany. It is an explicitly genetic dystopia where people are labelled at birth according to their chemical make-up. Those regarded as fully human are allowed to breed. Those with potentially deviant cells are not. Those classified as mutants live in internment camps, wear collars to neutralise their powers and must signify their status with a shameful M on their left breast. Watching government hearings in the present day, Moira MacTaggert evokes the Nazis, suggesting that what Senator Robert Kelly wants is 'registration of mutants today, gas chambers tomorrow'. It is, therefore, no coincidence that it is Kitty Pryde we first see running through this devastated state; Kitty is Jewish.

Kathryn 'Kitty' Pryde made her first appearance in #129, the symbolic cover date January 1980, the first issue of the new decade (though it was available for purchase three months earlier in the US). She was the creation of John Byrne, with Claremont adding the fact that her parents were divorcing and making her a child genius. Though Byrne disliked the latter idea, Claremont's belief that the comic needed a computer genius would be vindicated in the 1980s as information technology moved ever closer to the core of both everyday life and adventure fiction. A detail from Byrne's initial designs which Claremont developed was a Star of David necklace. Byrne had included this in his conceptual sketches because a woman he was using as visual inspiration wore one. That woman was not, in fact, Jewish, but Claremont felt the detail suggested that Kitty

was.[1] He himself was Jewish on his mother's side, and had spent time on a kibbutz.

This is not to assume that Kitty was intended from the beginning to carry heavy symbolic weight; indeed, her ethnicity is initially downplayed. The Pryde family are well assimilated into the American middle class and, as she is introduced walking home from a dance class, the necklace visible for readers to see, the panels are heavy with Claremontian wordage not about her ethnicity but about her home town ('Chicago -- the windy city, celebrated in verse by Sandburg, in song by Sinatra. Home of the world's tallest building and -- so they say -- best pizza...'), her youth ('She's 13 years old, going on fourteen -- -- and her world is slowly falling apart'[2]) and the headaches which are a symptom of her emerging powers ('She can't help crying as she sprawls on her bed, the throbbing pain gouging deep lines around her tight-clenched eyes').

Six issues later, the X-Men's attack on the notionally respectable Hellfire Club brings them to the attention of Senator Robert Kelly, a presidential candidate and a guest of the club that night – the man whose assassination the X-Men stop a few issues later in 'Days of Future Past'. Although his speeches would become increasingly shrill over the years, at this point he is described as 'intelligent, articulate, decent, popular, given a good chance of winning in November'. Kelly is not yet a zealot; he is a symptom of the wider mood. Angry at the police's impotence in the face of superpowered (apparent) criminals, he is susceptible to the suggestion of Sebastian Shaw, leader of the Hellfire Club's sinister Inner Circle, that the reactivation of dormant Sentinels might provide a long-term answer to 'this mutant menace'.

Previous fleets of Sentinels had been produced by rich fanatics such as Steven Lang in *X-Men* #96–100 (December 1975 to August 1976). Lang was easily marginalised as a lunatic, however. He called his Sentinel program 'Project Armageddon' and saw in it 'the final ultimate conflict between homo sapiens and homo superior -- between man... and mutant'. Clearly, his aversion to mutants was the result of an extreme, and purely personal, psychosis. With the backing of a 'decent' politician, this set of Sentinels would become something scarier: a genuine index of a wide public mood. This

new focus had a major impact on the comic. In #97 (February 1976), the responsible authorities had attempted to shut down Project Armageddon because the number of known mutants in the Marvel Universe was so small they couldn't possibly be regarded as a threat. That remained the case. 'Days of Future Past', potent though its imagery is, has to stretch beyond plausible social forces to SF apocalypticism to justify its narrative. The Sentinels have gone far beyond their original remit of fighting known mutants and, throwing off human control, decide to rule over everyone, executing any known superheroes, mutant or not. The Marvel Universe would need to contain a lot more mutants before the theme of prejudice could work without the use of high-concept devices such as this. For the citizens of the Marvel Universe to plausibly fear mutants, there would need to be many, many more of them. Even before the success of *X-Men* created a commercial desire for spin-off titles featuring new mutants, Claremont began to address the issue. This would change the way that new mutant characters were introduced.

Traditionally, the X-Men had had a device called Cerebro, which sensed mutants across the world. In the 1960s, once an emerging mutant was pinpointed, they would be invited to join Xavier's school. Magneto might make them a counter-offer. Such storylines were rare, however, because the comic was already sufficiently populated. The theme of good mutants vs. evil ones could be played out sufficiently with the current cast. In the 1970s, Claremont and Dave Cockrum introduced a research/containment facility on Muir Island where several criminal mutants were held, and when a new evil mutant was required (for #125–8, September–December 1979) he escaped from there. The initial Hellfire Club story of #129–31 (January–March 1980) plays out this traditional understanding. Cerebro registers the presence of two new mutants, Kitty Pryde and the musical performer Dazzler, and the X-Men go to meet them, arriving near-simultaneously with the Hellfire Club, who either have their own detection system or have bugged Xavier's mansion. Battle is subsequently joined for the hearts and minds of these young mutants.[3] The same drama is played out in the graphic novel *The New Mutants* (1982), which introduces a new team. The new theme of anti-mutant paranoia, however, required

that the world be full of mutants. Thus, new mutant characters appeared suddenly in public, mutants who had somehow slipped past everyone's detection systems. Caliban first appears in #148 (August 1981), speaking of living alone, but later revealed in #169 (May 1983) to be living with the Morlocks, a group of thousands of mutant outcasts who live in tunnels beneath New York City. *New Mutants* #16 (June 1984) revealed that the Hellfire Club had recruited a six-person youth wing without anyone else knowing, while #45 (November 1986) had a mutant called Larry Bodine living undetected within walking distance of Xavier's school. When Marvel launched a second spin-off comic, *X-Factor*, in 1986 its premise was explicitly based on the idea that new ways were needed to identify and reach out to the many mutants who were failing to be located by the usual systems. Outside of the X-books, stories about mutants, sometimes with sales-boosting *X-Men* guest stars, became popular, and so the number of mutants continued to rise.

MAGNETO'S REDEMPTION

Despite these developments, in an interview given in December 1981 Claremont was still happy to describe the X-Men's 'fundamental role' as 'combating "evil" mutants', but the use of inverted commas round 'evil' suggested a questioning of the traditional role.[4] As he spoke, he was writing stories in which a couple of those 'evil mutants' were reformed. A cure was found for Karl Lykos' need for the energy of living beings, so he would become Sauron no more.[5] More substantially, he was beginning the story of Magneto's redemption.

Magneto had been the X-Men's arch-enemy since the first issue. For much of the 1960s he had assistance from the original 'Brotherhood of Evil Mutants', superpowered underlings who carried out his instructions as the X-Men carried out Xavier's. Since 1976 he had been a headline threat, one against whom the new team could measure themselves ('Lord, no! We're still nowhere near ready,' reflects Cyclops as Magneto reveals himself from the shadows in #111, June 1978) and who could pass comment on their

progress ('Somehow, Cyclops got them to fight as a *team*, instead of individuals,' he concludes, after barely escaping two issues later). Despite this, Magneto was under-characterised, lacked even a real name, lived alone on an asteroid in space, and battled the X-Men at society's edges: on the isolated Muir Island and a base hidden in Antarctica. He would be revamped, in 1980 and 1981, as a man at the centre of world history.

Although a short sequence in #125 (September 1979) shows Magneto as a man still in mourning for a long-lost wife, substantial steps towards his rehabilitation begin in 'Days of Future Past'. In the 2013 sequences, he is part of the mutant resistance which seeks to change the events of history. Aged now, he is confined to a wheelchair and the panel in which he enters deliberately obscures his face, creating the expectation that the figure is Xavier. As the elder statesman of the mutant group, he has, indeed, taken much of the Professor's role as moral spokesman, his vocabulary showing that he thinks of everyone: 'Our actions may not make things better -- for humanity *or* mutantkind -- but they certainly cannot make them worse' (#141, January 1981) Franklin Richards calls him 'sir'. He has only this single scene, later dying in an unseen sequence, sacrificing his own life in a diversionary tactic so that the rest of the team may continue the assigned mission.

When we next see Magneto, in #148–50 (August–October 1981), it is in the present. Like 'Future Past', the story deals with the Cold War nuclear stockpiles and in it Claremont and Cockrum reimagine Magneto as an idealist, demanding that the world destroy its atomic weapons and turn its energies towards nobler goals:

> The nations of the world spend over a *trillion* dollars a year on armaments. I intend to deny them that indulgence. The money and energy now devoted to war will be turned instead to the eradication of hunger, disease, poverty.

Part of this reinvention of the character is the revelation that he was a prisoner in Auschwitz, an experience which will be central to his character from now on and act as an explanation for why he feels that humanity will never accept a people as 'other' as mutants. The issue

is not the first to show us Magneto without his helmet – significantly humanising him, and allowing for a full range of expressions – but he spends more time out of costume than ever before. His scheme is thwarted when Kitty phases through his computer systems, disrupting them beyond function and destroying the information he has spent a lifetime acquiring. In retaliation he strikes out angrily at her then regrets his actions:

> She -- she is a *child*! What have I done?! Why did you resist? Why did you not understand?! Magda -- my beloved wife -- did not understand. When she saw me use my powers, she ran from me in terror. It did not matter that I was defending her... that I was avenging our murdered daughter. I swore then that I would not rest 'til I had created a world where my kind -- mutants -- could live free and safe and unafraid. Where such as you, little one [sic] could be happy. [...] I remember my own childhood -- the gas chambers as [sic] *Auschwitz*, the guards joking as they herded my family to their death. (#150, October 1981)

This is the start of Magneto's redemption, and it is played out in typical Claremontian terms. His plans thwarted, he strikes out in anger, hurting Kitty not because doing so will advance his aims but because he is frustrated. Although the language is, as usual, not used, we recognise the familiar issues here. Magneto's superego must retain control over the blind needs of the id which will otherwise unleash unproductive destruction. That he speaks of the gas chambers while holding Kitty might be expected by readers familiar with later issues, but the relevant character traits here are not her Jewishness. The issue here is her youth and vulnerability, rather than her ethnicity. Indeed, there is less 'Jewish content' in these issues than is often assumed. Despite the later assertion of artist Dave Cockrum that he and Claremont had decided upon Magneto's Jewishness at this point, the reasons for his incarceration by the Nazis are left unstated. Later, there would be speculation that he was of Gypsy origin, and thrown into the camp on those grounds. Not until 2012, in the *Magneto Testament* mini-series, was his Jewish ethnicity formally acknowledged in a Marvel text.

The exploration of Magneto's past and of Jewish themes continued in *X-Men* #161 (September 1982), 'Gold Rush'. The story is a one-off flashback issue in which a comatose Xavier dreams/remembers an incident during the years after his service in the Korean War when he travelled widely, mostly around the Mediterranean. At this time, he visited a friend in Israel, another medical man now treating traumatised Holocaust survivors. Magnus – later Magneto – also works there and they become friends for a while, though it is clear that they disagree about how humanity would treat mutants if they became aware of their existence. Xavier treats a young woman, Gabrielle Haller, using his psychic powers to pull her from the coma she sleeps in. While inside her mind, he sees many strange images, including a vision of herself transformed into a golden statue. While they ponder the meaning of this, the hospital is attacked by neo-Nazis who kidnap Gabrielle. She has been programmed with subconscious knowledge of a hidden hoard of Nazi gold with which the kidnappers hope to establish a Fourth Reich. Xavier and Magnus, the latter revealing his powers to Xavier for the first time, free Gaby and defeat the neo-Nazis. Magneto flees with the gold, a wealth with which he will fund future operations to keep mutants safe from humanity.

This issue bears comparison with an earlier story, *X-Men* #117, 'Psi War' (January 1979). That was set in Cairo during the same period. Indeed, 'Gold Rush' refers to the earlier story in its dialogue: 'You have a nice time in Cairo?' 'The visit had its... memorable moments.' The earlier story, however, had no concerns with World War II or Jewishness. We can compare the two stories to see just how *X-Men* had changed over the intervening years. In 'Psi War', Xavier finds himself in a small nightclub where he meets another telepathic mutant, Amahl Farouk. Farouk is the kingpin of the local crime scene, and, recognising another telepath in Xavier, offers him a place in the future where powerful mutants like themselves will take what they want from lesser beings. Xavier refuses, with his customary lecture on the responsibilities which come with power, and the two engage in a psychic duel which Xavier wins, apparently killing Farouk.[6] This is Xavier's first ever encounter with an 'evil mutant', that phrase alone showing us how the story was rooted

in the themes and structures as Lee and Kirby had defined them in the 1960s. 'This story could be called his [Xavier's] origin,' wrote the preview on the letters page of the previous issue, 'for the events therein start him down the path that eventually led to his formation of the first X-Men team.' Aesthetically, 'Psi War' is short and to the point. It draws on a previous tradition of fiction about westerners abroad in exotic climes. A specific reference is the film *Casablanca* (Michael Curtiz, 1942), a link implicit in the north African setting but made explicit in Farouk's appearance, clearly based on actor Sydney Greenstreet, who played shady club owner Ferrari in that film. Readers are invited to recognise the allusion. Part of the pleasure of the *X-Men* in this period is the playfulness with which it shifts genres.

'Gold Rush' could not be more different. We could name some generic patterns it might fit: hunts for Nazi gold, tales of neo-Nazis dreaming of a Fourth Reich, 'Freudian mysteries' where the meaning of the strange images in a patient's subconscious must be decoded. 'Gold Rush' could conceivably be discussed with reference to any of those, but it does not encourage us to do so. The references it wants us to connect to are not specific Hollywood films or larger notions of distinct genres; rather, the story's foremost reference points are derived from real world history: the recently formed state of Israel, the Holocaust. Like 'Psi War', this is an origin story – and not just for Magneto, but also for the whole thematic terrain that the comic will be ploughing from now on. In both stories Xavier enters the mind of another, but where 'Psi War' gives us telepathy as combat and Xavier as warrior, 'Gold Rush' presents it as part of a healing process.

Magneto's appearance in this flashback story keeps him relevant to the ongoing narrative while allowing him to be absent from the narrative present. He is elsewhere at this point, no doubt brooding on what he has become and his next course of action. He will, in time, replace Xavier as head of the school. More immediately, his absence left a large gap, that of 'chief villain.' In #151 (November 1981, the very next issue after Magneto's tragic history is revealed and his rehabilitation begins) the Hellfire Club are resurrected to become the new primary villains of the Claremont era. They were

a brotherhood of evil mutants, but one which had been rethought for a more sophisticated age. They did not self-defeatingly declare their evil intentions, but rather hid behind social responsibility. As industrialists, socialites and educationalists they had political connections which meant they could never be brought to justice, and their pre-eminence spoke of a more complex theory of how power works (by manipulating the wheels of government and industry) than superpowered fist fights. As Magneto's brotherhood had been the opposite of the early X-Men, so the Hellfire Club were the opposites of the new, even to the point of having to hide their status as mutants lest public prejudice compromise their wealth. Magneto, as leader of the Brotherhood, had been Xavier's polar opposite. There could be no simple recreation of that opposition because the Club had no single leader, authority being dispersed among the club's 'inner circle'. A system grew up whereby varying inner circle members could represent the opposite of the X-Men, depending on the themes being discussed. When a spin-off comic, *The New Mutants*, came to focus on a teenage class at Xavier's school, so Emma Frost, the Hellfire Club's white queen, would be the primary villain. Her respectable life as the headmistress of a private New England school made her Xavier's polar opposite, a distinctly different type of pedagogue with different ambitions for her students.

The establishment of the Hellfire Club as primary antagonists, along with a new Brotherhood of Evil who had Pentagon access, allowed traditional business to continue as usual: good mutants faced bad ones in a shadow war which was sometimes, but far from always, beneath the notice of national powers. That theme, however, would share space with the new emphasis on the public persecution of mutants. When exactly had that become a major theme? The answer is complicated.

METAPHOR AND INTERPRETATION

Some critics and comics professionals argue that the theme of public prejudice was always central. Claremont himself took that

view in an interview in the early 1980s. When asked to elaborate on parallels between mutants in the comic and real-world Jewish experiences, he expanded the metaphor:

> Not just Jews. The *X-Men* is the only Marvel book I'm aware of that, when it was started, had a specific theme, that theme being that humanity hates mutants just because they exist [...] So what we have here, intended or not, is a book that is about racism, bigotry and prejudice.[7]

As this book goes to press, this quote can be found, boxed out to draw attention and give it prominence, on Wikipedia's *X-Men* entry. As such, it could quite easily be the most widely read piece of interpretative analysis which the comic has ever received. Claremont asserts here that the theme was always present, though that is problematic. Projecting the concerns of the 1980s (and since) backwards grants *X-Men* a coherence which no continued story produced to tough deadlines over decades could possibly contain. Stan Lee seems to have had some interest in the theme of mutant outsiders, but when the writing of the comic passed to Roy Thomas with its 20th issue this theme becomes so subliminal as to be invisible. While Claremont himself was making the issue central in the early 1980s, it had disappeared from view on those many occasions in the late 1970s when the X-Men left the United States; and even when it seems to be present, the meanings are ambiguous and open to multiple interpretations.

The opening scene of *Giant Size X-Men* #1 (1975) is sometimes cited as a sequence which states, from the very start, that the theme of the revamped comic is anti-mutant prejudice. Indeed, the word 'prejudices' is actually used. In the sequence, Nightcrawler is fleeing a Bavarian mob that would kill him for his difference. Xavier intervenes and saves him before inviting him to join the new X-Men team which he is assembling. The iconography of the sequence, however, shows us something very different to the anti-mutant plot lines which would proliferate in later issues. The mob are simple peasants – an insulting term, perhaps, but that is what the art deliberately evokes. They chase Nightcrawler with burning torches, not electrical ones.

Their buildings signify the style of the Middle Ages, and the tools which they brandish as weapons are agrarian implements. They do not fear Nightcrawler because he is a mutant (they almost certainly do not know the term – indeed, even the eloquent Kurt says only that 'I have heard that word' when Xavier introduces it) but because he looks like a demon, and they propose the traditional solution to supernatural evil, a stake through the heart. The comic at this point has no visual or thematic vocabulary about prejudice in the modern political sense to use. Rather, the scene is about the difference between scientific and superstitious world views. The peasants think Nightcrawler is a demon, but Xavier convinces him he is a mutant. Science trumps superstition. Something similar occurs a few pages later when Xavier visits Storm and persuades her to give up life as a weather goddess and embrace/explore her mutant nature instead. The sequence of Nightcrawler's pursuit will be echoed several times down the years. The 1982 spin-off series, *The New Mutants*, begins in a similar way, with religious fanatics chasing a newly emerged mutant. When such imagery is not directly dramatised it features in dialogue: 'They'll come after us with… with pitchforks or something,' worry the team in *New Mutants* #57 (November 1987). The notion of agrarian, peasant mobs is too visually dramatic, too rich in historical connotation, to ever be dispensed with completely, but it will not be part of the imagery which propels the comic from here onwards. (Nightcrawler's striking appearance will always make him a special case. A number of later recruits to Xavier's school, mutants themselves, are visibly discomfited by him. One subplot of 'Days of Future Past' contrasts the newly arrived Kitty Pryde, who keeps her distance from a man she finds frightening, with her older self who has learned to accept him.)

If *X-Men* had a metaphoric level of the sort which Claremont assigned to it in 1981 – and which is now central to the films and to critical discourse about the whole franchise – a number of obvious questions present themselves: who understood the comic in this way? Claremont, in the interview cited above, was happy to expand the metaphor in an explicitly political direction. Others were more circumspect. Bob Harras, who became *X-Men* editor in 1988, would define the metaphor in more general terms:

It's about being a person who feels left out, feels alone, feels isolated – and then magically finding that place where there are others like you. In a lot of ways, the *X-Men* concept is perfect adolescent angst in comic book form. I would say it's almost better than *Spider-Man*. When you're an adolescent, where's the place you feel most isolated? It's in school. But here's the *X-Men* franchise – comic, cartoon or movie – and tells you here's a school for *you*.[8]

This is a less political reading. It declines to talk about specific marginalised groups, favouring a view that what the comic articulates is a more generalised adolescent existence.

From a commercial point of view, Harras' is the more inclusive reading. It allows even straight white boys – always a key Marvel demographic – to feel that they have a stake in the team of outsiders. It is noticeable, however, that contributors to the letters page understood the importance of representational issues. Readers' letters from early issues focused on the ethnicity of the new international team. One letter in #97 (February 1976) from Tom Runningmouth recounted his pride in seeing 'an American Indian' joining the team, along with his disappointment at Thunderbird's early demise. 'A young black woman' had a letter printed in #103 (February 1977) expressing a particular interest in Storm. The letters page of #99 (June 1976) also provided an early example of the sort of rhetoric which would later become associated with the comic. At a time when Claremont was used to receiving praise for his writing of female characters, one correspondent objected to the way that the female character of Lorna Dane (a mutant who, when code-named Polaris, was affiliated with the X-Men but not an actual member of the team) was written. Believing that Claremont had written the character in a way which made her dependent on her male partner for fulfilment, the (male) correspondent asks, 'hasn't he [Claremont] ever heard of the women's movement?' After discussing the character, the reply – unsigned, but it does appear to be Claremont who wrote the responses at this time as he sometimes slips into the first person about himself – asks,

[I]sn't that the ultimate goal of all these People Liberation move-
ments: to give every *person* – regardless of race, creed or sex – the
right to be whoever he, she or it *wants* to be, and not play a role
imposed on them by the society around them?

The letters page would not feature rhetoric like that again for a while,
but more oblique commentary was provided in #113 (September
1978) when Jana C. Hollingworth, a frequent letter-writer to Marvel
in the 1970s, considered the position of Jean Grey's parents, who,
having been spectators at Phoenix's battle with Firelord, were now
'ordinary middle-class parents adjusting to a daughter who is now
not what they consider normal – something many parents have to
cope with.' In the same issue, another correspondent opined, 'Not
many mutants out here, but I think a lot of us feel trapped by the
accidents of birth or circumstance that made us what we are.' In
#134 (June 1980), one correspondent praised the comic for its
'assiduous descriptions of what it is like to be an outcast'.

It is impossible to know what deeper sense – if any – lies behind
those observations, but this last is from 1980, by which time evi-
dence of a gay reading of the *X-Men* was evident in fan publications.
That year, John Byrne gave an interview to *The Comics Journal*, the
content of which provoked this response on the *Journal* letters page:

I find it somewhat ironic that someone so obviously homopho-
bic as John Byrne is best known as the artist of the comic book
feature whose concept essentially reflects the gay experience of
alienation. (Yes, *X-Men*…it takes absolutely no effort to point out
the numerous parallels.)[9]

In the interview, explicit talk of homosexuality aside, Byrne was
happy to promote himself as a Victorian gentleman at odds with
the morals of the late twentieth century, a contrast with Claremont
who, he said,

[k]eeps souring me on the characters. He soured me on Colleen
Wing when he told me she was a) bisexual and b) promiscuous.
She sleeps with anything because she is looking for the big O.

And I don't want to know that. I don't need to know that to draw her, but I couldn't draw her properly from then on [...] I liked Colleen Wing right up until he laid this brilliant little bit of characterisation on me.[10]

Such commentary was rare, if not unique, in 1980, though in later decades readers of interviews would become used to revelations by *X-Men*'s past editors of Claremont's odder plans for the book (engineering situations where Xavier would be forced to put on women's clothing was a favourite, apparently, but was vetoed by successive editors).[11] Claremont himself was happy with sexualised readings of the *X-Men*. In an interview recorded in February 1981 with comics journalist Peter Sanderson, he said:

We got quite a few letters recently from a number of gay fans, who believe that *The X-Men* makes positive subliminal statements about gay rights. They identify very strongly with the X-Men's position because gays are hated and feared simply because they exist.[12]

Those letters would remain unpublished on the letters page at this point. Claremont could remain the author of this level of meaning in the comic simply by being willing to talk about it. For those able and willing to read the signs in the comic or the writer's extra-textual hints, gay and lesbian characters began to enter the comic. Although it has always been overshadowed by the dark visions of a dystopian 2013, 'Days of Future Past' itself saw the introduction of a new Brotherhood of Evil. Claremont had intended that the female leaders of this team would be lovers, though Marvel's editorial teams stopped this from being made explicit. Another member of the Brotherhood, the flame-controlling Pyro – also making his comics debut that issue – was given a foppish, book-reading personality, possible coding for his being queer.

Marvel did not at the time print the letters from openly gay readers which Claremont discussed but, given the storylines which were being produced, discussion of political content was inevitable. #149 (September 1981) contained this from a disabled reader who identified particularly with Nightcrawler:

I may not be pointy-eared and blue and able to go 'bamf', but because my hands and feet are mis-shaped and I wear an artificial limb I can no more pass for normal than Kurt [...] There aren't too many characters – in books, comics, movies or elsewhere – that us real life 'misfits' can lock onto to form or celebrate positive images of ourselves.

The letter was openly acknowledged by a later correspondent, who developed the argument thus:

the X-Men are essentially ordinary people with a small, but important difference.

The mutants represent the possibility of a broadened, all-encompassing Humanity that, with the proper support and training, utilises our multiplicity and benefits from our individual variance. Sex, race, religion and age are not issues to complicate the co-operation of these champions. They are facets of individuality – nothing more, nothing less.

I rather pity poor Magneto. He's internalised society's hatred and thus displays the human traits he most despises.

The female correspondent was from San Francisco, the self-proclaimed gay capital of North America. That may be a coincidence, of course (though when the X-Men themselves visit that city, we will be expected to make the connection: see the next chapter), but what seems beyond doubt is that here (in *X-Men* #154, February 1982), the modern reading of the *X-Men* finds full expression, with the editorial endorsement of a response which asserts, 'We couldn't have put it better ourselves.'

LIGHT AND DARKNESS, EGO AND ID

X-Men's new social storylines of prejudice and nuclear armaments did not eclipse the traditional psycho-philosophising around nature and the balance of light and darkness in the human heart. It lived next to stories in which the themes of the 1970s continued to

be replayed. The X-Men still live in a world where civilisation sits atop a nature which could quickly erupt and destroy it – literally so in the case of the volcano which Magneto activates to destroy the gleaming 'newly-expanded industrial center' in Soviet Russia in #150 (October 1981). A return to the Savage Land in anthology title *Marvel Fanfare* repeated many elements of #114–16 (October–December 1978): Sauron, an ecological threat, an opposition between the villain's technological citadel and the natural landscape surrounding it, and Storm even dons a bikini. More original was the pairing, in #145–7 (May–July 1987), of Claremont/Byrne creation Arcade with Marvel's top villain Doctor Doom. The former was a spoilt Californian who traps his prey within a lethal fairground – an improbably huge underground installation – called Murderworld. Contrasting Arcade's garish oversize games and his inability to see any issue beyond amusement with the art and history permeating Doom's Old World castle, the story posits the two men as id and ego. Doom pities his ally: 'We face ecological devastation of unparalleled magnitude –– yet, as usual, your concern is solely for your own personal gratification.' Arcade shows his lack of interest in this judgement in the same panel, lighting a match by striking it against Doom's metallic armour. At its best, *X-Men*'s two themes would intersect gracefully. As we have seen, the revelation of Magneto's past as a concentration camp survivor came in a sequence where he realises the need for his ego to overcome his id. The shattered New York which opens 'Days of Future Past' is another such image, both a picture of the comic's new political direction but also a liminal space between a civilisation which has collapsed and the feral nature retaking it.

Storm and Wolverine continue to be the characters around which the relationship between human rationality and nature are most centrally played out. The major villains of this period (appearing in #155–7, March–May 1982 and #160–7, April 1982–March 1983) are the Brood. Part reptilian and part-insect, the creatures wield modern technology and talk in sophisticated ways. They are monstrous, however, not merely because of their appearance, but because of their aggressive biological urges. Their burning need to

reproduce by impregnating others with eggs which will hatch and grow, absorbing the superpowers of the host, implies a nature which has not yet fully mastered biological imperatives – and as such, they are fair game for Wolverine's claws. A traditional Wolverine struggle occurs in #162 (October 1982). His clothing torn to shreds and barely hanging from his frame, the thick animal hair of his torso and limbs exposed for all to see, he fights a new struggle to retain his humanity as his healing factor, treating the implanted embryo as an invading virus which he seeks to destroy. Racked by pain, he reflects, 'When an animal knows its time has come, it quits fightin'. It literally lies down and dies. I hope it doesn't take too long.' His sense of self reasserts itself, however, and he recants such thoughts: 'I'm not an animal. I'm a man.'

Such a story plays out the familiar drama of Wolverine's battle to retain a hard-won humanity, and his increased strength of character means that the assaults on his rational mind must become increasingly fierce if there is to be any doubt at all about the outcome. Storm's self-control, by contrast, has always seemed more easily won. Her mastery of the elements reflects her control of her own nature. As ever in Claremont, however, there is an alternative version – a dark, savage shadow self, nature out of control and dangerous. In #111 (June 1978), the X-Men are hypnotised, regressed to less than fully conscious beings and paraded as animalistic carnival freaks. The scantily clad Storm displayed on the show's poster is not, as on other occasions when we see her bikini'd, a body at rest, but one who is aggressive, muscled, arms outstretched, glaring outwards at the observer. Her hair is free to swirl around her and the leopard-skin bikini she wears connotes carnivorous animals rather than gentle plants. Around her churn the elements (Cockrum routinely drew the X-Men with energy crackling around their bodies, but Byrne preferred a maelstrom of forces circling violently around the characters who stood, and often fought, at some calm eye in the centre of the hurricane).

When displayed in #111, that was an unusual image of Storm, and the point was that she had been uncharacteristically reduced from her natural personality. In the early 1980s, similar images became recurrent as her inner anger rose closer to the surface.

In #145–7, Doctor Doom uses a 'metabolic transmuter' to turn her into 'organic chrome', a metallic statue whose life processes have been slowed to almost nothing. While her conscious mind sleeps, her unconscious creates a massive tempest which ravages America's eastern seaboard. As the story reaches its climax, 'Rogue Storm' #147, the comic invites comparison with Jean Grey. *We did it before... Dare we do it again?* asked the cover copy. Just as the cover of #135 (July 1980) had depicted a giant Dark Phoenix with the X-Men as small figures lying inert on the floor, so this one shows an almighty Storm, a scantily clad primal goddess, towering above teammates a quarter of her size. While Storm is returned to her normal self by the issue's end, the effects on her psyche seem longer-lasting. In #148 (August 1981), she notes that thunderclouds have appeared in the sky after an upsetting argument with teammate Angel.

The assaults on Storm's calm only increase with the arrival of Count Dracula (#159, Annual 6), who wants her to be his consort (Jason Wyngarde, Doctor Doom, Count Dracula – seducers in the *X-Men* are usually European aristocrats). In a comic where the monsters are routinely characterised as those whose unbridled appetites lead them to prey on humanity, the appearance of vampires was probably inevitable. Indeed, years earlier, when the new X-Men were being devised, among the many character ideas which Dave Cockrum had shown Marvel's editors was a female vampire 'who, by one method or another, was going to try to keep it under control'.[13] It is not hard to imagine how that would have played out in Claremont's hands: 'I...hunger,' she would surely say on many occasions before finding the inner strength to rein in her appetites. In *X-Men* Annual #6 (1982), it is Storm, bitten by Dracula and transforming, who gets the talismanic line ('I hunger, little one'). The transition to vampire takes three nights in Claremont's version, for which there is precedent, long enough to play out the traditional agonies of a conscious mind struggling to retain control as animal appetites threaten to take over.

It is tempting to see X-Men's 'duality of humanity' plot lines (exploring good and evil in terms of individual psyches or as philosophical/religious problems) as essentially divorced from its

'mutant paranoia' strand, which deals with social forces. The comic and its authors, however, were constantly finding points of intersection. Speaking in February 1981, Claremont felt that *X-Men* readers viewed Senator Kelly, the anti-mutant politician, as a typical Claremontian good man with failings which led him to do bad things:

> The idea that one can be a villain and hateful and yet have totally justifiable motives is something a lot of letter-writers have picked up on in the future History stories. Senator Kelly, what he is doing and why he is doing it are quite rational. He is scared. He is frightened by what is understandably a real threat.[14]

The ongoing attempts made by the comic to find vocabularies to link the two themes are detailed in the next two chapters.

GROWING PAINS

During 1980–1 *X-Men* became a more self-consciously serious comic. It was not alone in seeking to present a more complex picture of how superheroes might fit into the world. *The Avengers* had run stories in 1979 and 1980 about how Marvel's premier supergroup – their strongest, mightiest heroes banded together – would function under government oversight. These comics were redefining their content for older, more sophisticated readers as the industry, which had seemed on the verge of collapse only five years earlier, discovered successful markets. While sales of comics through news stands continued to decline, the dedicated comic fan had emerged, and in such numbers that shops specialising in selling comics and little else became viable. These fans, concerned that their aesthetic experience was being compromised by cheap printing processes and poor-quality paper, constituted a market for comics with a higher purchase price, while the shops which served them did not purchase comics on a 'sale or return' basis, as news stands did, but retained unsold copies, confident that they would be sold as back issues in the months ahead. During this period, *X-Men* defined itself as the

market leader. For the year to October 1980, Marvel reported the comic's sales figures as 191,927, but a year later that had jumped to 289,525. (See Appendix for discussion of sales figures.) This redefinition of the market allowed comics companies to make longer-term plans, while putting them on notice that older fans required more sophisticated entertainment which embraced the complexities of real-world situations and adult emotions.

One source of this material was a new category of comic, 'the independent'. For those older readers prepared to leave the mainstream, there had always been alternative comics to read, and since the late 1960s they had often been closely linked with the counter-culture and drug consumption. By 1980 those titles were in decline, but the emergence of specialist shops provided a marketplace for comics which were produced independently of the traditional companies despite eschewing the explicitly political concerns of the counterculture. Though celebrated for certain differences which they exhibited from the mainstream, these comics were often conceived in broadly similar generic terms and were recognisably related to the Marvel/DC style in a way that drug-celebrating 'head comix' were not. Sold by mail and distributed through the comic stores, the smaller resources of these companies, often self-run from the creators' homes and initially publishing a single title, meant that they were in black and white. As a nod to a fandom which was reading these titles, *X-Men* alluded directly to the most prominent: *Elfquest* and *Cerebus the Aardvark*. The former was a 20-issue saga of elves and other races struggling for coexistence on a fantasy world with two moons, while the latter was the ongoing tale of a small pig-like barbarian. *X-Men* #153 (January 1982) is a fairy-tale version of the team's recent adventures retold by Kitty as a jokey bedtime story to Illyana Rasputin. She wears an *Elfquest* T-shirt throughout and a fairy is named Pini, after EQ's creators. Similarly, #160 (August 1982) introduces a demon called S'ym, often taken as an allusion to *Cerebus'* creator, Dave Sim.[15]

If Marvel was slow to respond to the formal challenge of the more stylistically adventurous comics, *X-Men*'s jokey references to prominent independents assured readers they were aware of them, and the comic's Holocaust allusions and increasingly visible

subcultural metaphors allowed it to keep pace on a thematic level. It was aided in this by the company's decision that the format of 17 story pages and a cover price of 40 cents was no longer economic. From the September 1980 cover dates the price of comics would increase to 50 cents a copy, but with the page count expanded to 22 pages.[16] Longer instalments allowed for a pacing of stories which gave more room for details and meant even more characterisation scenes could be included without compromising the scenes of physical conflict which were a staple of the superhero genre and which fans still required. It was in this style of comic that the theme of mutant prejudice, which had lived for so long at the peripheries of *X-Men*, came to flourish.

It was in this context that *X-Men* began to address its readers in a franker manner over relationships. Although 'Gold Rush' (#161, September 1982) is primarily about Xavier's friendship with Magneto, it also treats his relationship with Gaby Haller in a more adult manner than the comic had ever treated romance before. Having been healed by Xavier's telepathy, the young Israeli woman finds herself with romantic feelings for him, which he can sense telepathically:

> *Ahhh*, Gaby, you believe you're in love with me. But you aren't. Not really. And yet, your need to love and be loved… is as genuine, as great, as my own. I should not do this. But if it makes us both happy and brings us the solace we seek… what then is the harm?'

Since this is a single-issue flashback story with its emphasis on Magneto, there is no space to explore these issues at length, but the shift is obvious – as is the moral dilemma. In the murkier world of relationships, even romance could be the site of a typical Claremontian clash between the superego and human physical/emotional needs. Six months later it would be revealed that Charles fathered a son out of wedlock with Gaby, a significant shift of position from that held in 1979 when Claremont's intention that the evil mutant Proteus should be the child of (unwed) Xavier and Moira MacTaggert was vetoed by other members of the creative team.[17]

Sex came up for discussion again in #165 (January 1983). This characterisation-based issue was the first to be drawn by new artist Paul Smith, and substantially broadened the thematic range of the comic. In the issue, clearly influenced by/ripped off from the film *Alien*, the X-Men are adrift in space having been impregnated by the Brood. Although Wolverine's healing factor has caused his body to resist the impregnation, there is nothing the rest of the team can do but wait for their transformation into reptilian aliens. The story is one about the apparent death of all hope. Even the normally idealistic Cyclops agrees with Wolverine's assessment that they can achieve nothing from now on except a suicidal revenge attack on the Brood's homeworld before the transformation takes place. In this mood of despair, 14-year-old Kitty turns to Peter (Colossus) for a comforting hug. As the hug becomes a kiss, she says she wishes she were older. Peter says he shares the wish, but gently reminds her that she is young. She asks, 'When you're doomed, what's the point of playing by society's stupid rules?! We may never get another chance!' Peter once again declines the sexual offer, and they are interrupted by a vision of Storm which presages their safe healing. The same issue also brings Nightcrawler's Christian faith to the fore. Although his vocabulary and occasional thoughts directed to God have implied some sort of faith in previous issues, it has never been central to conceptions of his character. In this sequence, his best friend in the group, Wolverine, is surprised to find him at prayer. The theme is introduced in a familiar way. Kurt affirms the comfort he draws from faith, Wolverine responds that he believes in nothing his senses can't confirm, and Kurt opines that this a lonely way to live. Then the story moves on. The sequence recalls previous conversations around irresolvable questions – often between these very characters – but marks a significant shift. From this point on, Nightcrawler's faith will be a frequently discussed aspect of his character, and explicitly religious characters will appear.

Sex and religion. Two things you don't discuss – not, at least, in a traditional Marvel comic. However, in other areas, *X-Men* was still required to work within limits set by the company's sense of what constituted suitable entertainment for a young audience. The morality which had made Jim Shooter insist on Jean Grey meeting a

harsh punishment for her destruction of an alien populace continued to operate. Some fans could hardly believe his take on Wolverine.

> ... one thing I am forcing Chris and Louise [Jones, editor] to do is establish that Wolverine hasn't killed anyone. The other day I took Louise to lunch and I said [menacingly] 'I want my story with Wolverine's victims alive.'[18]

When Claremont had first been assigned to write *X-Men*, this level of oversight was non-existent. A single editor with more than 40 comics/magazines to oversee simply did not have time to concern himself with the details of individual titles. Jim Shooter, however, had seen that such a system did not work, and rising profitability had enabled him to hire a group of editors who would handle the day-to-day business, allowing him to think about the wider commercial strategy, stylistic coherence across the company and Marvel's public image. He was unsettled by Wolverine's violence and was in a position to enforce his demands, and the sequence he wanted duly appeared in *X-Men* #152 (December 1981). In #133 (May 1980) – the 'Wolverine Lashes Out' cover discussed last chapter – Logan fights the security guards of the Hellfire Club in a desperate battle which readers are led to assume is to the death. However, a number of the guards are back in #152, cybernetically enhanced. Wolverine beats them again, leading one to plead for his own death:

> Go ahead, crazy-man! Gut me! You'll be doin' me a mercy! All me an' my partners lived for was seein' you dead, Wolverine! If we can't have that, it's better to die ourselves! [...] because of what you did, they made us *freaks*! Part human -- but mostly *machine*!

Although the sequence is forced upon him, Wolverine's reply ('Artificial parts, mechanical limbs, can't take that essential humanity away. Just as flesh- and- blood can't give it to you') is well within Claremont's philosophy. Wolverine had previously opined, when goading his friends to push beyond their perceived limits, that you never give up until you're dead. Now it becomes the philosophy behind his refusing to kill. Dying is easy. By refusing to strike a

fatal blow, he is sentencing his enemies to all the agonies of being human to which a role in the *X-Men* – as hero or recurrent villain – condemns you.

Although Shooter got the Wolverine scene he wanted, he was fighting a losing battle. This wasn't where the readers were, and Claremont and other *X-Men* staff could joke at Shooter's expense with convention audiences about the whole situation.[19] Like a Claremontian hero, struggling to retain their rational humanity, Marvel's attempt to find a balance which satisfied their moral leanings and fan demands for a Wolverine unleashed would be ongoing.

CHRIS CLAREMONT, AUTEUR!

From this point on, where I quote from fan magazines or the opinionated comics press, the views of *X-Men* that are expressed will often be negative. Implicitly or explicitly, the comic would be judged against another version of what comics could be – either something as solid as the independent sector, or something as ethereal as the writer's utopian vision of what the medium could be. These were the views of an articulate group of fans with high aesthetic ambitions for the comics medium. *X-Men*'s rocketing sales in this period would have cut little ice with *The Comics Journal*'s reviewers when they looked back on 1981's output:

> Last year's outstanding title, *The X-Men*, went into a sharp nosedive with the departure of John Byrne [...] the Claremont/ Byrne team, volatile as it was, worked largely as a compromise between the two creators: Byrne's sharp drawing and no-nonsense co-plotting gave Claremont's work an edge that he has not found before or since, while Claremont's scripting contributed a human dimension Byrne can't (or won't) supply on his own.[20]

While fans regarded Claremont and Byrne as a writing team, the latter's view of the characters was increasingly different from Claremont's, and his departure was prompted by a feeling that

newly appointed editor Louise Jones would favour a writer-led process. Byrne had been credited as co-plotter since #114 (October 1978). The previous issue had credited Claremont and Byrne more vaguely as 'Raconteurs' – perhaps a negotiation on the way to the 'co-plotters' credit. For Byrne the point may have been hard won, because he would subsequently reflect that 'blood leaps from a stone compared to Chris giving a co-plotter credit.'[21]

Byrne departed *X-Men* with the issue cover dated March 1981. Editor Jones told *The Comics Journal* that incoming artist Dave Cockrum would have 'as much input as Byrne did'[22] but, whatever the division of labour, neither he nor subsequent artists were granted the co-plotter credit. Indeed, Marvel was happy to promote an image of Claremont as the auteur creator of *X-Men*. By accident or design, April 1981, the month following Byrne's departure, found Claremont's credit on three *X-Men* projects. In the comic itself, D'Spayre, an old *Marvel Team-Up* villain created by Claremont and Byrne appeared, with Cyclops vanquishing him with the aid of the Man-Thing, another Marvel character which Claremont was writing at the time. His other writing assignment at the time was *Spider-Woman* where, that month – in #37 – the X-Men guest-appeared to help the title character fight their old foes, Juggernaut and Black Tom Cassidy, in a story with repercussions which would be discussed in *X-Men* #148 (August 1981). In this unusually busy month for mutantkind, *Rom* #17, written by Bill Mantlo, also featured the *X-Men*. Marvel characters cropped up in each other's titles all the time, of course, but what was unusual – unique up to then, I think – was that Claremont got a credit as 'consultant'. When Spider-Man or Captain America guest starred in other characters' comics, no one expected the writer of those titles at the time to get a credit. The proliferation of crossovers and credits strongly implied Claremont's primacy as creator of *X-Men*.

We now recognise that this surely did Cockrum a disservice. Upon his return, he brought back much that had been central to the comic in its early years but absent since, most obviously the space-faring freebooters, the Starjammers. Cockrum, however, was a slower artist than Byrne and #151, #152 (November and December 1981), #159 and #160 (July and August 1982) were all filled in

by other artists, a process which again emphasised Claremont as
the only constant. An apparently permanent fixture as artists came
and went around him, he became understood as its central creator.
Cockrum, consciously or otherwise, was to some degree compliant
in this. He gave – or was asked for – fewer interviews to the comics
press than John Byrne, and did not insist on plotting credits in the
same way.[23]

Publicly, things boiled over when *The Comics Journal* praised
#153 (January 1982), 'Kitty's Fairy Tale', as a welcome change
of pace. The issue, in which Kitty Pryde retells recent X-Men
adventures in the form of an Arabian Nights fairy tale as a bedtime
story to Colossus' younger sister, is an exercise in the swash-
buckling fantasy which only graced the comic during Cockrum's
tenure. *The Comics Journal* reviewed the issue twice, once upon
its initial appearance and later as part of a year-end round-up,
both times viewing it through the prism of Claremont's known
characteristics. In the initial analysis, Dwight R. Decker opined
that 'in part it seems to be an answer to people who complain that
Chris Claremont doesn't have a sense of humour' and reflected
that it was 'a testimony to the characterisation which Claremont
has built up over the years that a thoroughly off the wall story
like this can sustain an entire issue.' Two issues later, Jan Strnad
concluded his overview of the past twelve months thus, 'And
finally a Sneaky Devil award goes to Chris Claremont for "Kitty's
Fairy Tale", an off-the-wall *X-Men* fable [...] Way to go, Chris,
[...] keep thinking crazy.' Neither writer considered the creative
input of anyone else involved. Cockrum wrote in, highlighting
his important contribution:

> Jan Strnad's 'Sneaky Devil' award to Chris Claremont for 'Kitty's
> Fairy Tale' (*Journal* #71) is the last ironic straw [...] 'Kitty's Fairy
> Story' would not have happened if I had not proposed to do a
> fairy tale. The story hook of Kitty telling Illyana a bedtime story
> was mine. Ditto the 'Crimson Pirate meets the Thief of Baghdad'
> format. Ditto Lockheed the Dragon. Ditto the 'Bamf'[...] Chris's
> main interest was to turn it into yet another retelling of the
> Phoenix story.[24]

In seeking to acquire proper credit for their input to *X-Men*, artists were pushing against an almighty publicly circulated image of Claremont as an auteur obsessed with his mutant titles. Marvel itself was happy to play along humorously. In 1982, Claremont appeared as himself in cartoons in the anthology comic *Marvel Fanfare*, boring the company's staffers with long speeches just like the ones he crammed his comics with:

> By the way, you remember that plot I told you about? Well I had to expand it to a forty-seven part story! And the main character — is there any reason he can't be a woman? You know, I'm writing 18 different specials, now? That's 'cause all my stuff sells so well... except *Spider-Woman*. Wanna hear my latest *Spider-Woman* plot? (#2)

It takes nothing away from Claremont's skills to suggest that the sort of auteur he became was made possible by changes to the remuneration package Marvel offered top talent in order to retain their services. The low rates of pay had forced Marvel's top writers of the 1970s to churn out more comics than they could care for. One of them, Marv Wolfman, looking back on the period, explained:

> to achieve the standard of living I wanted, I would have to write a certain amount of work. There was no way I could have the same enthusiasm for six books a month that I do now for two or three. So I wrote three books a month at Marvel that I cared about very much, and the other three were for a living. They were the best I was absolutely capable of, but there was something missing in those cases.[25]

By the mid-1980s, there would be no end of self-consciously serious fans labelling Claremont a 'hack', but he was never in the position which Wolfman describes, and this study shows how the marks of his caring are all over his work. What made that possible was that Marvel's terms and conditions markedly improved as the market stabilised and the establishment of new comic companies gave creators more choice of employers. Page rates increased and, from

January 1982 (issues cover dated April of that year, including *X-Men* #156), Marvel made an extra payment to creative staff based on sales, a payment labelled 'incentives' so as to avoid the term 'royalties' (which might imply that the freelancers concerned retained some sort of legal ownership). Payment was made on all copies of a comic sold over 100,000, the traditional point for avoiding cancellation at Marvel. As writer, Claremont was entitled to 1 per cent of the cover price of every issue, and an extra half a per cent if he was regarded as the sole plotter of the story. In total, 4 per cent of the cover price would be divided between the writer and artists who created the comic, with an extra 1 per cent going to the creator of the lead character (which on all characters created prior to 1982 was deemed to be Marvel itself, thus meaning no payment would be made).[26] Claremont's personal finances are none of our business, but in news conferences outlining the arrangement, Marvel put some figures in the public domain, and the maths is easy enough. Shooter declared *X-Men* to be selling 300,000 copies at 60 cents each. Collecting 1.5 per cent incentives on sales over 100,000 gives Claremont $1,800 dollars per issue on top of what he was paid to write it. When pondering how much work he needed to do to make a good living, Claremont could consider a very different calculation from the one Marv Wolfman had felt obliged to make in the mid-to-late 1970s.

This, then, was *The Uncanny X-Men* in 1982–3: the unqualified industry leader. Not just a rousing superhero comic, but something read for its political themes as well. For all that he had effectively created Kitty Pryde and plotted 'Days of Future Past', John Byrne's insulting dismissal of sexual minorities in the comics press meant that he could never be acclaimed as the originating source of this new focus on minority politics. Indeed, only one person could. In late 1981, comics journalist Peter Sanderson conducted interviews with all the major creative figures that had worked on the comic since its relaunch and published them as *The X-Men Companion* in two volumes. It was released under the oversight of *The Comics Journal*, and if that magazine was comics' *Cahiers du Cinema*, this was its Hitchcock interview book. Roy Thomas, Len Wein, Terry Austin, John Byrne and Dave Cockrum were all interviewed, and

all make the speech which concludes their chapters. Claremont alone is not left to sum up his position himself, but rather has it done for him editorially by his interviewer: 'Thank you, Mr. President.'[27]

For all the talk of comics as a collaborative art or a visual medium, Chris Claremont was the *X-Men*'s commander in chief.

BRINGING IT ALL BACK HOME

The Uncanny X-Men #169 (May 1983) to #209 (September 1986)

Central X-Men in this period: Professor X (Charles Francis Xavier – telepath and teacher of the mutants), Cyclops (Scott Summers – fires energy beams from his eyes), Wolverine ('Logan' – enhanced senses, healing ability), Storm (Ororo Munroe – weather control), Nightcrawler (Kurt Wagner – a teleporter and circus-trained acrobat who looks like a demon), Colossus (Piotr/Peter Rasputin – can turn into a superstrong man of steel), Ariel/Shadowcat (Kitty Pryde, whose powers of intangibility are joined here by ninja training), Rogue (Anna-Marie – absorbs the power of others by touching them); a new Phoenix (Rachel Summers – telepath), and Magneto (Erik Magnus Lehnsherr – the reformed master of magnetism).

Cyclops marries a red-headed Phoenix lookalike and leaves the team for semi-retirement, Wolverine gets engaged in Japan but issues of honour stop him reaching the altar, and Kitty gains ninja skills and takes the new identity of Shadowcat. Rogue, a villain from the Brotherhood of Evil Mutants, finds her powers spiralling out of control and turns to Xavier for help, becoming a corner-stone of the X-Men. The US government becomes increasingly concerned about mutants, to the point of hiring the Native American inventor Forge to produce a weapon capable of stripping them of their powers. He duly obliges, and Storm finds herself in the line of fire, losing her powers for years' worth of issues and beginning a typically complicated love–hate relationship between the two of them. The X-Men fight many foes in this time but completely vanquish few of them. Indeed, their major conflict during this period is not with costumed villains but against the increased public fear of/distaste for superpowered mutants. If Claremont infused *X-Men* with the political theory he studied at Bard College, this is the period when it is most visible. Spin-off projects proliferate in various formats, allowing characters to be shown in action, and self-reflection, outside

the team. As characters undertake individual quests, the X-Men's line-up varies markedly from issue to issue. The most controversial – but also one of the most financially successful – of these spin-offs is the return of the original team, including a 'she-was-never-really-dead' Phoenix. Driven by commercial concerns, Jean's return to life blows a major hole in Claremont's plans for Cyclops' marital bliss. Magneto continues his rehabilitation, culminating in a trial before a world court in #200 (December 1985), though a fight against supervillains causes the event to be abandoned before a verdict is passed.

Chris Claremont's credentials as a science-fiction fan were clearly genuine, and when *The New Mutants* was launched he made one of the characters, Sam Guthrie, an SF reader who made references to the same authors (Robert Heinlein in #21, Larry Niven in *Annual* 1) which Claremont cited in interviews as his favourites. In 1987 he published *First Flight*,[1] the first of several SF novels. It remains the case, however, that the X-Men spent more time in space when Dave Cockrum was artist/co-plotter than at any other time, suggesting that he was a significant contributor to this aspect of the comic. When Cockrum left in 1983, replaced by a new, young artist called Paul Smith, the X-Men came down to Earth for a sustained period. Smith's stylised rendition of the characters was popular, but he only drew 11 issues and several of these involved concluding stories which others had started (his first three issues conclude the sci-fi epic begun under Dave Cockrum, while two others continue the threads of a *Wolverine* mini-series), making it hard to see exactly what ideas he personally brought to the book. Even his departure was blurred. It was initially reported by *The Comics Journal* as a result of his creative differences with Claremont – making him another penciller who didn't like the way the comic was going, another artistic casualty – but this was clarified a month later, quoting Smith to the effect that his disagreements with Claremont were not the reason he left.[2]

Another change of personnel occurred when Louise Jones/ Simonson left her editing job at Marvel in 1984, being replaced by her assistant Ann Nocenti. Like Jones, and as Claremont had done a decade earlier, Nocenti mixed her editing job with writing,

pouring all her liberal instincts into the comic *Daredevil*. From healthcare to the war on drugs to the manufacture of consent by a corporate media, her writing from 1986 to 1991 sought to slaughter all the sacred cows of the Reagan/Bush administration. She was just the person to oversee the next phase of *X-Men*, a period when the mutants would remain largely on Earth, openly identify with America's oppressed minorities and be more socially situated than they had ever been before. In the hands of Paul Smith's replacement, John Romita Jr – the ultra-professional son of Marvel's art director – a new mise en scène emerged: the X-Men fighting villains on the streets of New York, Tokyo, San Francisco or Dallas while a crowd of onlookers would gather and articulate the thoughts of the proverbial 'man/woman in the street' about the twists of the battle or the desirability of mutant superheroes. A new style of speech bubble emerged, bubbles which would hang in the air together, above the onlookers, without being given pointers to assign them to individual speakers: they were truly the voice of the crowd, engaged citizens voicing their opinions on the mutant issue. As ever, there was a bestial inversion: the rioters who scream for mutant deaths in Paris in #200 have foregone the rationality which makes them human: 'A mob isn't people, Kitty. It's perhaps the wildest of animals.'

The X-Men had visited cities before, but never so recurrently, and they had never been so publicly visible. The first of these engagements with the urban environment was unrepresentative of what was to come. The New York we see in #169–70 (May–June 1983), courtesy of Smith, is darker than what will feature in the following years. Like Storm's trip to the ghetto in #122 (June 1979) or the derelict New York of 'future past', the story drew on familiar images of New York's urban decay – rats, graffiti, gangs – in a way which the comic would rarely do again once Romita Jr replaced Smith as artist.

It is often the case that a shift of emphasis in *X-Men*'s themes requires the creation of a new set of mutants. The evolution of Jewish themes and the simultaneous attempt to paint a more sophisticated picture of how power worked in the modern world had led to the Hellfire Club becoming the dominant villains and the establishment

of a new Brotherhood of Evil Mutants. Now, new themes of subcultural identity and urban politics would require another new group. The Morlocks live in tunnels beneath New York, a bomb shelter 'built secretly in the Cold War then abandoned'. (This makes that war seem like a thing of the past – odd phraseology for a comic published in 1983.) While the X-Men and the Hellfire Club seek acceptance and hide their identities behind respectable institutions, the Morlocks embrace life at the social margins as 'runaways, outcasts -- people with no home, no one to care for them, hated and hunted because of powers we didn't want or understand. Deformed, despised, deserted'. We subsequently learn (#179, March 1984) that anyone who joins undergoes deformation as a symbol of their rejection of the world above. Their clothing embraces subcultural values in a way which we have not seen in *X-Men* before. Their leader Callisto wears a piratical eyepatch, but is otherwise defined visually by the signifiers of punk rock: torn clothing, decorative chains, a studded dog collar and wristbands. The Morlocks are another id to the X-Men's superego, a group of mutants who neither train in the use of their powers nor hold any wider social ambition. The city's repressed, they rise to the surface of New York to kidnap Warren Worthington, the handsome millionaire who, code-named Angel, was one of the original X-Men, so that he may be forcibly married to Callisto. When Storm leads a team to his rescue (#169, May 1983), and they find him tied in cruciform position, Colossus wonders, 'She did such a thing out of *love*?' 'No, Peter,' Storm corrects him. 'Desire. Quite a different thing altogether.' Hatred and desire are the bedrock of the Morlocks' motivation. They despise beauty because they are excluded from it ('They pretty! Hate 'em. Want to hurt 'em') and sporadically prey on the world above. Desire is a similarly recurrent motif of stories about the Morlocks. At its gentlest, we see this in the innocent love that the deformed Morlock Caliban feels for Kitty. How this love is manipulated by other Morlocks to pursue their own end is the source of several stories.

After Storm becomes leader of the X-Men, they have to face a number of opponents led by women. The new Brotherhood of Evil Mutants are led in the field by Mystique, who herself takes guidance from another woman, Destiny, who has precognitive

visions (#141–3, January–March 1981; #158, June 1982), while the
alien Brood are led by a 'mother' (#154–7, February–May 1982;
#161–7, September 1982–March 1982). In none of these stories,
however, are these female leaders explicitly contrasted with Storm.
A two-part Hellfire Club story (#151–2, November–December
1981) centring on Ororo and the White Queen, positing the two of
them as alternate mother figures for Kitty now that her parents are
divorcing, hovers around the theme, but it never quite coalesces.
In the Morlocks' tunnels, however, Storm meets Callisto, a leader
who is her opposite in every way – one associated with the under-
ground while Storm is claustrophobic and most free when she
flies (Callisto does not value flight and, indeed, damages Angel's
wings so that he cannot escape her). Callisto rules by fiat, listens
to no disagreement from the other Morlocks, and talks casually of
killing, while Storm leads the X-Men as first among equals and is
pledged to never take a life. Their clothing is alike enough to invite
comparison – both favour black outfits with parts missing to reveal
flesh – but different enough to point up the contrast: Storm's cos-
tume gives way in bikini-like graceful curves while Callisto's sports
ragged tears. When the two meet in hand-to-hand combat, mutant
powers disallowed, for leadership of the Morlocks, it hardly seems a
fair battle: yet, to the shock of her teammates, Storm stabs Callisto
in the heart, a fatal blow which the Morlock leader only survives
thanks to a mutant with powers to heal even the worst wounds.
This is the start of a transformation in Storm. Tracing the next step
entails a sideways step.

It falls to Storm to fight Callisto for leadership of the Morlocks
not only because she is team leader, but because Wolverine, who
might normally be depended upon to volunteer for one-on-one
combat, is busy in Japan in a four-issue series of his own written by
Claremont and with art by Frank Miller and Josef Rubinstein. Miller
had come to Marvel in the late 1970s after short periods at Gold
Key Comics and DC, done some fill-ins and covers before becoming
artist, with Klaus Janson, on *Daredevil*, and in 1980 began writing
that book as well. Where Claremont and Cockrum had revitalised
X-Men by bringing SF to the superhero format, Miller favoured
crime fiction, film noir and martial arts drama. In 1981, in the story

which became the basis for the 2003 *Daredevil* film, the comic went from being a bi-monthly book on the verge of cancellation to one of the company's bestsellers. Daredevil himself becomes embroiled in conflict with his Greek ex-lover Elektra Natchios, now so trau-matised by her father's death at the hands of terrorists that she has become a ninja mercenary. Built like a bodybuilder and oozing sex and death in equal measures, she is a female power figure, but not in the Claremont model, and her twin sai (oriental swords with two curved prongs projecting upwards from the handle) give her an iconography as compelling as Wolverine's claws.

Even more than this attention-grabbing character, however, was Miller's storytelling. He would play inventively with time and space. Events would take longer to occur in a Miller comic as he would reduce the time which passed between panels, stretching the narrative time as a punch would take three panels or more to be thrown and arrive. Miller's stories were always followable, but unlike Byrne or George Perez he didn't subordinate everything to the clarity of the narrative, finding space for bold visual flourishes such as complex lighting effects which mixed large areas of black shadow with illumination realistically provided by harsh, in-story light sources. Miller's page layouts challenged the grid pattern more severely than anyone since Neal Adams. Comic pages had tradi-tionally been arranged in rows of panels, each row read from left to right. Miller preferred his panels to stretch the whole breadth of the page, resulting in images which were composed in the comics equivalent of widescreen cinema, creating pages which required a reading process that went from the top of the page to the bottom rather than left to right. Other artists had used that form occasion-ally (John Byrne understood perfectly the impact that panels which stretched across the page could have), but Miller made it almost the norm in his work. Compared to these visual pyrotechnics, *X-Men*, shaded in the more traditional bright colours of the superhero comic, looked like the epitome of a dated house style.

Linguistically, Frank Miller's lean way with dialogue led many to complain that *X-Men* was overwritten. In *Daredevil*, revenge, anger, love and desire looked like fully adult emotions, and Miller's treatment of them offered a new take on characterisation: a world

where characters simply acted on their feelings while Claremont's pontificated endlessly. Miller eschewed thought balloons and captions explaining the characters' thoughts. Instead, readers were forced to examine the facial expressions or take cues from the increasingly expressionistic environment to understand what was happening inside people's heads. Though still in his early twenties – or perhaps because of it – Miller seemed to offer the possibility of a major rearrangement of the way that words and pictures worked together on the comic page, and when he mused at conventions that thought bubbles and captions might soon become redundant in the medium, the evolution he envisaged seemed to be one where Claremont's foremost writing tools had been abolished.

Consequently, the news that Claremont and Miller would collaborate on a *Wolverine* mini-series lit fandom up with excitement, not just because these were comicdom's foremost real and fictional stars coming together but also because of the stylistic puzzle that it represented. Claremont himself, however, saw less of a clash of styles than a commonality of theme. He viewed Daredevil and Elektra as two sides of the same personality – both suffer the death of a parent, but respond in different ways: Daredevil, as Matt Murdock, chooses the ultimate superego, completing his legal training to practise law, while Elektra retreats into her own pain and becomes a paid killer.[3] In *Wolverine*, Claremont's concern with the title character's raging id and operative superego would allow the writer and artist to meld their concerns. Moreover, Miller had drawn on both the form of Japanese comics and the icons of samurai films, and that nation is the homeland of Wolverine's rarely appearing love interest, Mariko Yashida.

The story begins in the Canadian Rockies, a wilderness setting of the sort which had been common in *X-Men* during the 1970s but now rarely appeared. It played the same metaphoric role as such environments always had, being, as Wolverine's narration tells us, 'as stark an' elemental as my own soul'. The sequence balances the trademark Miller bloodshed with Marvel's ethical qualms by giving Wolverine an opponent – a bear turned man-killer because of injuries sustained during an illegal hunt – which he can slash with his claws. He then tracks the hunter who caused the bear's injuries

and apprehends him. Logan can hand out the required justice on both sides of the human–animal divide because he straddles that line and mediates between them. From there, the action moves swiftly to less familiar terrain for *X-Men*, a Japan defined by the same harshly lit skyscrapers which populated Miller's *Daredevil*. The series becomes a thriller set in an exotic locale, with Logan taking down a powerful criminal while interacting with local secret service agents. His flight from the US is numbered 007, so it is not hard to guess from where inspiration is being taken. In Japan, Wolverine learns that Mariko has been obliged to marry someone else. 'You must remember,' he is told, 'she is heir to traditions of duty and loyalty that are as old as these islands.' For Claremont, the attraction of Japan was its honour codes, those commitments to a greater meaning which, like superegos, require the suppression of immediate or personal needs, with all the conflict which that implies. Panels in which individual characters are dwarfed by mighty religious statues, cultural architecture or massive ritual swords make the point visually, but Claremont peppers the issue throughout the dialogue. When Wolverine declares that he and Mariko are in love, his friend Asano responds, 'So? We speak of *giri*, Logan -- of obligation, duty. Honour. To deny that would mean denying her essential self.' Claremont could not find this conflict in the West, where the appeal to an 'essential self' would more likely be tied to the couples' mutual feelings of love than to the cultural codes which frustrate them.

In planning the story -- all accounts agree it originated on a long car journey home from a comic convention – Claremont and Miller devised the understanding of Wolverine which would become the new norm, reimagining him as a failed samurai, someone who could not reach the levels demanded by the honour code and so must make his own way in the world without a noble house to serve. As well as the wilderness opening, the series plays out a number of tropes which had been long dormant in *X-Men*, such as Logan's ability to talk with animals. When he encounters guard dogs, 'We lock eyes an' wills, communicatin' on levels far more comprehensive an' subtle than speech,' and the creatures elect to let him pass unmolested: 'They're mean but they aren't stupid.' The story spends three issues

recalling everything animalistic in Wolverine, the villain stripping away his humanity in front of Mariko's agonised gaze: 'the "man" you profess to love. Except that he is no man at all, but an *animal* cast in a semblance of human form.' While fighting for the right to Mariko's love, Wolverine is courted by the 'wild child' assassin Yukio in a classic piece of Claremontian symbolism. If Mariko represents Wolverine's superego, Yukio is his id. With everything apparently lost, #3 (November 1982) opens with Logan reduced to drunken brawls in illegal barroom arenas, and he declares of Yukio, 'She's my lady,' but the moment is fleeting and Wolverine regains his humanity and dispatches the crime lord villain, Lord Shingen, Mariko's father. Unlike other human villains, Shingen is terminally dispatched by Wolverine's claws, a demise he has earned precisely because he pays only lip service to the family's honour codes and uses them as cover for his criminal enterprises.

Logan's heroic battling wins Mariko's hand in marriage. For further reasons of honour, the ceremony never occurs, and in the meantime the X-Men have travelled to Tokyo and taken part in an energetic sequel, during which Yukio returns. Having initially represented Wolverine's id she is subsequently paired with Storm, acting out the role of Ororo's suppressed wild side. The pair are forced to work together in sequences (#172–3, August–September 1983) which contrast Ororo's self-control with Yukio's casual attitude to the consequences of actions, even her own potential death: 'I envy you your madness, Yukio. It is a luxury denied me ever since my powers first appeared. My safety, and that of those around me, requires an inner serenity.' The story is about Ororo facing up to that loss of serenity. Embracing her own struggles, anger and inner demons, she adopts a new look not unlike that of Callisto. An urban costume of tight clothing with a decorative belt and a Mohawk haircut replaces the loose, flowing wardrobe and long hair which had defined her previously. The deliberate affiliation here is with marginalised groups – punks and native Americans – and signals a shift in the comic's understanding of the X-Men's mission. Their leader no longer passes for normal on the city streets but openly signals her subcultural status. When Kitty Pryde, appalled by the change in the woman she has treated as a mother figure, objects, Ororo asks,

So, for your peace of mind... I must force myself to be someone
— something — I am not?! [...] My doubts, and the needs that
sprang from them, have existed a long time, but I lacked the
courage to give them full voice — like a fledgeling [sic] wanting
desperately to fly, but not knowing how [...] life involves growth
and growth, continual change [...] We each have our lives to live,
our own roads to walk to our individual destinies. Friends — and
lovers — may walk by our side... but ultimately, the journey is
made alone.

This is #180, and its title is that totemic modern question, 'Whose
Life Is It, Anyway?' Anyone who knows *X-Men* in its modern reading
as a text primarily about minority rights will be unsurprised at this
language. This, I think, is where – in April 1984 – the vocabulary of
modern identity/liberation movements is fully assimilated, and it will
be a regular feature of the comic from now on. These arguments of
Storm's are extracted from a far longer conversation which stretches
over three pages, but we can see much of the lexicon of modern
identity politics here: Storm's insistence upon a personal identity
as a right (she doesn't use the word, but the meaning is clear); her
denial of Kitty's emotional claims on her, and characterisation of
Kitty's yearning for the old Storm as 'force'(ing) of herself upon her;
the conception of personal development as a journey; the metaphor
of flight for the full blossoming of an identity; and the process of
coming out, which is here enacted as Storm's 'courage' in publicly
admitting to the doubts and pains behind her previously assumed
identity as a serene nature goddess. Also new is the insistence that
identity formation is a journey made alone. This is a very isolating
rhetoric which will be repeated time and time again from now on.
Individual X-Men will be left in corners (or even forced into them)
by their teammates to face their demons alone.

We are moving, then, into a new era of the comic's self-conception:
the X-Men as atomised individuals facing issues and identities with
which their teammates cannot help them. The increased fluidity of
the team which escalates from this point is surely a symptom of this:
members come and go with increasing regularity or take temporary
leaves of absence as purely personal quests become more important

than team business. Issues which feature the psychic struggles of a single character, with the rest of the team relegated to a minor role or sometimes absent altogether, similarly increase in frequency from this point. Some superhero teams, such as the Avengers, had always had fluid line-ups, while others – the Fantastic Four or Power Pack – were bonded by family ties as well as public responsibility and remained more stable. As a group of outcasts who have found a surrogate family at Xavier's school, the X-Men always have had aspects of the latter, but now, whatever the rhetoric in the dialogue, the actions of the characters imply that that sense has been diluted.

Before this point, taking the stories to concern modern identity issues mostly involved the metaphoric reading of science-fiction/ superhero imagery. From this point on, the comic will undertake that act for us. In November 1982 Marvel published 'God Loves, Man Kills', a one-off story, not necessarily intended to fit into normal continuity, in the prestige 'graphic novel' format.[4] While the regular comic was still in space adventure mode – with Dave Cockrum handing the pencilling reins to Paul Smith – the graphic novel was a hint of the earthbound drama which was to come. The story pitches the X-Men against a popular Christian evangelist, the Reverend Stryker, who leads a crusade to purify the world of the 'abomination' of mutants, beings who do not conform to the 'divine template' used by God to create humanity. Concluding at a rally of evangelical Christians at Madison Square Garden, the story introduces the new trend for conflicts rooted in human fear of mutants and public battles amidst prominent city landmarks.

'God Loves, Man Kills' was priced at $5.95, almost ten times the cost of regular 60-cent issues. This price was one of several signals to readers that it was more sophisticated content for adult readers (the writer is credited, more formally than usual, as Christopher Claremont, and the story is divided into chapters) and the explicit reflection on contemporary social forces might well have been understood as something which, like Wolverine's use of the word 'bastard', was an exceptional form of content for a product marketed as prestigious. Actually, it previewed how the comic would soon begin to make obvious its real-world parallels. In #192 (April 1985), Xavier is the victim of a hate crime, beaten by some of the

very students whom he teaches at a New York university. In the next issue, Callisto talks of mutants as victims in a potential 'race war' while, elsewhere, two New Yorkers discuss an anti-mutant TV broadcast. When one agrees with the programme, his friend responds, 'Suppose that guy was talkin' about blacks or us Latinos?' While investigating the possibility of further hate crimes in #196 (August 1985), Kitty is confronted by an African-American student called Phil who asks 'You a *mutie* then, Pryde?' to which she replies, in a controversial panel, 'Gee, I dunno, Phil -- are you a *nigger*?' (she had also used the term in 'God Loves, Man Kills' to make a point about anti-mutant hate speech). The double-sized 'event' issue #200 (December 1985) sees Magneto's trial at a world court played out against the backdrop of pro- and anti-mutant rallies. Kitty speaks again, piling on the real-world referents, in #210 (October 1986), saving Nightcrawler from an angry mob who view him as 'obviously' not human:

> A whole chunk of my family was murdered in gas chambers because the Nazis said it was just as 'obvious' that *Jews* weren't human. And not so long ago, in this country, some people felt the same about blacks. Some still do. [...] Maybe *I'm* a mutie too?! Ever think of that?!! Maybe we all are?!! [...] Maybe, when you're done, you can hang our heads on your wall as trophies. Or, better yet, take our scalps, like they did in the Wild West.

With Nightcrawler as the victim, the scene has clear echoes of the sequence which began *Giant-Size X-Men* #1, the very opening scene of the new *X-Men*, but this time it depicts the mob not as agrarian peasants scared of the supernatural, but urban Americans prejudiced against mutants, a concept which they understand in fully scientific terms. Although these speeches demonstrate how the comic was broadening its explicit points of reference from Jewish experience, the recurrent use of Kitty as spokesperson also tied them to it.

While being blunt on the nature of racism or anti-Semitism, Marvel's sense of its young audience would not allow it to openly reference sexually defined minorities. In #202 (February 1986) the X-Men travel to San Francisco, where they are treated with

a respect that they are increasingly denied in the rest of America. The comic doesn't publicly acknowledge that the city is the capital of gay America, and only talks obliquely about the attitudes of the people there. 'People here are real neighbourly -- they welcomed us pretty much from the start, made us feel at home. Nice change from the way mutants are usually treated' (#203, the first of several similar reflections). In #206 (June 1986), a member of the SFPD declares, 'I don't care what the world says about mutants -- and especially you X-Men -- you've proven yourselves to me,' and uses her position to save the X-Men from a team of superpowered federal agents.

Letters pages were sadly rare in mid-1980s *X-Men*, and often only headline stories received coverage, so there is no direct evidence of how readers interpreted the team's trip to San Francisco. However, if homosexuality could not be mentioned in the stories, it was referred to a couple of times on the letters pages in the period, appearing in readers' lists of groups which experienced the sort of prejudice handed out to the X-Men. Readers were responding to the new direction which the comic had taken and wrote politically themed letters, such as one in #201 (January 1986) where an Arab-American reflected on his relationship with his Jewish best friend. The first letter from an openly gay reader was printed in #214 (February 1987). He – name and address were withheld – described himself as 'a gay white male, 24 years old' who had been reading comics for nearly 20 years but never written in before:

> when I saw Professor Xavier beaten to a pulp [...] simply because he was a mutant [...] well, to say that I identified is extreme understatement. I'm sure that somewhere else in Chicago a black, an Italian-American or Asian-American could read the same thing and had the same reaction [...] It is a fine line Chris Claremont walks [...] the one on which you can communicate vital messages, yet not become overly didactic and [...] still entertain.

The correspondence from gay readers, which Claremont had mentioned six years earlier, had made it on to the letters page.

RETURN TO FUTURE PAST

With the issue of mutant persecution so prominent in *X-Men*, the 'Days of Future Past' dystopia was returned to, but with the comic more socially grounded, the apocalyptic nuclear war/SF dystopia imagery was replaced with something more closely approximating real-world experience. In this plot line the telepath Rachel Summers time-jumps back to the 1980s from the 2013 last seen in 'Days of Future Past', in another attempt to make sure that timeline does not come to fruition. She is the daughter of Scott and Jean, but upon arriving in our present she finds that it is not the past she expected. Her mother's death has caused our timeline to diverge from the one into which she was born – a self-reflexive nod to the fact that Jean's death was a 'change' from the direction of the comic as Claremont saw it in 1980. She arrives in the *X-Men* in #182 (June 1984) and her various mental flashbacks allow us to see more of the future world.

Though rooted in the future as depicted by Claremont and Byrne in 1980, the representation of that timeline is modified. Giant robot Sentinels are rarely seen and New York has not yet been reduced to rubble. There is less science-fiction imagery and more scenes of human beings making major decisions and working to hunt down mutants. Shorn of its original 'apocalyptic SF' imagery, it is much more realistic, a convincing possible step between the contemporary world of the X-Men and the future as it was first depicted. This development sees the comic drawing on a wider range of sources than the 'Nazi-era Germany' imagery which had initially dominated it. This description of the road to that dystopia is taken from spin-off comic *New Mutants* #48 (February 1987):

Anything bad in the world… all of a sudden got blamed on *mutants*. America's enemies had mutant spies an' saboteurs, so people said, wreckin' our economy an' our defenses. The drought of '86 was our fault, an the winter of '90, an' the Great Quake. We were responsible for the decline of morality, we were a sign of God's displeasure -- you name it, we took the rap.

If the first half sounds like the Soviet Union making excuses for why the socialist utopia hadn't arrived, the second half draws on the rhetoric of America's religious right.

Having arrived in our time, Rachel joins the X-Men, having nowhere else to go. Her time there is not a happy one. Although she becomes close to Kitty, she perceives herself as a failure in the role of superhero. She is reluctant to tell the team of the horrors which she has seen, and readers learn a lot more about her experiences than the team do. As a telepath she had once worked, under slave conditions, to track mutants, a job given the title of 'hound'. As so often in *X-Men*, the danger is that of reduction to an animal state. When flashbacks/-forwards show her at this work, the art and language depict her in subhuman terms. In #189 (January 1985), we see her on the hunt, wearing a black jumpsuit with studs like a modern dog collar (the canine sort, not the clerical kind). She is rarely drawn erect in the sequence, but is shown crouched or bounding across the landscape with inhuman movements. Rachel is not just a dog here, but a Pavlovian one: 'She responds as she's been trained -- eager to please.' There is a similar sequence in #199 (November 1985), one which seems designed to chime with Magneto's talk in the same issue of how the Nazis 'tried their best to turn us into animals'. *X-Men* may be said to have two dominant themes – its sociopolitical plot about prejudice and its philosophical plot about human nature – and this is one of the points where they are deftly conjoined.

Even when in the present, and not directly threatened with dehumanisation, Rachel can fight the traditional Claremontian battle. In #193 (March 1985), she is asked to use her telepathy to mentally track the X-Men as they split up across a military base, but the request sounds so much like her work as a 'hound' that she simply collapses. Wolverine, articulating the new tough-love philosophy that people need to face their demons individually, tells Kitty, 'She'll either come to terms with it, or be destroyed. Can't worry about her now, though.'

As I suggested in the previous chapter, moments where the prejudice plot line and the question of human nature intersect are not rare. The 'mutant menace' theme is often presented in traditional

Claremontian terms. Like Puritan diaries which understood the wider movements of the surrounding world to be tests of personal faith, so the bigotry of others is understood as an attack on the X-Men's own integrity, an invitation to abandon high ideals which, if accepted, would diminish their essential selves. Thus, in #188 (December 1984), Nightcrawler, worn down by anti-mutant sentiment, begins to despair. His speech begins by recalling the events which opened *Giant-Size X-Men* #1, constructing the opposition as one between science and superstition:

> We live in the last quarter of the 20th century -- in an age where men have walked on the moon and, some of us, journeyed to the stars! We have split the atom, the secrets of space and time are ours for the asking! Yet when you found me -- not so many years ago -- I was being hunted by a *mob* -- who wanted to drive a stake through my heart because they believed I was a *demon*!
>
> I hoped joining the X-Men would make a difference [...] But who needs us, what purpose do we serve?! The school, yes, that fulfills a desperate need -- young mutants must be taught the use of their powers -- but as for the rest, let the Avengers and the Fantastic Four handle that burden. They're popular, they're accepted.

Claremont and John Byrne had once created a supervillain called D'Spayre to incarnate and escalate exactly these sorts of anxieties. By the angst-ridden mid-1980s, however, supervillain mischief was no longer required to force the characters into dark places. Asked if he would rather embrace Magneto's response of returning violence with violence, Kurt replies that 'In truth, I'd rather not be bothered at all.' Were Wolverine not otherwise engaged – in Japan, in another mini-series – he would no doubt respond with his oft-expressed opinion that giving up is what you do when you're dead. In this, as so often, he speaks the wisdom of the comic. The essence of the X-Men is to struggle endlessly in battles they can never finally win. Kurt's suggestion that they opt out of their public role of superhero and 'not be bothered' would be a failure of this small mutant community to forge a position for itself in the wider world.

We now take this theme of prejudice to be central to the *X-Men* franchise in all its forms. In the mid-1980s, however, some fans read the comic for other themes and reasons. Some of them felt that granting centrality to the 'mutant prejudice' theme was a mistake. Perhaps it is hard to imagine today, but there were a significant number of dissenting voices, and Marvel was prepared to acknowledge them in the letters pages. 'Maybe you should ease up a bit on the social issues you seem to be getting tangled in,' wrote one correspondent in #205 (May 1986). 'I don't mind social commentary, but please spare me this phony, contrived anti-mutant crusade,' wrote another in #212 (December 1986). A month later, another opined that, 'For several months, I've been rather bored with the anti-Mutant hysteria which has been sweeping through the Marvel books.' 'To me, it's just getting a little tiring,' said another (#230, June 1988). These fans clearly read *X-Men* for plot lines other than the social one. Claremont's characters continued to suffer psychic burdens beyond those normal to other superheroes.

POWERS PLAY

During the mid-1980s *X-Men* was commonly viewed by commentators as being more angst-ridden than ever before. The characters had always carried a heavier psychic burden than other Marvel heroes, but what is distinct about the pains felt during the mid-1980s is that they are inflicted by the team's own powers. A number of the X-Men have abilities which turn against them or misfire, while telepathy, once represented as an easily controlled power, is recurrently shown to be the cause of strain and internal struggle. As I outlined in Chapter I, many of the new X-Men enjoy the use of their powers and seem incomplete without them. This was not necessarily the case any longer once Claremont returned to the 1960s theme of regarding mutant abilities as a curse.

Nothing announces the new theme so completely as the introduction of Rogue (real name unspecified at this point). A young woman from America's south, Rogue transfers people's identities and powers temporarily to herself via physical contact while causing

the transferee to go into a short coma-like sleep. She has no control over the process, so it effectively bars her from all physical intimacy. She appears firstly as a villain, but seeks help from Xavier and joins the X-Men: 'Mah powers are out of control. The slightest touch triggers the transfer. It's gettin' so ah don't know anymore which thoughts -- or mem'ries, or feelin's -- are mine!' Rogue's attack on the superhero Ms Marvel, Carol Danvers, has resulted in a permanent transfer of powers while Carol's consciousness also resides inside her, sometimes taking control and hating her host for the vicious attack. Rogue reflects at one point (#203, March 1986) that 'Ah thought, by gettin' rid of her once and for all -- by destroyin' her body as ah had her mind -- ah'd silence the voices, the screams, the pain, the rage inside my own head.' The voice in her head never goes, however, and at times takes over her being entirely; in #182 (June 1984), for example, she loses control completely, believing herself to be Danvers.

Rogue sought to 'silence the voices' inside her own head. For the team's telepaths (and *X-Men* had always included at least one character, and often two, gifted with such power) this suddenly became a recurrent problem. Prior to this period, telepathy and related mental abilities had always been the gentlest of powers. Being associated with the mind rather than the body, they were never shown to be a cause of strain except when in prolonged psychic combat with other trained telepaths. Indeed, while physical powers are associated with the young, telepathy is, foremost, represented in the figure of the crippled, older character of Professor Xavier. For him, and for Jean Grey, telepathy had been shown to be something which caused no strain. The telepath, if they chose, reached out with their mind to read the consciousness of others. Xavier's speeches about how he would never violate the mental privacy of others implied a process which was completely under his control. To put it bluntly, the X-Men's telepaths impinged upon the consciousness of others with ease. In the mid-1980s, this changed. Telepathic characters were depicted as themselves permanently impinged upon. The thoughts of the crowd – and crowds were suddenly more apparent in the comic – were ever-present, always threatening to overwhelm their own consciousness. Telepathic characters were now shown as

always at risk, constantly on guard against the intrusion of others, hence this catalogue of moments:

> Of all these recent psychic attacks... this was by far the worst. I'm supposed to be one of the strongest telepaths known, but [...] I can't protect myself (#180, April 1984)

> Too many thoughts -- too close, too intense -- my psi-shields aren't working! (#184, August 1984)

> Rachel -- projecting psibolts as formidable as my own! She isn't this powerful normally, but rage -- and, I sense, *grief* -- are giving her a berserker's strength! (#188, December 1984)

> My psychic resources have been stretched so thin I can no longer screen out other people's thoughts. (#196, August 1985)

> Have to... maintain my psi-shields... block out the thoughts around me... or I'll go mad. (#208, August 1986)

Some of these are Xavier's experiences, some are Rachel's. Her psyche is the least solid of all the X-Men. The comic does not directly use the language of post-traumatic stress disorder, but it is clearly the model for her character's agonies. Haunted by what she has seen in the terrible future, thoughts and associations which cut close to her anxieties trigger psychic or physical transformations.

If Rogue and Rachel are the heroes most emblematic of this new theme of the psychic pain of superpowers, Empath is the villain who most incarnates the theme. As a teenager, he mostly tussles with the New Mutants, but he appears also in action against the X-Men. He manipulates the emotions of others, sinking their rational thought processes beneath escalating waves of desire or aggression. Much of this is played out as low-level teenage intrigue as he manipulates the affections of lonely young girls to make them do his (non-sexual) bidding, but when he pushes his power further, the familiar tropes are deployed. When he is detected on the grounds of Xavier's school

by two of the X-Men's non-mutant friends, he escalates a mutual fondness into a destructive, all-consuming desire:

> We were insatiable -- less than human, worse than animals -- we couldn't devour enough of each other. The slightest touch was ecstacy [sic]. At first, it was... beautiful -- a dream come true, our heart's desire fulfilled. But soon, it turned ugly. Love without limit -- passion without restraint -- the sensations quickly paled. We were addicts, demanding more and more stimulus to satisfy our craving. In the end, there was nothing left. Of us. Of what we'd felt. We were hollow -- empty -- death seemed like a welcome release. (*New Mutants* #39)

The personal nature of his attacks makes Empath, discussed again in Chapter IV, the most dislikeable of villains. His talent is initially represented in terms of a power which he controls and projects, easily and at moments of his own choosing, on to others. As with the telepaths, however, he will later be characterised – in *New Mutants* #62 (April 1988) – as a victim of his own power, another mutant struggling to retain the integrity of his own self, another Claremont psychic under siege in his own mind:

> Sometimes I can't tell the difference. What other people feel *is* what I feel. They *assault* me with conflicting emotions... needs... desires... signals all around till I can't breathe... and I grab hold of one *emotion* [...] and use it to block out all the *others*... and I'm in control... not threatened... not overwhelmed.

By this point, a number of villains were being characterised in such a manner. The evil mutant Selene maintains her youth for centuries by stealing, vampire-like, the life essence of others. In her early appearances this seems to be without psychic consequence for herself, but in #208 (August 1986) she will declare that 'such is the price demanded for my survival... that I experience the lives of those I slay. No matter how foul.' In the same issue the Nimrod sentinel – notionally, a sophisticated mutant-hunting robot – finds its identity evolving away from its core programming. Equipped

with a camouflage program so that it can pass as human, it takes
up residence with a family, helping a youngster with his homework.
'Strange,' it reflects,

> it is not my function to teach. Yet I... enjoy helping the youth.
> How is it I feel joy? Feel *anything*? Such behavior is anomalous.
> Upon returning from tonight's mission, I -- correction, this unit
> -- will run a full-systems diagnosis examination.

The slippage from its customary self-description as 'this unit' to 'I'
is seemingly the process of a new identity formation.

These psychic assaults coexist with a greater emphasis on the
physical harm done to superheroes. In 1982, the X-Men spent
six issues in space, fighting reptilian aliens who had impregnated
them. At the story's conclusion, Professor Xavier's genetic make-up
is so corrupted by infection that advanced technology has to be
employed to switch his consciousness into a cloned body. This
began *X-Men*'s mid-1980s interest in the plasticity of the human
body – and if some characters found their own psyches turning
against them, others found the physicality of their powers to be
under threat like never before. While bodily transformations were
hardly unknown in superhero comics (and were usually easily
reversed), mid-1980s *X-Men* took a greater interest in the phys-
ical aspects of its characters' powers, and pushed them to new
limits. Colossus' metal form is superheated then rapidly cooled,
causing it to almost shatter. Kitty finds herself stuck in permanent
intangibility. The Morlocks count among their number Masque,
a mutant who can reshape the flesh of others into any form he
wishes. Another villain, Spiral, opens The Body Shoppe, a centre
for physical augmentation where bodies merge into cables and
circuitry, organic and mechanical components becoming barely
distinguishable at times. Wolverine's healing ability is discussed
more frequently as his body takes ever greater blows. He is a
mature hero and, unless the plot requires him to go berserk, has
now achieved significant control of his animal side, so pushing him
to the edge of his humanity requires circumstances more extreme
than ever before.

The artwork in the comic often struggled to find a visual vocabulary for these unstable identities, though not for want of trying. Traditional tropes like blurred, shadowed or distorted faces became increasingly common, as did oddly shaped panels representing extreme psychic experience. When Kitty Pryde receives a complete 'mindwipe' in her own mini-series, and has a whole new identity implanted, artist Al Milgrom represents it as her returning to infancy and growing into a wholly new person. We later see her face coming apart in black shreds. When Rachel merges with the universe, the comic depicts her as a two-headed Janus figure – one shocked, one cackling evilly – with all of the cosmos inside her body. When she comes under psychic siege from an emotional mob in #208, one panel simply contains emotional words written large – fear, happy, hungry, lost, yearn, etc. – representing the emotions impinging loudly on her consciousness. Indeed, Rachel suffers most of all, extreme shocks triggering memories of her horrendous life in 'Future Past', or even reverting her to her 'hound' identity. In the Morlocks' underground lair in #207 (July 1986), we see fragments of her face reflected over two dozen times in a shattered mirror. Little wonder that when she leaves, two issues later, feeling herself a failure as a heroine, she enters The Body Shoppe amidst descriptions of a fragmenting identity: 'She takes a first, hesitant step, a second -- and with each... leaves a different reflection -- a different image of herself -- frozen in a mirror behind her. Forgotten.'

How was this years'-long trip through fragmenting identities, besieged psyches and physical extremism understood by critics? Comics historian Sean Howe, writing retrospectively, saw it as a triumph of artistry over corporate timidity:

> If *X-Men* was noticeably bleaker than ever before, it only proved that Chris Claremont, more than any other writer, had managed to retain control of the way his characters were portrayed, had refused to tailor his comics for an audience of eight-year-olds.[5]

Put like that, it is hard not to stand up for the grimness: who doesn't want to side with the author's personal artistry against corporate infantilisation? This was not necessarily how the comic was viewed

at the time, however. Heidi MacDonald wrote in *The Comics Journal* in 1985, 'I do not understand Chris Claremont's infatuation with suffering and death.' Listing the numerous occasions in the mid-1980s when dream sequences/illusions depicted the X-Men dead, the many temporary physical transformations which team members underwent, the recurrent use of alien medicine or the Morlock mutant with healing powers to save characters from the most ghastly physical wounds, she pleaded, 'Chris, let them live again. Let them love and be happy.'[6] This wasn't the voice of eight-year-olds. It was the plea of a fan wondering what had happened to the visual humour of earlier issues, and decrying the way that death and transformation, which had once been deployed rarely and therefore to shocking effect, had become routine and uninvolving. The cover of the issue which printed this critique – because, however critical the *Journal* was of Marvel by this point, they knew the value of putting *X-Men* on the cover – depicted Claremont as Dark Phoenix, looming over the characters he was routinely abusing.

Such writing correctly identified the tone of mid-1980s *X-Men*. Dave Cockrum, John Byrne and Paul Smith had all mellowed Claremont's anxiety-filled writing with visual humour in a way which John Romita Jr did not. Complaints about grimness were common in the fan press, but did nothing to stop the comic's sales figures rising. In 1985, Marvel was reporting average figures of 378,000 sold per month, rising to 417,000 two years later. Sales were ever increasing, and this would have consequences.

MARVEL'S EXPANSION

Whatever special claims you wanted to make for the artistic specialness of the *X-Men* during the 1970s, its stories had unfolded in the traditional manner, and fans followed them simply by reading each issue. The team did guest star in other publications with increasing frequency as their popularity rose, but even when those appearances were scripted by Claremont and seemed to contain game-changing shifts (such as Banshee's discovery of a niece with the same powers which he had himself once wielded in *Spider-Woman*

in 1981) they merited only a passing reference in the main title and made little impact.

That would change quickly in the early 1980s. The rise of the dedicated comic shop had not only allowed the development of independent publishers, but they had enabled the major players to expand. Comics delivered to dedicated stores were not done on a sale-or-return basis but sold outright, freeing the companies from a wealth of economic uncertainties. The suddenly highly visible fans were willing to pay higher prices for products tailored to their tastes, tastes which could be more easily anticipated than the vagaries of anonymous news-stand customers. The industry which had seemed on its knees in the mid-to-late 1970s was suddenly booming. Year-on-year in the 1980s Marvel would post record profits. The company was happy to experiment with the new formats which this market demanded, and it used the popularity of the X-Men to ensure high-profile launches of new products. *Marvel Fanfare*, an anthology title which was the company's first regular comic strictly for the comic-shop market (it was literally fare for fans), began with a four-part Claremont-scripted X-Men story. Similarly, *Wolverine* was the first of many mini-series (comics which ran for only four to six issues and told a single story rather than being ongoing) and Claremont wrote the fourth and fifth *Marvel Graphic Novels*, the debut of *The New Mutants* and *God Loves, Man Kills*. While *God Loves...* was devised to stand on its own, and for years afterwards was not referenced as part of standard continuity, the content of both *Wolverine* and *The New Mutants* was validated by its important relationship to the stories in *X-Men*. Claremont's trademark complex plotting had previously manifested itself through the length of time a story took to be told from its first hints to its final dénouements, and all of it came in the regular issues of *X-Men*. Now he could expand his stories horizontally across multiple titles, keeping the master narrative in his head. It became impossible to summarise the ongoing story without sounding like a geek – as evidenced by the following paragraph.

In #160 (August 1982), the X-Men travel to a demonic realm called Limbo. Upon their escape, Colossus' eight-year-old sister, Illyana, is sucked into a wormhole. She is pulled out instantly, but time has passed differently on the other side and she is now in her

mid-teens. Xavier's and Magneto's experiences shortly after the war are retold in flashback in #161, an issue which subsequently concludes with a short present-day sequence where the X-Men are captured by the alien Brood. The following issue is the story of Wolverine's escape (no other X-Men appear, save in his memories), then #163–6 detail his rescue of the rest of the team and their victory over the aliens. Back on Earth, Xavier, believing his students dead, is distraught, but is convinced by Moira MacTaggert to enrol another class of young students, whose initiation is detailed in the *New Mutants* graphic novel and the first three issues of their subsequent comic. While the new students engage in low-level adventuring, they seem threatened by occasional Brood presences within the mansion, something which isn't resolved until *X-Men* #167 (March 1983), when the main team return. *New Mutants* #3 is, thus, set prior to *X-Men* #167, even though it was published a month later. In #168, Wolverine leaves for a holiday, the events of which are told in the four-issue *Wolverine* mini-series and which lead him to Japan, culminating in his engagement to Mariko. The final scene cuts back to the X-mansion, where the team receive a wedding invitation. This extended holiday means that he is absent from the main comic for the three issues (#169–71, May–June 1983) where the team encounter the Morlocks. *The New Mutants* #5 and #6 (July and August 1983) see the junior team fighting a Japanese villain, Silver Samurai, who now has a particular grudge against Xavier and his mutants because of the inheritance implications of Wolverine's imminent marriage. The Mutants defeat the Samurai, but one of their own, Shan, goes missing under circumstances so strange that the X-Men are called in to help the search and appear in issue seven, just prior to their flight to Japan in #172 of their own comic, meeting up with Wolverine for his wedding (which is abandoned). Some months later, a four-issue mini-series details what happened to Illyana during her years in Limbo. That story has a contemporary framing sequence which leads directly into *The New Mutants* #14 (April 1984), during which she joins that team. The fate of missing mutant Shan is only revealed in #34 (December 1985), nearly two and a half years after her disappearance. The multiple comings and goings needed to be kept in mind because

later plot lines could turn on them. When the Morlocks return in #178–9 (February–March 1984), their plan to kidnap Kitty unravels precisely because they did not meet Wolverine during their original encounter (he was in Japan, remember?), and so do not anticipate his enhanced sensory powers.

Got all that?

The cross-promotion implied by this style of narrative was a deliberate policy. Magneto's redemption, begun in *X-Men* #150 (October 1981), continued throughout *The New Mutants* before reaching a climax with his trial before the world in *X-Men* #200 (December 1985). When Rachel Summers is made a regular in *X-Men*, having time-jumped back from the 'Days of Future Past' dystopia, her first arrival at the mansion actually occurs in *The New Mutants* #18 (August 1984). The commercial calculations were as obvious then as they are now, but many fans took it as a sign of increasing sophistication in the storytelling and were happy to be secret sharers in their own commercial exploitation (to this day many might challenge my use of the term 'exploitation'). Those with the disposable income to follow the stories could pride themselves on their ability to retain the multiple plot strands. With a fan base made up of teenaged boys, the predictable downside was the way in which apparently innocent conversations about current plot lines could actually be point-scoring exercises in who had the best knowledge of what happened where. When the crossovers became really complicated, Marvel would print full-page guides to the reading order in which X-adventures, spread over multiple different titles, should be read, guides which doubled as advertisements declaring that a big event was imminent ('The Mutant Massacre') and should be collected en masse.

The ability of these storylines to retain coherency even as they switched from one comic to the next was only possible because of the continuity of personnel involved. All mutant comics were overseen by the same editor. While colourists and letterers were largely regarded as interchangeable on most comics, Glynis Wein and Tom Orzechowski were routinely assigned all X-projects. In their history of the postwar comics industry, Gerard Jones and Will Jacobs record that Orzechowski was 'the best letterer in the business and the only

one who could make something readable of Claremont's piles of prose'. Consequently, and uniquely for a letterer, he was granted an incentive contract.[7] Atop all of them sat Claremont himself, the undisputed master of the X-verse. Other titles – *Daredevil, Fantastic Four, Thor* – had their moments in the sun as talent came and went, but *X-Men* was a constant, absorbing whatever worked elsewhere in the industry and refracting it through the prism of Claremont. Both Paul Smith and, especially, John Romita Jr incorporated Frank Miller's innovations – the wide panels, the blank spaces – but this could only be a matter of arranging panels on the page. With Claremont's lengthy captions to detain the reader, there could never be the same speedy flow of the eye from one panel to the next which came with Miller's wordless images. *X-Men* artists could never seek to control the passage of time from one image to the next. There was only one auteur on the comic, and his lengthy captions and copious thought balloons determined the time that a reader would take over each panel.

As the apparent master of the X-saga, Claremont thought long-term about the comic which he had no plans to leave, and which he foresaw as something which developed over time, explaining it retrospectively thus:

> I wanted *X-Men* to be a book that evolved. If you read issue #94 and came back to it with #294, *X-Men* would have a different cast and be a different book and that's something you just couldn't do with titles like *Spider-Man* or *Fantastic Four*.[8]

Given his knack for introducing new characters without diluting the series' popularity, he had every reason to think it a viable strategy. Banshee had been 'depowered' and retired, a fate which was also to have been Phoenix's, but she had been killed instead. Kitty Pryde and Rogue had joined. Illyana and the New Mutants hung at the edges of the parent comic. Claremont's most audacious shift in line-up, however, was to be the retirement of Cyclops.

Scott would make his final regular appearance in #175 (November 1983). After this he would retire from active duty and make only guest appearances. This timing was appropriate, not only because

significantly numbered issues (which in the expanding market meant every 25th issue) required headline events but because the comic in question would be, to quote its cover, the '20th Anniversary Issue!' The opening caption reads, 'Twenty years ago, more or less, Stan Lee and Jack Kirby created the Uncanny X-Men. A lot has changed since then.' To mark those changes and that passage of time, the issue works through the story of how Xavier's most loyal pupil, the character to have appeared in more *X-Men* issues than anyone else, leaves the school, and how the comic's most introverted character puts his demons to rest to build a life away from the mansion. Dark Phoenix is back, but as an(other) exercise in raising the spectre of that villain, this is dull. The Phoenix who walks through these pages is just an illusion created by Mastermind, an empty shell devoid of all the conflict between desire and duty which had made the original story so compelling. Only as a final step in Scott's progress does the story have any substantial content.

The comic begins with Scott being forcibly returned to the school, apparently by a resurrected Dark Phoenix. He has been dating Madelyne Pryor, a red-headed Jean lookalike, and the comic has played with the possibility that she is Jean resurrected. Scott himself soon realises that this is not the case, that any such indications are merely deceptions created by Mastermind, the illusion-casting villain who had seduced Jean into darkness back in 1979. The rest of the team, however, continue to be fooled. Believing him to be Phoenix, they attack Scott en masse, but he 'uses everything taught him by Xavier' to beat them all. In a protracted battle in the Danger Room we are constantly identified with Scott, his thought balloons being almost continuous while everyone else's are rare. His father gets to declare that he is proud of him (it turns out to be an illusion, but the sentiment is there), and even his dead mother appears inside his head to tell him it's not yet his time to die. When he is reunited with Madelyne, the dialogue ('Hi.' 'Hi yourself.') repeats Scott/Jean dialogue from #136 (August 1980), but this time there will be a happy ending with Scott marrying his red-headed bride.[9] He first needs to visit Jean's grave to say goodbye, then he goes to be wed. Personal demons vanquished, the one member of the original team who couldn't bring himself to leave in #94

(August 1975) is finally able to make a life elsewhere. The only remaining issue is whether the married couple will join his father with the Starjammers in space or build a life outside of heroics on Earth. #176, which concerns a fight with a giant squid as Scott and Maddy head off on honeymoon, resolves that and ends with them literally flying off into the sunset. He guest appears in a two-issue mini-series (X-Men and Alpha Flight) in 1985, largely so that the news of his wife's pregnancy can be announced.

However, Cyclops' retirement was not to last. Claremont had kept silent in the early 1980s while the industry had debated the rights of creators, but when his ideas for the comic's evolution clashed with commercial priorities, he would be reminded very sharply of who owned the characters. He had made *X-Men* Marvel's hottest property, the undoubted fan favourite which looked set to break into the cultural mainstream, and radical changes to the line-up turned out not to be on the corporate agenda.

When the toy company Mattel became interested in licensing Marvel characters they required a special publication or event to properly launch a product line, and their market research suggested that the young children who were their target audience reacted positively to the words 'secret' and 'wars'. As a consequence, *Marvel Superheroes Secret Wars* was the ungainly title for a 12-issue series which ran throughout 1984 and 1985 featuring all of the company's prominent characters, promoting the toys but also acting as Marvel's own corporate branding. The story, such as it was, involved a being of immense power, the Beyonder, transporting Marvel's major heroes and villains to the self-explanatory Battleworld, where they had to fight for their right to return home. This would showcase all of the company's greatest heroes, so we can read it for what it tells us about the company's perception of its key character assets. This branding would clash with Claremont's idea of a shifting membership. Kitty Pryde, for all that is said about her now as a fan favourite, did not make the cut, but Cyclops did. Far from living out a happy retirement in Anchorage, there he is on the front cover, a central image subsequently used as general publicity. Indeed, of the 16 characters shown there, six are X-Men. Since nothing of· consequence happens to Cyclops – little of consequence happens to

anybody in *Secret Wars* – and he is returned to Earth with everyone else at the end, the series did no obvious damage to Claremont's plotting, but it was a sign that the company regarded the character as a corporate asset with value as an active hero.

X-Men felt a more substantial impact from a *Secret Wars* subplot in which Colossus fell in love with an alien healer. She died in the series, but burnt so brightly in his memory that, upon returning to Earth, he terminated his 'will they-won't they?' relationship with 14-year-old Kitty. The reasons for this twist have never been, to my knowledge, publicly explained, but there had always been raised eyebrows in the early 1980s, wondering if Kitty was too young for such a relationship with an adult character. Marvel staff could become defensive when questioned. 'They are very close in age,' opined John Byrne shortly after leaving the comic, 'at least in my mind, though it was never clearly established, because I never thought of Colossus being much more than about seventeen years old.'[10] This was not a cause célèbre (as Shooter's decree that Jean Grey pay the ultimate price for her crimes had been) or a source of recurrent amusement (as was the denial that Wolverine had ever killed anyone), but it was always in the background, and with the Colossus relationship aborted, Kitty was given a new love interest, a fellow high schooler called Doug Ramsey. Colossus' love story was the biggest event to affect the X-Men which had been included in a story not written by Chris Claremont. *Secret Wars* put all writers and artists, Claremont included, on notice: Marvel had ownership of these characters and corporate needs would be paramount.

The lesson was brutally reinforced in 1985. In addition to the mini-series and graphic novels, Marvel was also concerned with expanding its roster of monthly comics to include more *X-Men*-related titles. Several years earlier Claremont and editor Louise Jones had seen the writing on the wall and, fearing that the intensity of *X-Men* would be diluted by inappropriate spin-offs, begun work with artist Bob McLeod on a new project about a group of young mutants who enrolled in Xavier's school to learn the control of powers which had suddenly manifested. They were working on this when told, by editor-in-chief Jim Shooter, that others within the company were pushing for a spin-off comic featuring those members

of the old team not currently used in the comic and based on the West Coast. Forced to reveal what they were planning, Claremont and Jones found their project green-lighted and *The New Mutants* became a regular Marvel comic. Shortly afterwards, Alpha Flight, the Canadian superhero team which had been Wolverine's home prior to his joining the X-Men, received their own comic, with John Byrne as writer and artist.

The bullet, however, could not be dodged twice. In late 1985 a new mutant comic, entitled *X-Factor*, saw the original team reformed, complete with a resurrected Jean Grey. This twist would entail revealing that the being who had burst from the waters of Jamaica Bay in *X-Men* #101 (October 1976) was not the real Jean Grey. Rather, the Phoenix Force had secreted the real Jean in a cocoon under the sea while creating a copy of her for its own self to inhabit. This copy had died on the moon, and the real Jean could be found under the sea and returned to mainstream continuity.

The knock-on effects would be huge. Cyclops would ditch his pregnant wife to return to both Jean and active duty. The team would set up as a group of professional mutant hunters, X-Factor. Bigots who had noticed the emergence of a mutant in their local area could contact the team who, under the cover of dealing with a 'problem' mutant, would make contact with the youngster, taking them to their hi-tech headquarters where they would be safe and trained. Editor Ann Nocenti made a point of telling Claremont about this development on a Friday night, so that he could not barge into Jim Shooter's office without a weekend cooling off, a weekend which he spent brainstorming alternatives to no avail. Within the Marvel offices, the comic became known as *Chris-busters*.[11]

Should we be surprised at Jean's resurrection? Claremont had acknowledged her centrality to the comic when he brought her back in #97 (February 1976) and, once she was dead, he teased readers several times with the possibility that she was back and used her in dream sequences. When even Cyclops had finally put her memory to rest and married – which might finally have drawn a line under the whole character – Claremont introduced Rachel, the daughter of Scott and Jean from an alternative timeline, who took the code name Phoenix. A number of the other X-Men were in ongoing

relationships, but with peripheral characters outside the team who could be absent for months on end: Nightcrawler's girlfriend was an air stewardess regularly flying overseas, while Wolverine's Mariko lived in Japan. The closest the comic had come to replacing Scott/Jean with a central romantic relationship was Colossus and Kitty, and *Secret Wars* had put an end to that. Claremont may have been angry that Marvel editors decided Scott and Jean were the primary relationship in the mutant saga and that the comic couldn't live without her, but he had provided them with much of the evidence.

Disregarding Claremont's objections, *X-Factor* went into production. However, producing a mutant comic proved harder than Marvel management might have anticipated. The first issue was completely redrawn at Shooter's request, and when he asked that the second be redone as well, editor Mike Carlin quit. Writer Bob Layton left after #5 (June 1986). His replacement was a familiar face with a new name: Louise Simonson.

A later official history of Marvel would label Simonson 'Ms Mutant',[12] so it would be best to review her relationship to the comic here. Simonson was the married name of Louise Jones, the woman who had become *X-Men* editor during the very last stages of the 'Dark Phoenix' storyline (#137, September 1980, was the first issue to carry her credit). She had been poached from another publisher, Warren, as part of Jim Shooter's imposition of a proper editorial structure. John Byrne had left *X-Men* soon after, feeling that her sense of the comic was closer to Claremont's than his own and that she would favour a writer-led approach. In later years Claremont would talk of Jones as his favourite editor. Together they created *The New Mutants* and made *X-Men* the industry's biggest seller. Known as Weezie to her colleagues (and, thanks to Marvel's circulation of that fact, to fans too), she acquired a strange visibility in the comics themselves. She makes a cameo in *New Mutants* #21 (November 1984) as a slumber-party guest, self-reflexively talking to the readers ('Hi, guys, I'm Weezie! Welcome to the party!') even though she'd stopped editing that comic some months earlier; her hairstyle is used in April 1983 as the model for Madelyne Pryor's when she is introduced in #168 (and lots of fans were expected to recognise that!); most bizarrely, half of her left foot appears in

X-Men Annual #10 (1986) with those of her husband ('Walter, do you hear croaking?' 'Be real, Weezie'). Leaving her editorial role to write on a freelance basis, Simonson sometimes seemed like a less intense Claremont. Her 1988 mini-series *Spellbound* concerned (and stop me if you've heard this one before) a young woman given cosmic powers which drive her mad every time she uses them. When Layton departed *X-Factor*, Simonson stepped in, becoming the series' regular writer with #6 (July 1986). She would later say that her appointment was

> partly because Chris was my friend. I think someone finally realised that splitting up the X-Men and fostering a hostile rela-tionship between the creators was a really bad idea. I believe I was brought on, at least in part, because everyone knew that I could and would work with Chris.[13]

Internal politics aside, it was a shrewd appointment. For all its high-concept premise, *X-Factor* had struggled for direction in its early issues, but Simonson understood the world-shattering rhetoric of the team comic, scrapping plans for The Owl, an ineffective villain from *Daredevil*, to become X-Factor's arch-nemesis, and creating instead a powerful being called Apocalypse. An immortal mutant who favoured an evolutionary creed that only the strong were worthy of survival and who passed judgement accordingly, Apocalypse would transform the character of Angel, leading to familiar agonies:

> Apocalypse *began* my transformation. He changed my body... and introduced me to the darkness in my soul. This is his legacy. She promised me *power*... to *destroy*. I want to... and yet... I must fight it... or what will truly be destroyed... is my *self*! (*X-Factor* #38, March 1989)

Suffused with this type of struggle, *X-Factor* truly became a sister book to *X-Men*, and when Simonson was joined by her husband, Walter, his kinetic artwork made the comic a hit.

Publicly, Simonson was happy to play second fiddle to the master of the X-universe. When asked in 1987 by the magazine

Comics Feature whether her X-Factor team would meet the X-Men, she replied,

> I think that they're still going to be avoiding each other for quite
> awhile unless Chris decides to do something different. Chris has
> a storyline worked out that will go on pretty far into the future
> which will take the X-Men away from New York and away from
> any possible connection with X-Factor.[14]

Was Claremont deliberately keeping the two series apart because he disapproved of the new title? It's hard to tell. Perhaps his own view of the comic might best be judged from *The New Mutants* #45 (November 1986), one of his finest stories. The story concerns a young man, Larry Bodine, at a high school close to the X-Men's own academy. He briefly crosses paths with the New Mutants at a joint mixer, but they are unaware that he is bullied at school by people who call him 'mutie'. The bullies think they're having a laugh, but the taunts hit home because Larry actually is a mutant, his power being a non-threatening artistry, creating sculptures out of pure light. The bullying escalates to the point of leaving X-Factor's flyers on his chair. The last page on which he appears has him agonising over the threat: 'This is crazy, I feel like a *criminal*! In X-Factor's eyes… I guess I am.' The phone rings and he answers. 'We called 'em, Mutie. X-Factor's on their way. You're done for!' Larry is told in his last panel. The next morning the mutants are informed by a sober Magneto that the young man they met the night before has killed himself, and Kitty's subsequent investigation reveals a suicide note is written on the back of the X-Factor advert: 'They're coming to get me! Where can I go? What can I do? What's the point if I can't create? Why do they hate me? What have I done?! I'm alone. Nothing left. No way out. I'm sorry.' X-Factor caused the young man's death.

However, if Marvel was overruling Claremont behind the scenes, it could still celebrate him publicly in publicity and in the release of *Classic X-Men*. Reprinting famous stories from the past was not a new idea. *Spider-Man*, *The Avengers* and others had previously been reprinted in packages which were the same format and price

point as standard comics. *Classic X-Men*, however, would be priced higher, but would feature no advertisements. It reprinted *Uncanny X-Men* from *Giant-Size* #1 onwards, inserting extra pages into the stories it reprinted and creating new stories – 11-page character-based vignettes – set between the early adventures.[15] Commercial considerations aside, the project was premised on the idea that with a few tweaks the saga of the X-Men could be made into a fully coherent whole in a way no other Marvel comic could. Early assertions about the limitations of characters' powers which had been contradicted later were rewritten. Storm had originally lost her parents in the Suez crisis of 1956 but that event, now too remote to reasonably be part of her life, was turned into a less specific 'military incident'. Speech bubbles in early issues were similarly treated to bring them into line with later usage. Wolverine calls a monster 'baby' in an early issue, and this was replaced by his more usual term 'bub'. Storm was given extra thought balloons in early issues, articulating a claustrophobia which hadn't been apparent in 1976 but was now a major part of her character. The same hindsight made possible by the passage of time meant that characters could be given extra, prophetic dialogue. When asked why he had invited a loose cannon like Wolverine to the mansion, Xavier replies, 'Given time and care, he has the potential to become a keystone of the team.' That wasn't a line anyone would have written in 1975, but to those who knew the subsequent ten years it made perfect sense. There is a significant amount of rewriting of history here, bringing the old stories into line with the newer ones. Flashbacks to Wolverine's life pre-X-Men had not been a feature of the early years, but now that they played a recurrent part in the comic they were retrospectively inserted in the reprints. The importance that the Hellfire Club and Apocalypse had acquired in the *X-Men* mythos was reflected in the way they are retrospectively included, added as the unseen manipulators behind events as early as 1976 – years before they had actually appeared. The narrational captions would often be rewritten, softening the breathless melodramic tone of 1970s Marvel. 'The mountain is called Valhalla, the home of the gods. Those who know it better... call it death' was acceptable writing in 1975, but it was cut out completely a decade later. *Classic X-Men* #22 (June 1988)

added a new caption to its reprint of #116 (originally December 1978), talking about humanity 'discovering that more and more of its wayward children are being born as mutants with powers and abilities that set them forever apart'. In these, and a hundred other captions and dialogue alterations, the comic projected *X-Men* as it was understood in the mid-1980s on to the stories of the 1970s. A project such as this one, which seeks to map the changes in the comic's direction as they happened, would be impossible using these reprints, as the evidence that there ever were any differences has been wiped away.

However, not all of the ideas which Claremont inserted into the narrative were recent developments applied retrospectively. The new dialogue and the vignettes committed to paper the para-text of *X-Men* as it had existed in fan debate and Claremont interviews of the late 1970s. When did Jean and Ororo become such good friends? *Classic X-Men* #2 (October 1986) shows them bonding on a traumatic shopping trip in Manhattan. Did Scott and Jean continue to see each other between *X-Men* #94 (August 1975) and #98 (April 1976)? #6 (July 1986) shows the latter preparing for a date. This vignette, 'A Love Story', is uncommon in that it contains no dialogue or captions, Claremont foregoing his usual tendency to write to what many regarded as excess for a visual medium. Instead, the story is told purely through the artwork of John Bolton. The only words are the chiming of a clock, some other sound effects and the writing on the posters which decorate the walls of the apartment Jean shares with Misty Knight. Preparing herself for a date with Scott, Jean uses her telekinetic powers to animate some clothes and a pair of ruby spectacles into his likeness with which she can dance. Touching and romantic, the sequence carries a sadness based on the recognition, through the clothing which both Scott and Jean wear, that the date she is preparing for is the occasion when the X-Men are attacked by the Sentinels, the event that triggers their journey into space and which concludes with her transformation into Phoenix. These imminent events are clearly signalled by a poster on Jean's bedroom wall promoting the E. Nesbit novel *The Phoenix and the Carpet* and the final page where, sometime after the couple have left the house, a loud 'ChBoom' and a large figure shooting

skywards announce the beginning of the battle with the Sentinels, an event which shatters both the window and the glass covering a photo of herself with Scott.

While the story not only looks ahead to the narrative events of the Phoenix saga, it also returns to the themes of the 1970s, equating Jean's imminent transformation into a creature of primal energy with her sexuality. 'A Love Story' is explicit that this night – the night which, ultimately, leads to her becoming Phoenix – is the night that Jean has tentatively marked for consummating her love for Scott. The note left by her flatmate urges her to 'GO FOR BROKE' and concludes, 'Be rude!! Be happy!!! It'll be great!!!!' In her diary, Jean has recorded 'Scott Dinner plus…??' and, upon entering her room, she takes a photo of her parents from its place next to her bed and puts it away in a drawer before lying back on her double bed and thinking about…well, we are not told. In the absence of Claremont's customary lengthy captions or thought balloons we do not know what she is thinking. For the same reason, it is hard to know what is intended here, if anything. The link between Jean's sexuality and her transformation into Phoenix is clearly reforged, but what interpretation is placed on that is left to the reader. Does the story castigate her again with a reminder of where her passion leads, or does it remind us that for all the 'lust' and 'desire' associated with the Dark Phoenix, Jean burns primarily with a genuine love for Scott?

*

In 1986 *X-Men* remained undoubted industry leader, an empire of its own with spin-offs and reprints in varying formats. That year, Claremont had in mind a story which, though he did not know it, would make the comic bigger news still and which would point it in new directions. The consequences of what became known as 'The Mutant Massacre' would be large, but before we turn to it, Chapter IV considers the very first *X-Men* sister title, the one which more than any other spin-off allowed Claremont, with Simonson as co-creator and initial editor, to explore his favourite themes: *The New Mutants*.

EXISTENTIAL X-MEN:
THE NEW MUTANTS

The New Mutants #1 (March 1983) – #54 (August 1987), #81 (November 1989)

Characters: Wolfsbane (Rahne Sinclair – can transform into a wolf or an intermediate state between human and wolf), Karma (Xi'an Coy Manh – takes temporary mental possession of people), Cannonball (Sam Guthrie – propels himself through the air after generating thermochemical reactions in the lower part of his body), Psyche (Danielle Moonstar – pulls visions out of people's heads, revealing their deepest desires or fears), Sunspot (Roberto da Costa – draws power from the sun to give himself great strength). Over the years they would be joined by: Magma (Amara Aquilla, taps into subterranean lava flows and tectonic faults), Magik (Illyana Rasputin, a mutant teleporter who has been trained in her early years as a demon sorceress), Cypher (Doug Ramsey, near-instant decoder of unfamiliar languages) and Warlock (alien shape-shifter made of bioelectronic circuitry). Professor Xavier, and later Magneto, teach/lead the team.

The New Mutants was the first regular comic to be spun off from *The Uncanny X-Men*. It was initially focused on five young characters, returning to the 'school for young mutants' premise which the X-Men at the time had outgrown. Characters would be in their teens and travel outside the US less often. However, the usual Claremontian ambition saw the comic's reach grow, particularly when more abstract artistic styles replaced those of original artists Bob McLeod and Sal Buscema, both of whom kept to the traditional Marvel look. Increasing abstractions included introducing Warlock, a shape-shifting mass of alien biotechnology, and transforming Illyana Rasputin, Colossus' younger sister, into a demon sorceress. The latter became Claremont's favoured vehicle for exploring the dramas of temptation and spiritual or physical hunger. Familiar characters appeared, notably the Hellfire Club's White Queen, Emma Frost, who ran her own private school with its own small mutant intake. When

Xavier decided to build a life in space with his alien love Lilandra, a reformed Magneto took over the school. Claremont wrote the comic for 54 issues, handing the writing job to Louise Jones/Simonson upon his departure. Though it never attained sales comparable to *X-Men*, it was one of Marvel's most successful comics while Claremont was the writer.

A quick way to register the speed and impact of *X-Men*'s escalation in sales in the opening years of the 1980s is to compare two comics about mutants which Marvel launched in the period. *Dazzler* debuted with a March 1981 cover date without drawing on any *X-Men* themes. The character had been introduced in *X-Men* #130 (February 1980) where Xavier and the Hellfire Club had both sought her out, sensing a possible recruit, but she had also appeared in *Amazing Spider-Man* #203 (April 1980), and although the X-Men appear in the first two issues as guest stars, so do a wealth of other heroes, just as a number of other familiar Marvel characters – Doctor Doom, the Hulk and Galactus, to name but three of many – appeared across its first year. Inserting the character within the wider Marvel Universe was clearly a priority over any particular *X-Men* connections. Thematically, *Dazzler* had little in common with Claremont's comic, being resolutely urban at a time when *X-Men* was largely set in natural spaces. The representation of New York's club scene was clearly intended to be part of *Dazzler*'s attraction, though it failed so badly in this respect that anyone familiar with the comic has almost certainly laughed at this assertion. Its conception of human nature – if it could be said to have one – did not embrace concepts of ego and id. Whatever its reputation, the *X-Men* had yet to establish itself as something which could or should support a spin-off project.

By contrast, *The New Mutants* was launched two years later specifically as an *X-Men* tie-in. It would share its senior creative personnel (Claremont would write it, Louise Jones would edit) and setting (Xavier's mansion). Continuity with the parent title was provided not just by Claremont's recurrent tropes but by the inclusion of the 'mutant menace' theme. The prejudice plot was a transferable storyline which did much to allow *X-Men* to proliferate

as a franchise. Indeed, the opening sequence of *New Mutants* is based on the theme, using it to hark back to the parent title. *Giant-Size X-Men* #1's opening sequence, the scene which had launched the new team, began with Nightcrawler being pursued by European peasants only to be rescued by Xavier's intervention. This is replayed in *New Mutants'* own opening, when the mutant werewolf Rahne Sinclair is chased by a similar mob armed with Christian iconography and flaming torches (no electrical illumination in this part of Scotland!) before being rescued by Moira MacTaggert.[1]

Before commencing its own regular series, *The New Mutants* debuted as a Marvel graphic novel, and fans were quick to spot familiar elements. *The Comics Journal*'s review made humorous predictions of future plot lines based on long-recognised Claremont tropes:

> 'Karma' can possess other people while still controlling her own body. I think it is a fairly safe bet to guess that at some point in time we will read the following thought balloon: 'NO! Evilbadguy won't let up! I can't concentrate! Losing control!'
>
> Another New Mutant, Rahne Sinclair, can turn into a wolf. I gather that she can also transform herself into a form intermediate between wolf and human. I predict someday we'll read something like this 'Rahne! No! Don't rip his throat out! You're still human underneath! You mustn't lose control!'[2]

For all this familiarity, *New Mutants* took a consciously different tone from its parent. With these mutants less likely to fight cosmic-powered foes, and based at Xavier's mansion while the senior team was out on the streets of urban America during this period (1982–6), *New Mutants* consciously looked back to the style of *X-Men* five years earlier. Some of those more joyful elements which fans such as Heidi MacDonald felt had been lost in *X-Men* are recurrent here. This young team finds time to play sports in the grounds of Xavier's mansion and travel abroad for rest and relaxation in a way that had long since vanished from the parent book. The new characters are once more drawn from around the world (Karma is Vietnamese, Cannonball from Kentucky, Rahne Scottish, Illyana Russian, Psyche a Cheyenne American and Sunspot Brazilian), allowing the comic

to repeat X-*Men*'s incorporation of familiar foreign words ('merci', 'Señora', 'obrigado') into the dialogue, and due to its familiarity with the parent title, the readership was ready – in a way which it hadn't been in 1975 – to discuss the cultural baggage of individual characters right from the start. Early letters pages are a wealth of cultural analysis: 'Kentucky is basically a southern state, but it's not "deep" south'; 'Most Asians have two big influences in their lives, hidden though they may be – Confucian teaching and Taoism'; 'Cannonball is probably a Baptist'. These are only a few of the observations which make up the letters page of #5 (July 1983), and reflect back to the readers a view of themselves as cultural commentators. To some degree, this is cued by the title itself. Like a later X-spin-off, *Generation X*, the title is taken from sociological journalism, the literary critic Leslie Fiedler having used 'New Mutants' to denote the emerging counterculture of the 1960s, a term not taken up by the popular media, which much preferred to use the word 'hippie'.[3]

As a comic about a group of teenagers coming to terms with their powers and how best to use them, *The New Mutants* was well suited to Claremont's fables of moral choice, conflicting desires and psychic growth. Adolescence has often been represented as a period particularly ripe for tales of temptation and the id's conflict with the superego, and the characters certainly agonise over right and wrong behaviour. However, it was during Magma's first appearance that Claremont's ambition for the comic became apparent.

After four issues where the new team had stayed close to Xavier's mansion, going no further than the local mall to battle Sentinels and meet some of the other local teenagers, and a two-part trip to California, the team travelled to the family home of Roberto da Costa in Brazil. #7 (September 1983) and #12 (February 1984) are set in Rio, bookending the main storyline which is set in the Amazon. In both issues, members of the team are spontaneously kissed by passers-by, a significant contrast to the restrained, slowly developing friendships that the mutants are developing with local teenagers back home. *X-Men*, as we have seen, was starting to use sexuality as a theme. The younger age of the New Mutants would preclude much of that, but their South American adventure is rife

with sexual desire. The rich male power brokers of the Hellfire Club's Rio branch explicitly lay on young women for the entertainment of guests (something the New York club had not yet been seen to do), and when Psyche pulls a desirable image from the minds of the same club's soldiers to act as a diversion it turns out to be scantily clad women. These are coy images of adult desires, but they contrast with the lack of such imagery in the comic's early US-based stories.

This contrast of North American superego with southern id has its parallel in the main Brazilian story. When the mutants travel up the Amazon with Roberto's archaeologist mother, chasing rumours of a lost civilisation, they unexpectedly discover Nova Roma, a lost outpost of the Roman Empire which has remained undiscovered by modern society. The early parts of the story are standard adventure fare, featuring all the threats which a ten-year-old would expect to find in a story about Roman colonists in the Amazon. In the river, Danielle is almost eaten by piranha fish, on the shores they meet local tribespeople armed with spears, and in Nova Roma itself the boys must fight in the arena. Politically, Nova Roma is the Enlightenment imagination writ large – a pre-Christian republic where noble white men, a little overweight as a sign of the good life, walk tall amidst classical architecture and discuss politics at the senatorial baths. The framework of civil society is a state religion which is a celebrated source of social cohesion but which makes no supernatural manifestation. Senator Lucius Aquilla is the spokesperson for these values, a plebeian-born senator who is so in tune with the values of the comic that his daughter Amara, whose mutant powers are revealed in the course of the story, later compares him to Charles Xavier. The public rhetoric of the state is of the nobility of the civilisation:

> I am of the *patrician* class, lad -- the nobility -- born and bred to
> uphold the ideals and traditions that have made Rome great...
> Caretakers of the eternal dream she represents, guardians of her
> immortal soul. [...] many senators are commoners, some even
> descended from slaves -- and they serve as honorably as any
> patrician. (#10, December 1983)

Like any soul in a Chris Claremont story, however, this one is under threat. Beneath the surface (literally so, in underground tunnels carved from rock, comics being good at visualising this particular metaphor) there is a disturbance. In order to sustain population levels, Nova Roma has taken in many locals down the centuries, descendants of the Incas, and this part of the populace seek an 'absolute monarchy' of the sort found in the civilisations of the pre-Columbian Americas: 'a faction has arisen seeking to transfer Rome into the same kind of imperial state' (#9). Although this opposition is clearly stated (Rome's democracy is threatened by South American absolutism), it is only falteringly executed. We actually see few of these Incan monarchists, the story concentrating instead on those privileged elements of Nova Roman society who are using this movement for their own ends, confident that they can rise to the top in a post-democratic Rome.[4]

The exotic exception to this preference for Caucasian villains is Selene, a powerful female mutant of unstated ethnicity. Consciously named for the Greek goddess of the moon, Selene's powers are mutant in origin but come dressed in the language of the super-natural. Her followers are said to be a 'cult', and they sacrifice themselves – or, if unwilling, are sacrificed – in ritual ceremonies beneath the earth because Selene's mutant power allows her to take the energies of those she kills to sustain her own life. Like the Phoenix Force, she is a primal power, declaring in #10 that 'I am, after all, a *goddess*, who has walked the earth since before the dawn of history.' As ever, the use of her power is expressed through metaphors of hunger and pleasure, with sexuality hovering closer to the surface than it had in the 'Dark Phoenix' story three years earlier: 'Come, children, give yourself to me', 'Feel it, Danielle... the darkling ecstasy that sustains me. Is it not wonderful?! Do you not hunger for more?!?' (both #11). Where Jean Grey struggled, Selene has simply gone over to her dark side. She is defeated only when her attempt to kill Amara Aquilla (the Roman teenager who is daughter of Selene's political opponent) goes badly wrong. Amara has been suffering headaches, a sign (though she doesn't know it) that her mutant powers are beginning to show themselves, and Selene's dis-patching her into an underground 'abyss' is the event which brings

her ability to manipulate lava flows to full manifestation – and she returns, empowered, to help the New Mutants defeat Selene.

Down but not out – for few villains in Marvel, and almost none at all in *X-Men*, are ever completely vanquished – Selene would make her way in time to New York, where she joins the Hellfire Club, reappearing frequently in the mid-1980s playing out the familiar tropes: she is a 'vampire' who will 'consume your soul' (both quotes from *X-Men* #189, January 1985). Still looking for a disciple, she will scream in #184 (August 1984), 'Embrace my darkness, Rachel, be one with me. Savor in full measure the joy of the hunt eternal… the ecstacy [*sic*] of -- the kill!'

Amara herself, as someone who drew her primal powers from the depths of the earth, was similarly a candidate for repeating so many images from the Dark Phoenix story. En route to America from her Roman home, this chaste Roman maiden is casually and unexpectedly kissed by Brazilian boys, prompting her to run in panic from such brazenness. Unused to the Rio sunlight, she becomes dazed. Phoenix actually consumed a star but, caught in the power of our own sun, Amara deludes herself as joining with it: 'Oh, Helios, lord of the sun, torment me no longer! Let my inner fire be joined with thy celestial glory!' 'Her wish is granted…,' the captions of the subsequent panel tell us, '…her humanity instantly consumed' (#12, February 1984). The art, which had previously been rigorously realistic, enters her confused mental state, depicting her as a giant figure standing over the city and causing a volcano to rise and destroy it: 'She sees nothing wrong or evil in this -- for a goddess should have her sacrifices. And besides, it's fun.' The whole sequence takes only a page, so while it may not be Claremont at his best, it is among the deftest workings out of a favoured theme. On the next page she feels 'a pit' gape open in her mind. At its bottom stands Selene, 'the black priestess…a mutant like Amara'. For Amara, who has not yet met Xavier, Selene is the only adult mutant she knows, the only potential role model, leading to a typical rejection of evil: 'I'm not like her! I won't become like her!!' The heartfelt cry resonates across subsequent issues when 'dark' alternative versions of the characters begin to proliferate.

If *X-Men* became regarded for its use of strong female heroines, *New Mutants* is notable for its female villains. As a series about young pupils, it was perhaps inevitable that Emma Frost's White Queen, the headmistress of another school, would become the central villain. A dark reflection of Xavier, she tampers freely with the minds of others. Her first major storyline is one which, even for Claremont, is dominated by female characters to a very large degree. Frost captures Kitty Pryde at her school, the Massachusetts Academy, so the mutants attempt a rescue, whereupon they are all captured – save for Dani and Illyana, who escape but must return to free their friends. The story also introduces the Hellions, the Hellfire Club's own group of teenage mutants-in-training, some of whom have powers which directly duplicate those of Xavier's students. Just as Illyana (who has been corrupted and taught dark sorcery – see discussion later in this chapter) is haunted by the Darkchilde, an evil persona which she may become as corruption spreads within her soul, so the whole team is shadowed by this dark inversion of themselves. Twice (#17, July 1984; #39, May 1986) things get so bleak that the New Mutants will, purely for their own survival, voluntarily join with the Hellions, transferring to Frost's school and taking on the uniforms of their rivals. In #49 (March 1987) a dystopian future has been brought about by an alliance between Xavier's school and the Hellfire Club. In this reversal of the familiar 'future past' scenario it is the mutants who rule, living in a hi-tech police state while non-powered humans are left in the slums.

Claremont's penchant for internal dramas found a partner in Bill Sienkiewicz (pronounced *sin-KEV-itch*), the comic's new artist from #18. His previous work on Marvel's *Moon Knight* and *Fantastic Four* had been noted for its dark blacks and expressionist leanings. Putting such a stylist on a comic which had previously trod the Marvel mainstream and involved the high jinks of adolescents rather than the twisted psychologies of criminal adults was a play for credibility in the fan market, where innovative visual styling was valued. *Don't Call 'Em X-Babies Anymore*, boomed the ads which ran in Marvel's comics to announce the new artist. It wasn't just the kids who were growing up – it was the comic itself. Sienkiewicz himself was in transition, throwing off the heavy influence of Neal Adams

which had marked his early work and mixing the traditional pencil and ink drawings of the four-colour comic with oil paint and other materials, creating collage effects as he juxtaposed different styles upon a given page. *New Mutants*' most compelling landscapes were abstract melds of internal and external space: alternate American plains, untouched by western hands but home to the Demon Bear, which psychically seeks Dani's death; the fractured mind of David Haller, which represents itself as war-torn Beirut; and Limbo, the demonic land which represents Illyana's soul. The characters would be forced to ever more extreme spiritual and psychological states to justify Sienkiewicz's off-centre compositions, decontextualised faces and heavy use of black ink. 'Demon Bear' soon found itself a fan favourite, perhaps because it is Sienkiewicz's most effective collage: a mass of black body, tinged brown at its furry edges with claws of white, and a mouth blood red. It towers above its 'badlands' environment, its eyes made up of varying visual effects as required (colour and size shift from picture to picture), while Claremont's favoured theme of creeping corruption is depicted in shaky, childlike grids where black marks on a white background represent 'areas of land consumed by Demon-Bear's shadow' (#20, October 1984), though how this map fitted against the environment depicted or the story being told is ambiguous.

Sienkiewicz pencilled *New Mutants* for a little over a year. His final story as primary artist took the team outside their own psycho-spiritual states to California. While the X-Men were finding San Francisco agreeable during this period, the New Mutants found trouble down the coast in a noir Los Angeles. Exploring the underside of the city which makes stars allowed Claremont to integrate Dazzler into his mutant universe.

Dazzler was a comic about a mutant, but by remaining divorced from the world of the X-Men (which she had declined to join) it had struggled to find a readership. The title character was Alison Blaire, a singer who dreamed of a career in music. After the comic was cancelled, *X-Men* editor Ann Nocenti had used the character in *Beauty and the Beast*, a 1985 four-issue mini-series. Her career as an entertainer in ruins once she has been publicly outed as a mutant, and hitting rock bottom, she becomes a gladiator in an underground

arena where LA's jaded rich watch mutants engage each other in combat to the death. These gladiators are more subcultural than other mutants, even the Morlocks: most of them are bipedal but otherwise inhuman, and they wear the disfigurements of combat as signs of distinction: 'We define what's attractive around here. I love scars. They do have a sort of disturbing... beauty.' Perceiving herself as wanted nowhere else, Dazzler is dragged further into this culture, adopting the role of the persecuted outsider to the point of dressing as a Native American for one performance. The series chronicles Dazzler's descent as she embraces the arena, partly because of drug-induced manipulation, but also because her weakness is a desire to be a star and this is the venue where she can be applauded. Nocenti's story ended with the apparent break-up of the gladiatorial ring, but she and Claremont brought it back for *New Mutants*.

Although her own comic had offered few of the moral agonies common in *X-Men/New Mutants*, Claremont, focusing on Alison's desire for fame, brought the metaphor of addiction to the fore. Phoenix had worried that she was becoming addicted to the thrills of her power, but other metaphors were more prominent. Dazzler, by contrast, is referred to many times as an addict and likened to a junkie. It is the primary metaphor of her struggles. The New Mutants seek to infiltrate the gladiatorial ring and Alison, already known there, is the obvious candidate, but, like all junkies, her friends no longer trust her. Indeed, she no longer trusts herself.

Addiction raises issues, but they are not visible here. For Claremont it is simply another term for the endless struggle against the weaknesses of the self. In line with the new ethos of 'tough love' and letting people fight their demons themselves, it is Dazzler who infiltrates the Gladiators, claiming to want a return to the spotlight just so that she can see if she has the willpower to leave it when required. 'She has to confront who and what she is,' Kitty Pryde opines. The writing and the stakes are familiar enough. Dazzler risks her 'soul' by returning, but triumphs eventually. More shocking is the revelation that the villain is the New Mutants' long-lost comrade Karma, now possessed by Amahl Farouk, the telepath dispatched by Xavier in *X-Men* #117 (January 1979).[5] Claremont's favoured themes had changed a lot over the years between Farouk's

appearances, and the villain was amended accordingly. In his original appearance Farouk had been a normal man. He was a bit overweight, and his neck had vanished under flab, but he was nothing outside the normal range of human appearance. He ran 'the thieves' quarter' of Cairo and his club offered 'manifold... delights.' No doubt he partook of some of those delights himself – upon his entry into the story, he was accompanied by two young women – but he had too much ambition and self-control to let himself be consumed by his vices. The story was a tale in the Lee/Kirby paradigm, a battle between Xavier and an 'evil mutant'.

When I compared *X-Men* #117 with #161 (September 1982) it was to contrast the representation of Xavier in the two appearances and to consider exactly what the comic was positing as a suitable 'origin story' for its themes. Here, we can draw out similar points by considering the changes in Farouk's character. Reincarnated in 1986, he is a sensual glutton, exhibiting all the worst aspects of his real-world namesake.[6] With his psychic identity lodged inside Karma, he indulges his greed, and their shared body becomes bloated and repulsive in the extreme, a physical grotesque beyond what the mid-1980s audience would have thought possible (though post-millennial obesity documentaries have sought to find bodies of this shape). In #29 (July 1985), anticipating a triumph, he orders 'a celebration -- nothing terribly fancy -- bring champagne and a light snack: caviar, squab, a roast'. Two issues later, he sits in his private box at the underground arena where mutants fight each other for their lives. Servants bring trays of roast food and beside him is a pile of discarded food, clean-picked bones and empty cans. This Farouk never rises, but squats and views events. Presumably he is transported between his various residences by a large team of carriers.

Power and profit are still part of Farouk's vocabulary, and presumably profitable crimes fund his life of consumption, but his major concern is with the corruption of innocents regardless of whether it will actually profit him. Where he once owned a small club, now he has larger venues: a combat arena and a nightclub, both of them packed to the gills with a mob of the decadent rich. 'Too rich, too bored, too desperate for their thrills' is how the crowd at the arena

are described. They are another Claremontian mob, animal-like in their lust to see blood. In the Pharaoh nightclub in Cairo, Farouk reflects of his patrons,

> They call this the most wicked place, my poppets -- and me, the most evil figure -- in Cairo. Yet they flock to Pharaoh. My club is always full. Regardless of what I do, they hurry back for more. Here, these pathetic fools dance a step or two over the line, into the shadow -- secure in the belief that tomorrow they'll be back safe and sound in the light. But they're wrong! I infect them with a taint they'll never be rid of, a corruption that will grow and grow until it rots their souls! (#34)

This is a new sort of villainy, like little we have seen before. Previous villains craved power or wealth while monsters sought to consume people as food. Farouk, by contrast, now enjoys the corruption of humans as an end in itself even if there is no obvious material pay-off for himself. Outside a brief flirtation with horror-themed comics in the 1970s, Marvel had rarely used such motivations. This is an unmotivated evil with near-theological implications, and it brings Claremont's use of religious imagery to the fore. The rest of this chapter considers that imagery, Claremont's recurrent use of the word 'soul' and the responses of Christian readers to these developments.

THE CLAREMONTIAN SOUL

In 1982, Marvel's prestige magazine *Epic Illustrated* published the first of several tales about a woman called Marada, nicknamed the She-Wolf, a swordswoman who lived during the Roman Empire. *Epic* was Marvel's response to *Heavy Metal*, a publication which reprinted artistic European comics on high-quality paper. The stories in both magazines were aimed at adult consumers, *Epic* being one of Marvel's late-1970s attempts to break out of the low price-point market which seemed to be permanently shrinking. *Marada* was written by Claremont with artwork by British artist

John Bolton. Like their cheaper brethren, the heroes of these magazines struggled against great odds, but the female characters consistently battled one obstacle which rarely bothered their male counterparts: the psychological trauma of rape. Whatever social value might be gleaned from any individual story, the repetition of the rape motif in the 'mature' market became tedious and distasteful. Marada's rapist was a goat-horned demon, a 'lord of the abyss'. As he penetrated her, some small part of his evil passed into her and she would need to be ever vigilant from that point on against this malign influence inside her: 'Y'garon took part of my soul and replaced it with a piece of his.'

No one was going to get raped by a goat-horned demon in a mainstream Marvel comic, but the emerging sexualisation of the characters in the 1980s allowed for the story to be reworked around Illyana, the younger sister of X-Man Colossus. In *X-Men* #160 (August 1982), six-year-old Illyana is lured to an alternative dimension called Limbo, where time and alternative futures overlap. The X-Men follow, finding themselves facing their own corpses in a reality where the rescue attempt has failed and they have all died, save an aged Storm, who has turned to sorcery as her mutant powers faded, and a Nightcrawler who has been made corrupt by Limbo's ruler, Belasco, a demonic figure who serves the Dark Gods seeking a passageway to our world. The corrupted Nightcrawler describes Limbo as a land where 'there is nothing to fear... but your own desires'. Young women in particular are the focal point of the desires that manifest themselves in the region. Nightcrawler gropes Kitty before asking the six-year-old Illyana, in the most forceful double entendre yet to see print in the comic, if she would 'like to... *play* with me'. Belasco himself plans that Illyana's adolescence will be one long preparation for a dark union: 'when you have grown into a woman and learned in full measure the arts arcane'.

The X-Men escape and return home, but a late twist finds Illyana momentarily vanishing into a wormhole and emerging, seconds later, aged 13. What happened to her in those seven years was signalled as a mystery for a year and a half. She refused to discuss the period with her friends, but readers learned the details in a four-issue *Magik* mini-series in 1983.

Magik is the story of Illyana's corruption, a familiar Claremontian theme, this time with sexual imagery closer to the surface. Her aged corrupter calls the six-year-old child 'delightfully pure and unspoiled' and Illyana talks of what she will be like once 'Belasco has had his wild, wicked way with me.' She is initially protected by an alternative version of Storm who practises magic and Cat, a semi-demonised Kitty Pryde. The small area in which she lives is a garden, a contrast to the blasted wasteland which Belasco has made of the rest of Limbo. The natural settings which had largely vanished from *X-Men* in the mid-1980s are central to *Magik*. Kitty's transformation into an animal has left her plagued with appetites she cannot control, though she retains enough humanity to plot her own resistance to Belasco. Drawing on the full theological connotations of a garden, Claremont situates action around a tree where Ororo teaches Illyana to resist temptation but Cat, more recklessly, promises knowledge. Upon discovering that Cat is plotting against him the demon lord draws the usual direct line from humanity to moral agency:

> I see now my mistake. I left you too human -- which, in turn, gave you a semblance of free will -- but that, fortunately, is easily rectified. *Cat* you are in name. Let you now become one in fact.

With Illyana's soul corrupted, there can be no final redemption, but only endless conflict: 'I cannot eliminate the magickal cancer that consumes her...,' Storm says, 'but I may be able to teach her to combat it.' The use of cancer as a metaphor is unusual, but everything else is Claremontian business as usual. The teaching Storm must give is the traditional taming of the id by the super-ego. As a six-year-old, Illyana naturally wants to do all nice things. Restraining one's needs in the face of the larger realities of existence is what she needs to learn, a natural process of growing up which is dramatised here in exaggerated terms. Illyana would change the flowers in the garden to suit her passing tastes, but Storm cautions higher patterns: 'To change things for the sake of change, to satisfy a whim, is Belasco's way. It is wrong. There is an order to the universe that must be respected.' In language which echoes the Savage

Land story discussed in Chapter I, she continues, 'You must act in harmony with nature, shape its forces gently to your will, not ride roughshod over them.'

With Illyana's return to our world she, now 13, must continue her battle against Belasco's influence within her in the pages of *New Mutants*. Just as other characters needed to constantly affirm their humanity against animal urges, so she must consistently prove that she is not a demon. As with Phoenix, the use of powers is a pleasure: 'I'd forgotten how good it feels to use them, how empty I am when I'm not' (#14, April 1984). Just as Phoenix became Dark Phoenix, so Illyana has another self, Darkchilde, a blood-red demonic version of herself with horns, a tail and cloven hoofs – the visual representation of what is within her soul. *Soul* is a word Claremont frequently uses in his comics. By my count it occurs 101 times in his four-and-a-half-year run on *New Mutants*, not including some associated words such as *soulsword* (Illyana's psycho-spiritual weapon) and *soulfriend* (Warlock's description of choice for his closest friends). What does he actually mean by it?

The battle for the Claremontian soul is ultimately an individual struggle. It has no wider theological context, nor could it have, given the comic's need to carefully balance the conflicting belief systems of the characters. It also needs to remain coherent with the wider Marvel Universe, where the meaning of death is largely elided except for certain attempts to square it with Norse mythology – which has been a metaphysical presence in the comics since Stan Lee built a comic around Thor, the god of thunder. Thus, although the team sometimes find themselves in a house of worship (a situation which always prompts anguished prayer or reflection) and sincerely and routinely appeal to God in a crisis, none of the team go to church for regular Sunday worship (and none of them has Nightcrawler's excuse of an alarming physical appearance) and no one suggests that a Christian exorcism might aid Illyana. All of this despite the fact that the supernatural imagery of the comic tends to push the characters' moments of self-conflict towards the Christian vocabularies of temptation and self-denial rather than the Freudian drama of the id and superego. We can relate this to wider theological elisions within the comics: the anguished breast-beating over whether the

Beyonder (the villain of *Secret Wars* and the most powerful being in the Marvel Universe) is God or not is only possible if the concept of God has been stripped of all moral or existential content and become merely a question of wielding mind-boggling power.

Devoid of any substantial theological content, the philosophy underlying Claremont's notion of a soul must be broadly humanist. Despite sporadic letters accusing him of writing non-mutants only as a bigoted mob, Claremont takes a generally positive view of human nature. His stories continually imply that humans are born with a capability for noble actions and that villains are those who have succumbed to darkness in difficult circumstances. Just as Magneto's villainy comes to be explained by reference to a tragic past, so a number of other villains can be celebrated for the people that they once were. Roberto da Costa's father is a millionaire industrialist, prepared to sacrifice anything (including potentially his own son) for more wealth, but his wife can recall 'the gentle, decent man he once was' and wonder, 'However will he find his true self again?' (#12, February 1984). Patrick Roberts appears, in #41 (July 1986), to be nothing more than a bigot, picking on Moonstar for her Cheyenne ethnicity, but they were once friends: 'inside him it's all turned to hate... because of what I did,' she reflects.[7] Presenting villainy in this way inevitably leads to solipsism in which actions in the real world – usually the main focus of an action-based superhero comic – retreat to the background while the integrity of the 'soul' is the major issue. When Roberts dies at the end of the issue, it is the tragic death of a young man not yet out of his teens, but we are meant to find great comfort in the fact that in his final hours he is reconciled with Moonstar, rebecoming the good person he once was. *The New Mutants* is littered with stories of this nature, often a single issue in length and focusing on one member of the team. In #42 we find Cannonball learning to curb his judgemental nature about his girlfriend's past as a thief, and a month after that the entire team go up against the hellion Empath in an interesting essay on the responsibilities of being a supervillain.

Empath's power is to amplify and manipulate emotions, usually negative ones, within people. His victims must fight the eternal Claremontian battle as primal feelings, amplified beyond the norm,

swamp their conscious selves. When Xavier elects to spend some time in space with Lilandra, he bequeaths responsibility for the school to the reformed Magneto. Empath permanently escalates Magneto's doubts about his fitness for this new responsibility, resulting in the closure of the school and the disbanding of the new mutants. Once the scheme is uncovered, the school reopened and the team re-established, the New Mutants, seeking redress, capture Empath before coming up against the rest of the Hellions. The Hellions don't like Empath any more than the mutants, but are bound as ever by an honour code to look after one of their own. Part of the story is Sunspot's anger. Roberto would happily kill Empath but does not do so at the crucial moment, and this refusal to sink to Empath's level is the victory which the comic celebrates. In wider terms, Empath is beyond the pale, even to his criminal teammates, because he attacks people in such a personal manner – warping their emotional states – rather than engaging in the traditional physical combat, and because he plays with people for his own amusement. Supervillains have superegos too, remember. The unwritten rule of the Marvel Universe, at least at this point, was that villains always worked towards world-shaking or self-enriching strategic ends but weren't callous or self-indulgent along the way. That the Hellions are the junior team of the Hellfire Club, an organisation devoted to increasing, by any means necessary, the wealth and worldly power of its core members, fades to the background of the issue. Their personal honour is asserted at various points as a contrast with Empath, who lacks their sense of right and wrong.

Regardless of the truth of the human condition – maybe a final resolution of these issues is possible – the ongoing nature of the series narrative means that no one's battle can ever really be won. The next temptation to lash out in anger or use one's powers for trivial personal gain at someone else's expense will soon manifest itself. If we cannot save ourselves, of course, this being the Marvel Universe, there are figures of phenomenal power to remake reality at will. They could remove the stains from our souls with little more than a click of their cosmically powered fingers, but would it be right? In the mid-1980s, Claremont addressed the theme several times.

This was perhaps in part because the creation of the Beyonder, and the corporate plan to use him in every comic several times in 1985 and 1986, presented a being with the power to restructure humanity at a fundamental level. Both *X-Men* #202 (February 1986) and *New Mutants* #36 (also February 1986) tie in to the *Secret Wars II* project in which the Beyonder comes to Earth, attempting to learn what makes humanity tick. In *X-Men*, he seeks to resolve Rachel's guilt for surviving the 'future past' holocaust which destroyed all other mutants by constructing a scenario in which she alone can successfully save the X-Men in San Francisco. She does save the others, but her awareness of the artificiality of the situation denies her any healing. In *New Mutants* #36, 'Subway to Salvation', the Beyonder turns to the even greater challenge of Illyana and removes all the evil from her nature, making her the person she'd be if Belasco had never captured her. She is understandably excited and rushes to share her good fortune with her friends. But, the issue asks, is Illyana's freedom from evil real if she hasn't earned it through moral choice and struggle?

The same question had been asked in the *X-Men and Alpha Flight* mini-series (1985). In this two-issue story, 'The Gift', the Asgardian God of mischief and lies, Loki, is required by powers higher than even Odin to do something good in order to receive a reward. He seeks to fulfil this requirement by bringing to Earth a fountain of fire, immersion within which allows a person to reach their 'ultimate human potential', thus transforming them into people capable of miraculous tasks: some become suppliers of endless food, while others become healers or swift constructors of tools and even buildings. Maddy Pryor's transformation into a healer of physical and psychic disorders even brings resolution to some of *X-Men*'s most prominent themes. Once she has ministered to Wolverine, he explains to a suspicious Kitty that Maddy 'burned the berserker madness out of my system [...] I'm *sane* now, I'm *human!*' The fountain promises humanity a golden age where physical deprivation – poverty, hunger and disease – has been abolished. Nightcrawler suggests that in a world where everyone wields such powers, mutants will no longer be feared and prejudice against them will subside. However, joy at this imminent transformation of human fortunes

('a new Garden of Eden') is shadowed by the realisation that the power behind the fountain is anathema to magical beings, thus as its influence spreads those touched by the supernatural, including Illyana, will die. Can the good of the many justify the sacrifice of the few? This impossible moral mathematics splits the teams down the middle, and battle ensues. One side tries to shut the fountain down, the other attempts to stop them, while the usual arguments posed by both sides of this familiar philosophical question are discussed. Since 'The Gift' is four times as long as the *New Mutants* issue, it has substantially more space to play out the moral arguments, though both articulate them within the usual Claremontian terms of personal choice. Despite the world-reshaping terms of the events in both stories, the focus is always on freedom to choose. The New Mutants refuse to join Illyana in using the Beyonder's powers to save souls. 'If you are happy, Illyana, that is wonderful,' says Shan. 'But I am content with my own beliefs. I feel no need to be part of yours.' In 'The Gift', when Rachel affirms the good that the Firefountain will do, Wolverine ripostes, 'Your choice, girl, your privilege. You've no right to make it for anyone else.'

Of course, Chris Claremont can't resolve these issues finally (any more than Marvel's sales department could countenance a Wolverine stripped of his berserker rages). With the moral arguments irresolvable, both stories can be concluded only by the discovery of new information which makes the debate moot and means everyone must reject the enlightenment on offer. Illyana's dark side has not been dissolved, but merely carried over to Kitty Pryde. The X-Men and Alpha Flight are made aware that the Firefountain also has a corrosive effect on human imagination and creativity, with the transformed beings only being able to produce basic materials. While a talented architect has been made a builder it has also robbed him of his capacity for original design: 'in the process, they lose the ability to dream -- that indefinable, transcendant [*sic*] something... that makes us *human*.' In the end, Loki is reduced to physical threats and emotional blackmail to try to make humanity accept his gift, but they turn away, repeating the usual Claremontian wisdom: 'One does not get something for nothing,' 'the best things are those we *earn*, rather than what we're given,' and Maddy's oddly theological

'I should have known my sins couldn't be wiped away so easily.' Rachel in *X-Men* #202 (February 1986) had taken the same view after the Beyonder's attempt to ease her survivor's guilt: 'It isn't that easy! You don't just *give* somebody that knowledge. If it's to *mean* anything -- if we're truly to learn, to grow, as individuals and a species -- it has to be *earned*!' This is a species-wide articulation of a point which is recurrently made in individual stories: 'You offer salvation. I prefer to make *my own*!' (Psylocke in *New Mutants Annual* #2, 1986).

There is a large claim being made here because, ultimately, all of these stories affirm the superiority of mankind over the beings of godlike power who occasionally visit the earth in the Marvel Universe. They can remake the physical world at will, grant our material needs and possibly even heal our psychological damage, but something about us continues to escape them. They cannot truly heal humanity because we have depths that they cannot know and we are, finally, better, deeper beings than they are capable of perceiving. When Claremont's notion of the soul isn't just a synonym for something like an essential self, it is this that he uses the term to refer to.

X-ISTENTIALIST X-MEN

Wolverine's comment 'Your choice, girl, your privilege. You've no right to make it for anyone else' expressed the wisdom of late-1980s *X-Men/New Mutants*. Perhaps the one word Claremont deploys more than *soul* is *choice*. It recurs at almost all major moments. Illyana is finally redeemed by the realisation that, as a teenager, she has something which her six-year-old self did not: 'You have a choice.' The idea of choice was implicit in a lot of early stories. If Wolverine does not sink into his animal nature, it is because he chooses not to. However, the ethical debate was rarely framed in those terms in the 1970s. In *X-Men*'s earlier years, morality was the control over one's own desires. Now, a decade later, it was more usually framed in terms of making the right choice when presented with hard possibilities.

In #203 (March 1986) of *X-Men* the team have fought and been beaten by the Beyonder. In their own comic, the New Mutants have done no better. Indeed, it is clear that no amount of superpowered heroes can defeat the Beyonder. Humanity – and everything else – exists merely at his whim, and universal destruction will undoubtedly come as soon as it crosses his mind to enact it. Despairing at this situation, Rachel, her powers amplified, transports the X-Men to the M'Kraan crystal, the mystic gem which her mother, the original Phoenix, once used to repair the fabric of the universe. Rachel, by contrast, declares her intent to unleash the neutron star contained within the gem, destroying the universe but taking the Beyonder with it, so that whatever life can spring up from the remaining void will have a chance to exist without him. (The infamous declaration 'We had to destroy the village in order to save it,' supposedly spoken by an American major during the Vietnam War, haunts a number of *X-Men* tales, most notably this one.) When challenged about this plan, Rachel asserts, 'I have no choice,' only to be told by an angry Storm, 'You *always* have a choice.'[8]

For the happy resolution of the stories, the permanent availability of choices must be a liberation, as it is for Rachel when she realises that she doesn't have to destroy the universe. In this respect, it may represent the biggest weakness of Claremont's dramatisation of moral philosophy. His characters do always have a choice. No one has been so broken by their weaknesses as to lack moral agency. The notion of the 'addict' may play itself out around Dazzler and her desire for stardom, but she is not someone who has become physically dependent on a substance to the point where it robs her of the capacity for ethical action. The only figure so compromised was Jean Grey, someone caught in a cycle where the acceleration of desire required larger and larger power rushes simply to maintain pleasure levels.

In the postwar West, the most prominent philosophers of the question of choice were part of the movement known as existentialism. Although the philosophy has historic roots, it has become inextricably associated with the west bank of the Seine and, decades later, it remains central to popular images of what it meant to be a Parisian intellectual. The existentialists of the 1950s and 1960s

began from the proposition that 'existence precedes essence'. In believing this they argued against the grain of Western philosophy which had searched for an inherent nature of humanity. If all humans are rational beings, or fallen beings, then humanity would be said to have an essence. You and I, upon our birth, would take on the blessings/curses of these qualities. We would have no choice in the matter. The essence of humanity precedes our actual birth, and we have to fall in line with it. In the West, the search for a human essence was escalated by Christianity, which not only had a definite view on the nature of man but an Old Testament which asserted several times that our benevolent creator, God, knew our identities long before we were granted material existence: 'Before I formed you in the womb I knew you' (Jeremiah 1:5). In renouncing essence, the existentialists cast us into a universe where – with no human nature to determine or excuse us – we were forced to take absolute responsibility for our choices.

X-Men had always had such a thrust to it. Wolverine and the many others who seek to retain their humanity against forces which would turn them into animals are making existential choices. Magneto becomes a significantly existential figure once his character is rethought as a man who has become conscious of the fact that he has spent his adult life acting violently as a reaction to the violence done to him. He elects instead to become a man who rises above the traumas he has suffered to make his own serious moral decisions. However, it was during the editorship of Ann Nocenti between 1984 and 1988 that the existentialist vocabulary of choice became the dominant way in which ethical debates were framed. As a writer, Nocenti had created Marvel's most openly existential hero in her six-issue mini-series *Longshot*. This mullet-haired hero had been stripped of his name and memories and so was forced to forge an identity purely by the choices he makes when thrust into situations which he barely understands. Uncovering the truth of his origins, he confronts the geneticist who made him only to be told 'Existence precedes essence -- stop *living* like a slave and you no longer *are* one' (#6, February 1986).

After his mini-series, Longshot was incorporated into *X-Men*. He fitted there because the comic's themes of mutation led necessarily to

an interest in science's rapidly advancing understanding of genetics. The cloning of even animals was still a decade away in the real world, but the Marvel Universe was one where science – particularly as practised by shady villains in hidden laboratories, far from public view – was significantly advanced compared to our own. Characters that had not been born but grown from small amounts of genetic material became common. Were such creatures human? Do they have 'human nature' (whatever we think that is)? Or are they blank slates, existences without imbued essences?

The comics had a ready existential answer. With *New Mutants* #55 (September 1987) Claremont took a six-month sabbatical from writing the comic, a departure which became near-permanent. #55–60 (written by Louise Simonson, with Nocenti editing) continued to lay out the existential understanding of selfhood. In these issues, a deranged scientist, Dr Animus, splices human DNA with that of animals in order to create new creatures, the Ani-mates. Many of the characters are at the border between human and animal – not just the Ani-mates, but Animus himself, who wears the skin of a leopard in the hope that some of the beast's 'ferociousness' will transfer to himself – and when at the end of this run of issues the Ani-mates overcome their deeply ingrained fear of Animus and join the mutants to defeat him, it falls to Sam Guthrie to recite the house moral: 'Makin' *choices* is what makes you a *man*. [...] *You* comin' ta *our* rescue [...] makes you *Ani-mates* more human than a lot of folks.'

Whatever else we might say of it, the new vocabulary of choices was what *X-Men* and *New Mutants* needed to unite their two major themes: the moral agency of people and the 'mutant prejudice' plot. The late-1970s vocabulary had emphasised self-control, consistently labelled 'desire', as the road to monsterhood and defined heroism in terms of the suppression of those aspects of humanity which needed to be denied full expression. By the late 1980s, that sort of formulation had been politicised. What did those gay fans of the 1970s *X-Men* make of the equation drawn by Claremont and Byrne between Jean's ongoing corruption and her increasingly sexual appearance? Did they agree that our appetites required suppression? No one asked these questions in print back then, but

a decade of social activism would see the 1970s lexicon rendered problematic given the comic's affiliations with cultural subgroups of all types. In the mid-1980s, *X-Men* and *New Mutants* adapted its vocabulary accordingly.

Of course, not everyone who read *The New Mutants* was an existentialist…

CHRISTIAN QUESTIONS

However vague Claremont's idea of the soul was, and however often its theological overtones disappeared under closer scrutiny, *New Mutants* remained a comic with significant religious content. The young characters often prayed, appealed to the Lord or contrasted their own hectic and dangerous lives with the serenity of Heaven. As we have seen, early correspondents were keen to include religious affiliation as part of their discussion of cultural influences upon the core characters, and the topic would become recurrent on the letters page. Like its parent title, *New Mutants* printed letters with more candid self-expression than other comics and, more than any other Marvel comic of the period, it printed letters from readers self-identifying as Christians and wondering about the beliefs of the characters. Given its religious vocabulary, *New Mutants* was potentially appealing to young Christians forming their own identity and responses to 'temptation'. Several letters printed on the correspondence page suggest that this was the case. This example is drawn from #38 (April 1986), the letters page of which is unusually dominated by religious themes:

I was born and raised in a small town in western North Carolina. Before I was eight years old, we lived in a two-room shack with no indoor plumbing. I grew up in a very conservative Baptist church. As I grew older, I began to question many of those teachings. When I received a scholarship to Wake Forest University, I remember my first semester: I had Intro to Philosophy and Intro to New Testament. It took me two years to put my value system back together with any coherency.

For others, the issue was not their personal identification, but the overall ideology of the comic. In #22 (December 1984), Peter Bishop had an urgent tone:

> Dear Mutant-Makers
>
> I want to know if Lilandra, Professor X, and the New Mutants are Christian. I know Rahne is, since it said so in NEW MUTANTS #12, but what about the others?

At this point, it was a question simply answered:

> Lilandra is not, Peter. Professor Xavier has never volunteered such information and we deemed it impolite to ask. Rahne is – as you said – and so is Sam Guthrie. Roberto da Costa and Xi'an Coy Manh (Karma) are Roman Catholics, Danielle Moonstar hasn't said, and Amara Aquilla most definitely is not. She's a pagan.

Another correspondent, Rick S. Jones, observing in the same issue that 'just like Americans or Russians or liberals or any ethnic group you care to name, there are also good and bad Fundamentalists', was bang on message, the editorial response simply being 'No argument, Rick, to either point.'

The discussion of Christian values, however, shifted significantly when two narrative developments took place. One was the inclusion of demon-sorceress Magik/Illyana (from #14, April 1984) and the other was Psyche's recruitment – in *X-Men Annual* #9 (1985) – into the legion of the Valkyries, the Norse gatherers of the slain. Both of these narrative turns invested the comic with a heavy dose of supernatural imagery. Although Illyana's story, as I have discussed, entailed a good amount of Christian imagery and themes, her trajectory was a source of concern for reader Lennie Markwik, another correspondent to #38:

> I'm a Christian and a comic book lover [...]
>
> Illyana controls demons. That is wrong. Man cannot control them, *demons can control man*. Just like they control Illyana, they can

control you when you write stories about exorcism and demons. I am not in anyway [*sic*] saying you are possessed but I am saying that when you write about it and I buy it, we give them, in a way, our support. That is wrong.

The editorial response was a deft merging of the comics' two big themes: the 'good and evil in the human heart' plot and the prejudice one:

it may be that you miss the point with Illyana. True, her magickal power derives from a source that is the most foul evil – but what, we sincerely hope, makes her noble and truly heroic is that she fights that negative influence. She is a creature of the Shadow trying with all her strength to climb into the Light [...] She may fail – she may be condemned and consumed – but it won't be because she didn't try. Is that wrong? Should she be condemned, and abandoned, simply because of what she is, ignoring what she's trying so hard to be? Is the label the only thing that matters, not the person inside? The answers to those questions, friend, might give you a clue as to what the NEW MUTANTS and X-MEN series are really about.

I suspect that the reader in question didn't need a 'clue' as to what the comics are about (frankly the response is a bit patronising). He probably knew very well. What he and other correspondents were looking for, I think, was a way to reconcile their Christian faith with their enthusiasm for a comic increasingly populated by supernatural imagery. How easy that reconciliation would be varied with individual interpretations of faith. Reader Richard O'Bryan, letter published in #74 (April 1989), clearly struggled. He began with a broad overview of the Marvel Universe which, he felt,

seems to be infatuated with the world of demons. [...] Now, I'm no religious fanatic, but I do believe in God and the Devil and regardless of whether or not you do, the subject is not one to be taken lightly. Marvel is not only exposing its readers to demons, there is also paganism, i.e.: Greek gods, Norse gods, Egyptian gods, Indian gods etc.

Ever since the company had reimagined the Norse thunder god Thor as a superhero in August 1962, Marvel had incorporated heroes from ancient mythology into its universe, and this was generally uncontroversial. Generations of Christians – nominal and enthusiastic – had found no contradiction between a faith in Jesus and an enthusiasm for the classical world, and Marvel kept the exact nature of these powerful beings vague. They lived in powerful places (Asgard, Olympus) accessed by abstract means, but took little interest in the day-to-day life of planet Earth. Their existence was said to be dependent upon the worship of mortals, but they made no moral pronouncements and what human spiritual needs they fulfilled was never explored. Whatever these characters might have meant to ancient societies, the West had simply integrated them into the worlds of scholarship and entertainment as uncontroversial figures. Such they might have remained but for the rise of America's highly visible evangelical community, which emphasised Christianity's supernatural dimensions, and the near-simultaneous revival of interest in paganism, which invested the figures of myth with greater relevance. In 1962, when Thor was introduced as a Marvel hero, few if any Christians would have worried that the representation of Asgard would stimulate interest in pagan spirituality. The 1980s, however, had seen a resurgence of interest in paganism, and its symbols had become more culturally powerful. This was a concern for some, and *New Mutants* is where those concerns, rightly or wrongly, registered on a Marvel Comics letters page. After his discussion of Marvel's pagan heroes, O'Bryan moved on specifically to *The New Mutants*:

> Recently Illyana attempted to communicate with her supposedly dead brother Peter with necromancy. Necromancy is a satanic ritual [...] I don't believe in sheltering society from these subjects of demons, paganism and mythology, but they have a place to be learned [...] Illyana is supposed to be one of the good guys, yet we find her constantly dabbling in Satanism and/or the occult [...] And in the midst of all this, is there ever a mention of God or Jesus Christ? No, there isn't. Why not?

There is a clear escalation of tone across the years. Peter Bishop sounded urgent, Lennie Markwik concerned and Richard O'Bryan confrontational. This reflected the more hotly contested social sphere of 1989. Christian claims to be the definitive response to spiritual questions met with a harder response than previously when another reader responded to O'Bryan's letter in #78...

> Religions should not concern themselves with comics. What Mr. O'Bryan doesn't understand is that the world consists of more than one religion. No-one should have the right to choose what books people should read [...] only the most insecure people would worry about what people read and how it will affect their religion.

By this point, Claremont had left the comic, and Louise Simonson was writing less intense stories. Seeking to emphasise the youth of the characters – which she felt had been lost – she wrote less about souls and resolved the Illyana storyline, returning her to preadolescent, pre-Belasco innocence. Ironically, by the time this culture war broke out on the letters page, much of the imagery which had provoked and/or intrigued Christian readers had been dispensed with. It might never have returned, but when the creative team fell behind schedule, a fill-in issue had been arranged for #81 (November 1989), and an old, unused Claremont story was pulled from the files. The story, 'Faith', had been announced over four years earlier on the letters page of #30, but for whatever reason had never appeared. Presenting it four years after its initial completion required that a three-page framing sequence be added to anchor the story in current continuity. A number of the characters featured were no longer members of the team, so it had to be presented as a flashback. The issue, then, features two distinct religious dilemmas, one in the original story and one in the framing sequence.

The original story deals with the difficulty of sustaining faith in a secular world. Amara Aquilla was raised in Nova Roma to honour and worship the Greek gods (in their Romanised form), but in contemporary America they are no longer regarded with awe. When Amara watches a film in which Hercules is played for laughs, she reflects:

My father sent me to America... to learn of the modern world...
beyond our ancient, hidden land. Would he have done so, I wonder,
had he known that one of my lessons would be... how to mock
my deepest beliefs?

This is a real question, and the correspondent quoted above who
had his belief system shattered by the teaching at Wake Forest
University might well have empathised. Hearing Amara's ago-
nised prayer, Zeus sends Hercules to bolster her faith. However,
Hercules' initial attempts to prove his divinity by acts of strength
are disregarded because all such acts can be replicated by Amara's
non-divine mutant teammates. Equipped with her own version of
the Claremontian superego, Amara views Hercules' riotously pagan
lifestyle of carousing and drinking as simply more evidence against
him. The two of them leave the school and head to New York, where
they rescue some children from a burning building only to find that
one has inhaled too much smoke and cannot be saved. In the face of
the teenager's death, Hercules proves his divinity to Amara through
evidence of his compassion and moral feeling. However, the incident
having forced him to face his own doubts about his worthiness, he
prefers that they become friends, rather than god and worshipper,
until such time as he becomes worthy of her adoration. There is,
perhaps, an element of secularisation here (in the shift from worship
to friendship), albeit one which is open to renegotiation at a later
date (since Hercules would presumably accept Amara's worship
once he felt himself worthy of it), but that is not the major narra-
tive operation here. The story requires a resolution, but Claremont
cannot solve the dilemma of faith in an unbelieving world, and so
deploys a strategy long familiar in popular culture's discussion of
'issues'. It personalises them. Amara's feelings of doubt are quelled,
but in a way which has relevance only to herself, not in a way which
resolves the broader questions.

The same operation is at work in the framing sequence. By the
time 'Faith' saw print, Amara had left the New Mutants and had
returned to Nova Roma in Brazil with Empath as her love interest.
In the framing sequence, he has gone to attend a Catholic service,
and while she awaits his return she ponders that church's claims

to be the exclusively true religion; 'Why one church, one supreme being, to the absolute exclusion of all others?' When he returns, on the last page, she cites her encounter with Hercules as evidence of the existence of gods other than Yahweh. Empath cannot provide similar tangible existence of his God's existence, but turns that into a plus point, arguing,

> As you say, you've met your gods. You have *proof* of their being, and even their so-called divinity. How *easy* then for you to believe in them. I, however, have nothing *but* my belief. My faith. Which then, I wonder... is truly the stronger?

The question has shifted over the course of the sequence from a theological one – can two distinct religious systems be simultaneously true? If not, which (if either) is correct? – to a personal one which contrasts the relative strength of two people's beliefs, a matter which reflects little more than their own internal psychology. Why can Empath claim no evidence of his God's existence? The question has multiple answers. Marvel offends few people (though, as we have seen, there were some) by writing stories about Hercules as if he actually existed because no one thinks that the company is seriously making that claim. Empath's God, however, still commands massive belief and is, thus, a controversial representation.

Is there a Christian reading of Claremont to be gleaned from this? Christian readers would find satisfying the emphasis on moral decision making. Depending on how they understood their faith, the 1970s vocabulary of self-control and containing one's desires might well have been relevant. Ultimately, however, a Christian reading would turn on the question which powered so many of his stories – how can a tainted person achieve a purifying redemption for their past actions? Christians would agree that this is life's fundamental question, and it is the one to which Christianity claims a final, conclusive answer. There are all sorts of cultural reasons why an endorsement of Christianity could not be included in the comic: Marvel had no taste for the controversies which inevitably followed that sort of representation, and an unquantifiable (but surely sizeable) percentage of the readership would not have

accepted it. Beyond those concerns, however, was the simple fact that Claremont told stories about the agonies of those seeking redemption. Nothing would bring his writing to a close quicker and more definitely than the revelation that all those agonies had been lived already in the person of Jesus and individual redemption required not some act of painful battle or self-will, but only the quiet acceptance of that fact.

*

As my switching between comics in this chapter implies, the narrative and themes of *X-Men* and *The New Mutants* were closely tied. When Claremont handed the scripting duties of *New Mutants* to Louise Simonson in 1987 it was so that he would be free to work on other aspects of the X-universe as it continued to expand. More mutant titles would be added and bigger storylines required as Marvel continued to exploit its most popular characters. The narrative links between those titles would become tighter still with the development of the X-crossover, stories that were told across all of Marvel's mutant comics.

THE HARDER THEY COME...

The Uncanny X-Men #210 (October 1986) to #279 (August 1991)

Central X-Men in this period: Wolverine ('Logan' – enhanced senses, healing ability), Storm (Ororo Munroe – weather control), Rogue (Anna Marie, who absorbs the power of others by touching them), Dazzler (Alison Blaire – converts sound into light for laser beams, blinding light-bursts, etc.), Psylocke (Elizabeth 'Betsy' Braddock – telepath), Havok (Alex Summers – fires blasts of plasma energy), Longshot (unconsciously alters probabilities, making him the luckiest man alive), Gambit (Remy LeBeau – generates kinetic energy which he transfers to small objects, turning them into energised projectiles). Many other superpowered characters appear as the storylines fragment into multiple strands. Professor Xavier returns from space towards the end of this period.

Team rosters and plot synopses become difficult, with members coming and going as large, heavily promoted 'event stories' change the situation, and the corporate desire for spin-offs sees team members leave to populate other mutant-based comics. New villains, the ultra-violent Marauders, slaughter the Morlocks before turning their attention, unsuccessfully, to the X-Men. Storm's powers are returned to her and, facing powerful new threats, the X-Men take advantage of their apparent deaths on worldwide television to hide out in Australia with new, magical allies. Madelyne Pryor – Cyclops' wife, now a narrative inconvenience in the wake of Phoenix's resurrection – is manipulated into becoming a villain, the Goblin Queen, and is written out. Genosha, an island in the Indian Ocean where mutants are kept as slaves, becomes a recurrent point of conflict. As the X-Men increasingly face hardbodied foes with cybernetic enhancements, the story arcs grow longer and more unwieldy than ever. After a long period travelling the earth, the team reassembles back at its traditional home, the mansion of Professor Xavier, who himself returns to Earth after a long period in space as consort

to Lilandra, ruler of the Shi'ar Empire. New artist Jim Lee made it a comic people not only read but talked about again, but how many auteurs can one comic possibly have?

Headlines were made in the second half of the 1980s by a stream of action cinema heroes often referred to by commentators then and now as 'hardbodies'. Films such as *Lethal Weapon* (Richard Donner, 1987), *Die Hard* (John McTiernan, 1988) and *Cobra* (George P. Cosmatos, 1986) depicted aggressively masculine cops cleaning the streets with violence, while *Rambo: First Blood Part II* (George P. Cosmatos, 1985) and *Missing In Action* (Joseph Zito, 1984) cleared up the unfinished business from the Vietnam War (which apparently wasn't over; there was still time for America to win). The hardest bodies of all were *The Terminator* (James Cameron, 1984) and *RoboCop* (Paul Verhoeven, 1987), the former a cyborg, the latter a fusion of man and machine. Some of these films were advertised in Marvel's comics, implying a presumed shared audience, and the company produced a RoboCop comic in the early 1990s. Most of them generated sequels, ensuring that their imagery and themes resonated across popular culture for many years. Marvel's own contributions to this zeitgeist were the resurrection of its own gun-wielding cyborg, Deathlok the Demolisher (who had originally been featured between 1974 and 1977 but was given his own comic again from 1990), and the increased use of the Punisher, a vigilante who fought crime from his hi-tech, weapons-packed van. Created in 1974 as an anti-hero antagonist for Spider-Man, the Punisher – real name Frank Castle – saw the world in black and white (the only colours he used on his costume/combat suit) and killed criminals without remorse. In issues of *The Amazing Spider-Man* and *Daredevil* in the 1970s and early 1980s, Marvel would contrast his attitude with that of the more liberal title characters. The stories were on the side of the latter, of course, but beneath the moral surface the company was having it both ways – condemning the vigilantism while investing the relevant stories with the frisson of excitement which the character provided. The Punisher crept ever closer to the Marvel mainstream during the Reagan decade, finally

getting his own comic in 1987. A second, companion title (*Punisher: War Journal*) debuted the year after that, and a third, *The Punisher Magazine*, in 1989. That same year he was brought to the screen in a poorly received film directed by Mark Goldblatt and starring one of the hardest-bodied action heroes of the period, Dolph Lundgren.

Cultural critics have related the appearance of these hardbodied characters to the emergence of the vocal New Right in American politics, which wished to reverse many of the social changes that had taken place in the preceding two decades. The emblematic figure of the movement was Ronald Reagan, the Republican president for eight years from January 1981. Hardbody films valorised a strong individual body just as New Right rhetoric valorised a strong body politic, one free of the weaknesses which they claimed 20 years of liberal reform and federal expansion had encouraged. Heroes like Rambo or the Punisher fought villains who were similarly muscular, because one of the reasons America was told to toughen up was that its enemies had not grown soft on welfare and misguided compassion and would overtake the nation if it did not change its ways. Reagan was celebrated by the New Right as a man who acted forcefully and had not, as the nation had under President Carter, lost its way in the introspection of the post-Vietnam era.[1]

The Uncanny X-Men was not an obvious home for New Right rhetoric. It enjoyed a liberal reputation among fans for allying itself with those who were being pushed to the social margins outside the Reaganite norms. The characters doubted both themselves and their place in society. They hoped that the country might improve, but did not presume to speak for it. All of these values kept the comic largely insulated from fan debates of the 1980s about whether superhero comics endorsed vigilante violence. However, while *X-Men* could be excused, and *The Punisher* written off as the disreputable end of the market, fans could not be unaware of the vigilantism apparent in the two most acclaimed comics of the mid-1980s: *The Dark Knight Returns* (1986, Frank Miller) and *Watchmen* (1986–7, Alan Moore and Dave Gibbons). In Miller's four-part series, an aged Batman comes out of retirement to save a post-apocalyptic Gotham City which is sinking under the weight of mutant perverts and psychobabbling liberal reformers. *Watchmen*

featured diverse superheroes, including the unlikeable and violent Rorschach. Though psychologically damaged for sure, this character was propelled to hunt injustice by a moral purpose otherwise largely absent from the world it depicted. Despite the trumpeted liberal intentions of the authors, these characters were capable of multiple interpretations. These comics did not condone vigilantism, but they got their energy and much of their appeal from its representation.

This was the comics environment within which *X-Men* was produced, and it could not ignore these developments. Claremont continued to treat aggression as a sad fact of human nature requiring self-control, notably in a run of issues in 1988 and 1989 where, having joined the X-Men, Scott Summers' brother, Alex, consistently lashes out angrily and impetuously at supervillains as a result of strains in his complicated personal life. As ever, however, it was Wolverine around whom questions of violence would be most consistently played out. The character shared his 1974 creation date with the Punisher, and few could deny that Wolverine's metallic claws and aggressive traits, however constrained by the narratives surrounding him, had played a large part in the comic's popularity. Marvel was still required to find a midpoint which balanced the desires of many fans to see Logan lash out with the company's sense of what was suitable for a comic with pre-teen readers. Whatever attitudes Claremont might take, the characters belonged to a wider comics culture which might make links he would hesitate to forge. Thus, in 1989, the third edition of *The Official Overstreet Comic Book Price Guide* – the period's definitive text on the grading and pricing of comics – came with a cover depicting Wolverine and the Punisher with their backs literally to the wall as bullets fly around them. They're seemingly working together, apparently morally equivalent. It's hard to imagine Claremont endorsing that. He was always happy for other Marvel heroes to guest star in *X-Men* for an issue or two – Spider-Woman, Spider-Man, Captain America, Doctor Strange; the list goes on – but the Punisher is noticeably absent from the list. Indeed, in the pages of *X-Men* itself, a critique of sorts was assembled as hardbodied characters appeared frequently in the role of villain and the X-Men agonised, as ever, over what to do about them. Villains had traditionally been named

for their powers (Magneto, The Vanisher, Pyro, etc.), but from this point on many take code names which reference their capacity for violence: Bonebreaker, Skullbuster, Hardcase. Claremont was never going to agree to Reaganite rhetoric, but, as the resurrection of Jean Grey showed, he no longer had total control over the comics' direction – and in pitting his characters against the hardbodied, he set the scene for others to make the argument that they must become hard themselves.

The first of two hardbodied teams to appear had their origins in Jim Shooter's early-1980s assertion that Wolverine had never killed anyone. The Hellfire Club guards who had been apparently cut down in #133 ('Wolverine lashes out!' the cover copy in May 1980 had roared) were brought back in #151 and #152 (November and December 1981) having been mechanically enhanced. They return – this time with reinforcements and no longer playing second billing to the Hellfire Club's mutant Inner Circle – calling themselves The Reavers, a team made up of villains who have felt the cut of Wolverine's claws somewhere in their misspent criminal lives. They want revenge, upgrading the technology now enveloping their bodies after every failed encounter. They first appear in this form in *X-Men* #205 (May 1986), a stand-alone Wolverine-only issue which bears no relation to anything going on in the issues surrounding it. Logan first appears naked (as usual, when stripped of clothing he has also been stripped of his humanity and reverted to near-animal status) running through a December snowstorm, instinctively seeking escape while his healing factor rebuilds his mind and body. Once the healing process is complete, battle commences, notably against Yuriko Oyama, another one of Logan's Japanese adversaries, who, renaming herself Lady Deathstrike (or occasionally Deathstryke), has had her body rebuilt with unbreakable bones and claws which have a longer reach than Logan's own. If the story begins with the traditional threat to Logan's identity (that he might become bestial), it ends with him talking about how his humanity has been violated not by his animalistic nature but by the technology imposed upon him: 'Lacing my bones with adamantium an' giving me these claws -- that was done to me. But -- you asked to be changed. You did this to yourself. Threw away a humanity I'd give pretty near anything

to possess.' Technology, not nature, has become the threat to his identity as a human being. Some of the technologically enhanced villains feel the same tensions. Yuriko intends to be converted back to normal once she has killed Wolverine, but even Spiral understands the irony here: 'This so-called "humanity". To dream of regaining it through the murder of another.' As ever, there was Claremontian agony to be played out here, with villains occasionally reflecting that while hunting Wolverine in this way they were eroding their own selves.

Although the Reavers would become recurrent foes, more immediate impact is made by the Marauders. *X-Men* renewed itself every few years by changing direction and I have discussed how these shifts were invariably accompanied by the appearance of a new mutant group which incarnated the new focus. The Hellfire Club, though not actually new, were promoted to lead villains because their political influence meshed with the X-Men's early 1980s battles in the corridors of power. The Morlocks reflected a new interest in subcultural identity in urban centres. As the themes shifted, previous mutant villains, such as Magneto – or, now, the Hellfire Club – were redeemed or brought into a loose alliance with the X-Men to battle the new threat. The Marauders, a vicious group with large guns and often bionic enhancements, represent violence and brute strength. They target all other mutant groups, rendering divisions between the X-Men, Hellfire Club and Morlocks moot, and in doing so realign the oppositions which had structured the book since #150 (fully five years earlier). The comic was shifting again, and, apparently incidentally, it created a new brand of story: the X-crossover.

Claremont felt there were too many mutants in the Marvel Universe. Wishing to reduce the number to a more manageable level, he elected to dispose of the Morlocks. Once he'd envisaged a slaughter of the underground mutants by the Marauders, Claremont's story grew, particularly after he had explained it to his closest friends at the company. Those *Marvel Fanfare* caricatures of him explaining his upcoming projects at length to colleagues were, by all accounts, based on genuine behaviour. 'Chris was telling me the story,' Louise Simonson would later remember. 'I thought it

was a really cool idea [...] What if we do this massacre in New York City and make it a big event and I'll tie into the story in *X-Factor* and *Power Pack*?'[2] Ann Nocenti, Claremont's editor on *X-Men*, incorporated *Daredevil* – which she wrote – into the story, and Simonson's husband Walter similarly brought *Thor* to the scene. Claremont himself was still writing *The New Mutants*, and naturally involved them as well. These other characters would enter at the edges, encountering a portion of the event, but it would be centrally told in *X-Men*. This collusion between Claremont and Simonson merely escalated a tendency long visible in *X-Men*. Claremont had always liked to cross characters over from other comics he was writing (*Iron Fist*, *Spider-Woman*, *Man-Thing*), but now that he was writing nothing other than mutant comics he had no outside source to draw from. Instead, he turned to the work of his friends. Simonson's *Power Pack* had already appeared in *X-Men* #195 (July 1985) and #205 (May 1986). The X-Men, New Mutants or members thereof crossed into *Power Pack* even more frequently (#12, #19, #20, #27, #33, #35, #40, #42 and #44). Nocenti's Longshot also joined the team at this time.

With full-page ads in Marvel comics showing which issues of which titles were part of the story and the chronological order in which to read them, the mutant massacre unwittingly set a pattern for what would subsequently become the Marvel norm: a coordinated event crossing over between all the mutant comics and seeping into other titles as well. To those who felt that *X-Men* had become too grim, the announcement of a major storyline entitled 'The Mutant Massacre' probably didn't appeal, and the cover of #210 (October 1986) may have confirmed their worst expectations. The team are pictured against a grey background, shadowed and aggressive. Wolverine has his claws unsheathed. The cover writing gives us the Clint Eastwood-esque *C'mon, mess with us -- make our day!!* Inside, things are more interesting. The X-Men are actively considering the grim world in which they have been recently living. When Nightcrawler is cornered by an angry mob spouting anti-mutant hatred, Colossus does not – as the cover might suggest – go on the physical offensive but instead attempts to reason with the mob, although it is Kitty's subsequent speech about Nazis

and racists (discussed in Chapter III) which shames them into dispersing. Asked why he has chosen this riskier strategy to rescue Nightcrawler, Colossus replies, 'You are not the only one who felt that what we do -- our being X-Men -- was losing meaning and purpose.' Nightcrawler is unable to teleport because he seems to have lost the ability, and the next issue finds him consoling himself with Wolverine: 'some pair, ja? So bashed and battered we're pretty much useless.' Wolverine's healing factor is taking longer than usual to repair his body, and as he walks listlessly round the grounds of the X-mansion, it is clear that the cause is psychological. The complaints of some fans about a lack of direction and violence in the comic had self-reflexively entered the storyline. Meaning and purpose are subsequently tested hard by the Marauders, who enter the sewers of New York and slaughter hundreds of the Morlocks, but their presence allows the X-Men, over the course of several issues (#210–16), to rethink their mission.

For those who wish to be critical of action narratives, this arc may seem an easy target, a distasteful case of regeneration through violence of the sort which some find all too common in American culture. The comic does not see itself that way. Marvel was always conscious that their duelling heroes and villains might appear morally equivalent, and worked hard within the story to differentiate them on a moral level. Aside from the physical threat, the challenge of the Marauders is that they will drag the X-Men down to their level. #211 ends with Storm, her face in shadow, dispatching Wolverine deep into the Morlock tunnels to find the killers and bring one back for interrogation: 'One prisoner is sufficient. The remaining Marauders are yours.' The promise to readers – the hook to bring them back next issue – is that of Logan letting rip. Even the most blood-hungry reader, however, understands that the comic is posing a moral dilemma here: will the X-Men become killers like those they face? With Logan venturing into the heart of the darkness, it is only appropriate that he meet his most vicious doppelganger yet in #212 (December 1986): Sabretooth. While several of the Marauders use technological weapons, Sabretooth is a mutant with a healing factor, sharp claws and unbreakable bones. The comparison to Wolverine is obvious and, like Wolverine, Sabretooth is a primal force of nature.

He is humanoid, but covered in body hair as if he is less evolved, a throwback to prehistoric men just as his name recalls the sabre-toothed tiger. Wolverine is himself hairy, of course, and this has often been an indicator of his animalistic nature. However, compared to Sabretooth, who has an untrimmed mane, the sculpting of Logan's facial hair into impressive sideburns is a sign of his having been relatively socialised. While the story seems to be pulling Wolverine back to the harsh violence of his pre-X-Men days ('Been a long time since I saw slaughter like this,' he reflects as he looks among the bodies), Sabretooth taunts him that he has long lost his primal edge. 'We're the *very* best there is at what we do. Like you *used* to be,' he taunts, unknowingly throwing Wolverine's own favoured self-description back at him. In the combat which follows, Wolverine does not sink into violence but retains composure enough to rescue the Morlock healer: 'You were right, Sabretooth. *You're* the killer. I'm a *man* -- who sometimes kills.' This is familiar stuff: Wolverine pushed towards a berserker rage but pulling himself back by force of his own humanity.[3]

Positive reader response to the mutant massacre ensured that it would become the template for annual themed story arcs which would run across all the mutant titles and spill over into other comics. The massacre's tie-ins had been the serendipitous result of Claremont's friendship with the Simonsons, but it would become a corporate strategy, the template for future events which were dictated and overseen from the top, beginning a year later with *The Fall of the Mutants*. 'Originally we weren't going to do a big crossover the following year,' Simonson reflected, 'but "Mutant Massacre" sold so well that [editor-in-chief Jim] Shooter told us to do another.'[4] These crossovers and their publicity would get larger and larger.

Promoted as unmissable events, these stories had to produce game-changing consequences. Claremont was not averse to this and used 1986's 'The Mutant Massacre' and its 1987 follow-up 'The Fall of the Mutants' to overhaul the team. Nightcrawler, Rachel and Kitty left, replaced by Dazzler, Havok, Psylocke and Longshot. 'Fall...' represents the climax of the period in which the X-Men had been publicly fighting villains in the streets, and a number of the motifs of their 'urban phase' are concluded here. They save the

world live on worldwide television, gaining an audience far larger than the crowds in the street who routinely watched them in the mid-1980s. Though retaining her urban-style clothing, Storm dispenses with her 'punk' haircut, returning to the flowing hair which had defined her when she first appeared. Believed by the world to have been killed in the televised conflict, the X-Men have allowed the world to think them dead and worked from a base hidden in the Australian outback. The social settings of the previous year are abandoned in favour of an engagement with more fantastic imagery.

For all that he had spent several years keeping the X-Men fighting in urban environments, Claremont, like other genre writers, was always drawn to magical – usually pre-Christian – sites of all sorts, finding in them a source of fantasy narratives which New York or Tokyo couldn't really provide. In #223 (November 1987) and #253 (late November 1989), characters go on Native American spirit quests and #248 (September 1989) dabbles in the Aboriginal concept of the Dreamtime. However, if there was one country guaranteed to ignite Claremont's interest in pre-Christian mysticism, it was Great Britain. The foremost exploration of the theme was *The Black Dragon*, a six-issue series for Epic, Marvel's creator-owned mature comics line, wherein a noble knight could sit at a council of war alongside such diverse allies as Eleanor of Aquitaine and Morgan Le Fay. This strand of English fantasy had protruded only occasionally into *X-Men*: the leprechauns in Banshee's castle, the castle in *X-Men Annual* #6 (1982) which was 'built atop one of the holiest sites in Britain, a storehouse of eldritch energy which rivals Stonehenge'. As part of his 1988 revamp of the comic, however, Claremont turned to magic and Arthurian legend. Nightcrawler and Kitty Pryde were dispatched to England to form the core of a new team, Excalibur, while magical allies rendered the remaining X-Men undetectable by any technological surveillance system and made them guardians of the Siege Perilous ('As Avalon was for King Arthur, so may the Siege be for you,' #229, May 1988). They were relocated to the Australian outback, a region from which they could be instantly teleported around the world by Gateway, an indigenous Australian whose teleportation powers were left ambiguous (mutant or magical?).

The outback itself was exactly the sort of natural environment in which so much of the comic's 1970s stories were set. The nightclub singer Dazzler struggles in a place so devoid of culture, but Wolverine fits right in. Intense weather again becomes a motif (#251, #253, early and late November 1989) and Claremont's whimsical side, largely absent throughout the socially serious mid-1980s, could return in stories like ''Twas The Night...' (#230, June 1988) when the team, having identified the proper owners of a hoard of stolen property, return it all secretly and silently in the course of a single night which turns out to be that of 24–5 December. Despite this, the X-Men continued to fight largely cybernetic foes, causing the characters to repeatedly make reference to hardbody films: *Robocop* in #246 (July 1989) and #255 (mid-December 1989), *Terminator* in #252 (mid-November 1989) and #255, *Die Hard* and *Rambo* in #254. These were not casual references. They acknowledged a real intertextual relationship because in this period the X-Men grappled with cyborgs repeatedly. The Brood return, but otherwise flesh-and-blood monsters are thin on the ground. When Wolverine is pursued by dingoes in issue #252 they are cybernetic, not natural, in origin. No one says 'I... hunger.' This line, the comic's iconic denoter of bestial appetites run wild, is absent for years.

For all that this reformatting of the comic saw the return of some familiar tropes, a team of X-Men who faked their deaths and lived in hiding had failed in one core mission. As a correspondent to #251 complained,

> None of your X-teams, save Excalibur, have a home that is grounded in reality. X-Factor used to live in a relatively normal building in Manhattan, and the X-Men and New Mutants used to live in Xavier's mansion. Now the teams live in mysterious space-ships and futuristic complexes in the Australian Outback [...] the order of the day is only to save the world, not to actually live in it.

The X-Men had failed, in short, to live freely as mutants within human society. Potentially, the comic could have shed a lot of its prejudice themes at this point. The X-Men's televised heroism could have been used to make humanity rethink its attitude to mutants;

and Rachel had left the comic, thus severing the link to the 'Future Past' plot. However, the comic was now so popular that only so much change was possible. Nor could the team remain in isolation from the rest of the Marvel Universe for long. Marvel had learnt the sales potential of large-scale 'event' stories which crossed all the mutant titles, and only *X-Men* was big enough to lead crossover tales which kept getting bigger and bigger. The company ran adverts for 'Inferno' four months before it began, and these events became the motor that powered the plotting leading to the new phenomenon of issues which existed only in relation to the large story arcs on either side of them. The 'Fall of the Mutants' arc finished in #60 (February 1988) of *The New Mutants*, but #65 and #66 are still about the emotional fallout from those events (Illyana, blaming Forge for the death of the X-Men, seeks revenge) while building towards the next event, 'Inferno', with precognitive villain Destiny foreseeing the forthcoming trials and the demon S'ym gathering his forces.

This was *X-Men* as the 1980s closed. It was no longer the most talked-about comic or the most award-laden, but it remained the bestselling. It juggled stories across multiple titles in a way that other comics could only do with company-wide coordination of a narrative event. But what were all these new titles that its multipart narratives played out across?

COMICS, COMICS, EVERYWHERE...

Marvel comics with the cover date November 1987 – including *X-Men* #223 and *New Mutants* #57 – carried the announcement that Jim Shooter had 'stepped down' from the position of editor-in-chief, a euphemism for his sacking by Marvel's owners. The chaos which had defined the company's (lack of) organisation upon his arrival had been long since banished, and in the expanding comics market the company was declaring bigger profits and turnover year on year. He had, however, alienated key creators with his rigid style of storytelling, and his preference for clarity over all other concerns had led to constant demands that work be redrawn. Most Marvel

staffers and freelancers had their war stories from Shooter's reign. Claremont's biggest wound would always be the resurrection of Jean Grey.

Shooter's replacement as editor-in-chief was the man who had been his assistant, Tom DeFalco. DeFalco understood that there was a growing demand for stories about Marvel's major characters, both at home and abroad. He instigated a tradition that the most prominent titles – *X-Men* included, obviously – would be published twice a month during the summer, and the practice of exploiting major characters with four-issue mini-series' was abandoned in favour of granting them ongoing comics. Thus, DeFalco oversaw a period when the stable of X-comics rapidly expanded. *Marvel Comics Presents* (September 1988, an anthology comic featuring four different stories each issue, and beginning with an eight-issue Wolverine story written by Claremont), *Excalibur* (October 1988, the British-based spin-off featuring characters seconded from X-Men after 'The Fall of the Mutants') and the self-explanatory *Wolverine* (November 1988) were added to the Marvel stable. Claremont wrote all of these titles, at least initially, and his presence authorised them as legitimate extensions of *X-Men*'s master narrative. Even while the look of the characters had diversified as guest-starring artists depicted the team in prestige projects or special issues (Frank Miller, Walt Simonson, Barry Smith), Claremont and Louise Simonson had kept the tone of the mutant comics consistent. Perhaps it reflects the departure of Shooter and his rigid ideas of what a Marvel comic was, but this is the point where the mutant comics adopt varied narrative tones. *Excalibur*, discussed below, was played for laughs. *Marvel Comics Presents* saw the company rehiring a number of the 1970s generation of auteur writers who had fallen out with corporate Marvel. In the pages of *Marvel Comics Presents* Steve Gerber and Doug Moench were reunited with their signature characters (The Man-Thing and kung fu master Shang-Chi, respectively). These strips ran as backups to a Claremont-scripted Wolverine story and their presence implied that, as a writer, he was now of a similar critical stature to the stars of the 1970s.

The Wolverine story in *Marvel Comics Presents* took Logan to Madripoor, a lawless south-east Asian island nation where wealth

and poverty live in close proximity to each other. This was to be the setting for Wolverine's own ongoing series. The question of violence hung over the new title. In his original Claremont/Miller mini-series, Logan had unambiguously killed the villain, and in the follow-up, *Kitty Pryde and Wolverine* (1984–5), the resolution had required him to go into a berserker rage. The precedents were clear: while *X-Men* would strike a moral pose, projects which were less visible to the general public (and *Wolverine* was distributed only through comic stores, where an older audience prevailed) were less obliged to do so. While this balancing of conflicting impulses clearly had its roots in commercial and social pressures, Claremont publicly presented it as a matter of characterisation, telling *Marvel Age*, the magazine through which the company promoted upcoming projects, that Wolverine would be

> less inhibited in terms of using ultimate force. That's because Storm and the other X-Men are a restraining influence on him [...] Here, he's running by his own set of rules [...] when he is with the X-Men he is willing to subordinate his own personal ethical structure to a degree to the group's ethical structure, which is considerably more tolerant and benevolent than his own.[5]

For whatever reason, Claremont only wrote eight issues of *Wolverine*, passing it to other writers from #9 (July 1989). In February the following year, *Classic X-Men*, rebranded as *X-Men Classic*, ceased to feature new material. Claremont was, by this point, no longer writing all of the new backup stories. Whatever the commercial calculations involved in that decision, the reformatting had one massive implication: Marvel no longer felt the need to retrospectively reconstruct the saga around one world view.[6]

EXCALIBUR

If you wanted a cruel caricature of Claremont (and I don't, but I have to cover all the angles), it might be as one of his vampiric villains, omnivorously hoovering up the latest trends in comics

and culture and integrating them all into *X-Men* to keep it fresh and top of the sales chart. For example, Ann Nocenti's character Longshot was incorporated in this period, and with him the alternative universe, the Mojoverse, from where he came. In that reality the populace are kept pacified by the bread and circuses of gladiatorial entertainments provided by the bloated network controller Mojo. All of this had been rendered by new artist Art Adams, whose work was an instant hit with fans. Its most obvious feature was the sheer amount of detail Adams included, inevitably meaning that he produced pages at a slower rate than other artists, and he could not create an entire issue's worth of comic art on a monthly basis. During 1986 and 1987 Nocenti and Claremont not only integrated Longshot himself into the team but also hired Adams for a wealth of mutant projects: *X-Men* annuals #9 and #10, *The New Mutants Special Edition* and covers for *X-Men* and *Classic X-Men*. The year 1988 brought more to assimilate, because – not for the first time in American pop culture – the British had invaded.

Among his earliest projects, Chris Claremont had created, with artist Herb Trimpe, *Captain Britain*. In the early 1970s, Marvel had begun a UK operation, repackaging American material for a comics market which, per head of the population, was far larger than America's. When the need was felt for a British hero to spearhead Marvel UK the job passed to the company's resident Anglophile, Claremont. The first issue of *Captain Britain* appeared in October 1976 (roughly concurrent with *X-Men* #102), and was to be released weekly. Much of the content continued to be reprints of Marvel's American comics, but the title strip was new material. When a nuclear research station just south of the Scottish border is attacked, physics student Brian Braddock escapes on a motorcycle, but he comes off the road, finding himself thrown into a stone circle, the Siege Perilous, above which loom the images of an aged man and a young woman. They ask Brian to choose between a sword which projects from one of the stones and an amulet which hangs around another. Eschewing the violence implicit in the sword, Brian selects the amulet and finds himself remade as the UK's first superhero, Captain Britain. (That Brian becomes Britain's hero precisely by

electing not to pull the sword from the stone is an oddity which only grew in incongruity as the strip accumulated Arthurian imagery over the years.) Claremont himself only wrote the first ten episodes, but the character lived on for several years, lurching between the superhero genre and the myth/folklore which had been part of its origination. Not until the early 1980s did the strip find writers who could adequately merge the two: Dave Thorpe, Jamie Delano and the man who would overshadow them both, Alan Moore. All of these writers were assisted by Alan Davis, who redesigned the character's costume and whose lengthy stay as artist lent visual continuity across many years and diverse writing styles.

The Moore/Davis *Captain Britain* strips were part of an early-1980s renaissance of British hero/adventure/SF comics, and improved international communication was bringing them to the attention of American fans and publishers. Many of the writers and artists began to work simultaneously for companies on both sides of the Atlantic. 'The British Invasion' was the intrusion of a less polished, punkier, in-your-face British attitude to creativity. Alan Moore worked for Marvel's biggest rivals, DC, but had an impact on the entire industry. His dense scripts described a story panel-by-panel in amazing detail. He fervently considered – and experimented with – how different arrangements of panels would look upon a page, something which Claremont, working to Marvel style, left to his artists. As such, Moore became the latest prophet of the much-anticipated new relationship between image and word on the comics page. His wordage could be as lengthy as Claremont's, but was even denser, more allusive, informed by a range of arts and philosophies more diverse than any which had previously graced a comics page. Where Claremont affirmed the superhero genre, Moore made his name in Britain by interrogating the origins of fantasies of power in realities of helplessness, notably in his strip *Marvelman* (later retitled *Miracleman* for legal reasons which are surely obvious). As a writer at DC, Moore's projects, primarily *Swamp Thing* and *Watchmen*, had scooped up awards at the sort of rate *X-Men* had done in the 1970s, and Moore wasn't above making it known that he saw obvious limitations in Claremont's work.[7]

But if Marvel US could not land Moore as a writer, it could pull in Davis and it could assert its legal ownership of *Captain Britain*. Among those American professionals who had been reading the strip was Claremont, enthralled by the way that the characters he had created had been enlarged, and 'being a greedy, acquisitive sod, I couldn't wait for the chance to play with them myself'.[8] He got his chance when, with the other X-Men believed dead in Dallas, Nightcrawler, Kitty and Rachel decamped to the UK to form a new team with Captain Britain. *Excalibur's* UK settings and Davis' light-hearted, comical art gave it a tone somewhere – but not too far – outside the Marvel mainstream. The villains of the first two issues, the warwolves, literally consume people, but there is no play with the usual hunger allegories and the creatures, once beaten, are placed in a zoo where visitors can view them while engaging in quintessentially English pastimes such as smoking pipes and reading the newspaper. Rachel still wears her hound uniform from 'future past', but the emphasis is not on the dehumanisation which it symbolises but on its male-magnet tightness and Kitty's consequent frustrations at being perpetually overshadowed. A two-issue 'Inferno' crossover with the parent title allowed for the inclusion of some trademark Claremont agonies (sudden bursts of psychic pain, physical transformations based on the 'shadow' inside a given hero's soul), and the intrusion from another dimension of a ghostly Kitty Pryde who served the Nazis after their successful invasion of the UK was suitably shocking. The comic was more interested, however, in the benevolent magic which sustained olde England, while a series of trips across alternate dimensions played to Nightcrawler's swashbuckling side.

Excalibur's playfulness gave the series a self-reflexive edge which the more intent mutant series' could not indulge. The comic's very first scene (a dream sequence in which the X-Men appeared as film stars, their powers activating only when the director, Xavier, called 'Action') cued self-reflexive readings. Claremont and the artists, or obvious avatars of them, appeared regularly as the comic playfully made its way across alternative dimensions. Claremont and John Byrne appear in one – unnamed, but recognisable from the props which surround them – working at an almighty computer:

Anything comes up here, *those two* grab it, turn it into the catalyst for the latest cataclysmic cosmic cross-continuity caper [...] One gets an idea, the other figures he has to top it... back and forth, forth and back. Nothing's sacred, where they're concerned. (#14, November 1989)

Claremont is manacled to this computer, working hard while being served drink by scantily clad Hellfire Club waitresses. Was this a throwaway gag or did he truly feel such ambiguities in his position? The next page features Phoenix bursting from a cocoon in a direct parody of the story which had brought Jean Grey back from the dead and hurt Claremont so much. Perhaps he could laugh about it now.

Or perhaps not. The comic returned several times to the Mojoverse, the alternative 'bread and circuses' reality where the X-Men had signed harsh contracts to serve a grotesquely bloated media mogul who despises all beings who have a spine. The dialogue on these occasions bristles with references to *X-Men*'s corporate ownership: 'Stand and be exploited -- in the name of *Mojo's Trademark Police*!', 'Is it too much to ask... those entities play their proper part until I've drained them dry?' The story just quoted, 'Mojo Mayhem' (December 1989), depicts Marvel itself as a building. At its centre stands the original company, envisaged as a small hut called 'The House of Jack and Stan'. From this emanates a massive structure emblazoned with all the names of recent company-wide crossover events ('Secret Wars', 'Atlantis Attacks'). In the ensuing battle, the small hut is robust enough to survive while the rest of the structure crumbles. Such moments articulated distaste for what Marvel had become, and by this point – December 1989 – Claremont had cause to be concerned.

THE NEXT GENERATION

As editor-in-chief, Tom DeFalco did not impose strict stylistic rules upon Marvel creators as Jim Shooter had done. Chris Claremont took the opportunity to reinvent *X-Men* yet again, this time with a sprawling, diffuse narrative which Shooter would have been

unlikely to have approved. In rapid succession during late 1989, Storm was reverted to a 13-year-old, becoming a thief on the banks of the Mississippi; Longshot left; and most of the rest of the team, backed into a corner in Australia, cast themselves into the Siege Perilous, there to be judged worthy or otherwise and thrown back into the world with no memory of their previous lives/identities. Only Wolverine and his new 'sidekick' Jubilee retained their memories, and their search for their missing comrades was interrupted by Logan's assorted other businesses in maritime south-east Asia. The mutant research centre on Muir Island, meanwhile, came under attack, causing Moira MacTaggert – herself radically changed as the mutant telepath Legion took control of her mind – to create her own team of X-Men drawn from the book's sporadic guest stars. As the comic worked its way around these multiple locations, major characters could be absent for months and often an issue would feature only one plot line. While Claremont had written long story arcs before, readers had never seen anything as extreme as this. When the team were believed dead in Antarctica in 1978/9, the long saga of their return to New York had been made up of a number of discrete stories as they tangled with different villains in different locations on the route home. Throughout the 1980s, while the X-Men might never completely defeat the Hellfire Club, they could at least stop their schemes reaching fruition. Here, mostly mind-wiped and pursued by heavily armed militias seeking only the X-Men's deaths, there were not even incremental victories to be won. If Claremont had claim to be an innovator during this period, it is in this diffuse narrative arrangement.

Whatever claims might be made for this as an innovation, there are familiar Claremont tropes aplenty amidst the strangely spiralling narrative. The mind-wiping of the X-Men plays to the theme of the divided self which had always been central. Colossus, now an on-the-up artist in New York, is given the life he might have had if the responsibilities of being a mutant superhero had not intervened. Storm's regression to adolescence plays out ego and id. Her transformation is accompanied by a tempest of the sort which was once common in the comic ('Never seen weather like this,' Wolverine reflects in #251, early November 1989), while the

hounds which the Shadow King subsequently sends to track her are human beings rendered bestial: 'She looks human -- but I have never seen an animal so fierce' (#265, early August 1990). Any or all of these themes might be explicated as I have explored them in previous chapters. This would be to miss the true story of *X-Men* 1989–91: the rise of other strong authorial talents at Marvel and Chris Claremont's loss of control over the comic he had kept as the industry number one for a decade.

Marvel's writers may have celebrated Jim Shooter's replacement as editor-in-chief, but Shooter was a writer himself – a good one, as his acclaimed work on *Avengers* in the late 1970s testifies – and his mandates often manifested a writer's concerns. He was famously hard on artists, sending back pages to be redrawn if they did not meet his idea of the Marvel standard. It is probably no coincidence that as his time in charge continued, the company produced fewer and fewer superstar artists. Miller and Sienkiewicz had debuted years earlier, and few had followed them. Art Adams was the closest Marvel came to producing a star artist in the mid-1980s, but the time he took on his detailed renderings meant that he would appear as a guest artist on prestige projects rather than sustaining regular work on a monthly title. He had fans aplenty, but no base from which to expand his influence. Similarly, Chris Claremont and Alan Moore had their differences, but their prominence meant that writers were still honoured in the visual medium of comics.

The relaxing of the strict rules of storytelling which Shooter had enforced allowed the next generation of artists greater freedom. The average age of a Marvel artist fell suddenly in the late 1980s, and a group of young men emerged as the new stars. Todd McFarlane, Jim Lee, Whilce Portacio and Rob Liefeld had not known the Marvel of the 1970s when lax editorial oversight had coexisted with fears of the entire medium's collapse. They knew the Marvel of incentive payments, escalating sales and editorial coordination, and change at the top freed them not only from Shooter's aesthetic prescriptions but also his moral qualms about heroes killing people. McFarlane made his name on *Spider-Man*, Lee on *X-Men* and Liefeld on *New Mutants*. They were at the heart of Marvel's bestselling titles, they understood that their target market was mostly young men, they

knew what that market wanted and they were all stylists, ruthlessly dispensing with mimetic realism as they pushed the poses of their characters through contortions no human body could plausibly undertake. This new wave favoured larger panels and even 'poster shots', images of heroes in poses which could stand by themselves when stripped of a narrative context. McFarlane explored the aesthetic possibilities of Spider-Man's webbing, distorted his costume by enlarging the eye panels and introduced Venom, a ferocious black creature with unfeasibly large and mighty teeth. On *X-Men*, Jim Lee emphasised the gender-specific characteristics of his characters. The muscles of men were lovingly detailed. Women developed oversized breasts, bottoms and thighs. When introduced to the *X-Men* universe in 1986, Psylocke was a demure English telepath. The drama of #213 (January 1987) was based around the contrast of her English rose demeanour with the savagery of Wolverine, Sabretooth and the mutant massacre. Her victory on that day – which won her a place in the X-Men – was her capacity to find 'serenity' amidst the violence, enabling her to enact some psychic trickery on the Marauders. In the upheaval of 1989, her psyche was transplanted into the body of a swimsuit-clad ninja, granting her physical combat skills atop her telepathic ones which now included the ability to form a 'psychic knife', a formidable weapon in mental combat. Chris Claremont's negotiation of this art is a complex matter, discussed later in this chapter, but the conflicts of the period were very easily read on the pages of *The New Mutants*.

Claremont's stylistic influence on *X-Men*'s first spin-off title had waned after 1987, once it became apparent that his departure was permanent. Louise Simonson replaced many of the team members she had inherited with new creations of her own, characters who were arguably interesting in their own right but who lacked the weaknesses and metaphysical reflection which were Claremont's stock-in-trade. Illyana's salvation, and her subsequent writing out of the comic, was a crucial marker of this shift away from such themes. Sales were declining – though the book still had 200,000 readers, figures which would have made it a market leader ten years earlier – and the letters page reflected the views of some readers who felt that the comic was drifting aimlessly. That drift was abruptly

halted once Rob Liefeld became regular artist. It is standard prac-
tice, a generation later, to sneer at Liefeld for his obvious failings.
His characters had bulging biceps but strangely small feet, and the
backgrounds could be inconsistent (the shape of windows could
change between panels). None of this was apparent to a generation
of adolescent readers in the early 1990s. The oddly shaped heroes
and villains which Liefeld was asked to draw initially obscured some
of his anatomical eccentricities, and his page layouts, dominated
by tall, thin panels and seemingly random blank spaces, certainly
caught the eye. In their history of comics in this era, Gerard Jones
and Will Jacobs describe Liefeld as someone who 'felt the lack of
nothing in himself'.[9] Lucky man – but what could such a sensibility
possibly bring to Claremont's mutants, characters endlessly divided
within themselves?

Liefeld made an instant impact with the character of Cable,
who debuted in his second issue (#87, February 1990). Created
when editor Bob Harras decided that the young team needed a
new leader, Cable was from the future and had time travelled
back to prepare the mutants of our time for the dystopias ahead,
which seemed, from his descriptions, to be worse than anything
yet imagined. Liefeld designed the figure, equipping him with a
large gun, bionic implants, body armour and spiked wristbands.
Designed to be an immediate hit, he dominated the covers of #87,
#89, #90, #91 and #94, and was handed instant conflicts with both
Sabretooth and Wolverine, the latter of whom he apparently had
a long and antagonistic relationship with. He talked constantly of
life as 'a war' and he told the New Mutants to buck their ideas up
accordingly, a tough love to which they responded. 'Cable has faith
in us and our abilities,' reflected Sunspot in #93. 'He listens when
we talk and he believes in me.'

Cable speaks the arguments of the New Right, and this brings
him into disagreement with the X-Men when they return from the
failed experiment of faking their own deaths. When he criticises them
for neglecting their responsibilities to the New Mutants he lambasts
them for exactly those things which the New Right criticised the
1970s/President Carter for. They have spent their days in endless
self-doubt, questioning themselves, all the while taking hits from

opponents who have no such qualms. They battle a lot, but resolve little. 'The time for straddling the fence and not choosing sides is over,' Cable bluntly asserts, demanding action in *New Mutants* #99 (March 1991). When his guardianship is questioned by the returning X-Men, he responds, 'Somebody had to look after these kids... and none o' *you* hotshots were around -- or willing -- to take the job' (*X-Men* #270, November 1990). No one, to my knowledge, has ever argued that the *X-Men*'s rise to comics prominence in the late 1970s was because its endless self-questioning reflected the national mood, but once Cable is offered up as a New Right alternative, the pieces of such an argument fall easily into place.

Instantly popular, Cable and Liefeld ended the slide in sales of *The New Mutants*, speaking urgently and strongly to a new wave of fans who came without the artistic and cultural baggage to which *The Comics Journal* clung. These fans had their own magazine of commentary, *Wizard*, and it did not seek to contextualise mainstream comics within the wider art of graphic narrative but simply followed muscle-bound, heavily armed superheroes across product lines: trading cards, action figures, T-shirts, Saturday morning animation, etc. While the *Journal* made enemies inside the industry with its editorials demanding constant artistic rights and creative freedoms, the publisher of *Wizard*, Gareb S. ('for Stud-Muffin') Shamus rambled about girls and corporate freebies at a convention he'd attended:

> If you hadn't noticed from the above picture, Wizard has a new spokeswoman named 'Crystal'. You'd better come visit us or she'll... she'll put a spell on you, yeah that's it.
>
> Just to let you know, my entire food bill for the week was $4.50 for a can of dry roasted peanuts I took from the hotel food cabinet. It was great – everybody took us out to eat. What more could you ask for? Free food is the best kind.[10]

Pushing forward the graphic art in this manner, *Wizard* wrote from a teenaged male perspective (literally so in the case of its 16-year-old computer games columnist) with an art tips column called 'Brutes and Babes'. A third of every issue (70 pages or so) would

be taken up with a guide to back-issue prices, a handy supplement
to columns such as 'Top Ten' (which highlighted those back issues
rising steeply and suddenly in value) and 'Top 100' (which listed
the bestselling titles of the previous month). The magazine handily
outlined what new comics were debuting that month, not because
readers might have aesthetic reasons for buying them but because
'#1 issue [sic] have been known to appreciate considerably when
a series becomes very popular.'[11] Stripped of arguments about
aesthetics, the message was clear: the primary value of comics was
financial. What face-saving interest in quality was appended to this
discourse consisted mostly of the rampant use of the word 'hot', a
word which itself carries as many overtones of commercial success
as it does creative merit. I could go through the issues, counting
the use of the word – just as I counted Claremont's deployment of
the word 'soul' in *New Mutants* – but life's too short, the calculator
couldn't handle it, and my brain would melt. If you squinted hard
enough, you could just about see this raucous celebration as being
what happens when a medium has established its aesthetic value
and needn't labour the point any more. Or you could view it as
a hedonistic and relativistic subculture that sneers at highbrow
aesthetic debates. The editor of *Wizard* desired free food, and his
broadcasting it in an editorial suggests that it wasn't an attitude
which was going to offend his audience. He would find soulmates
aplenty in the *X-Men*, of course, but they had always been the
villains. Proteus, Sauron, Selene and Dark Phoenix, to name but
four, had all feasted at the expense of others. The core values of
these new comic buyers and those of Chris Claremont could surely
never coexist.

THE FALL OF THE MUTANT-MAKERS

It is, I would argue, hard to read the authorial signatures working
in *X-Men* throughout 1990 and 1991. The history books are clear
on what we should find there; Claremont was losing control of
the comic's content. Whatever plots he constructed, the art pages
were returned with fight scenes extended and the subtleties of

the storytelling diminished. Editor Bob Harras, born in 1959, was something of a midpoint between Claremont (born in 1950) and the young artists (Jim Lee was born in 1964, Liefeld three years later), and he favoured the ideas coming from the latter over Claremont's suggestions. These conflicts are all well outlined in the history books, arguments which are extensively backed up by retrospective interviews with all the main players.[12]

These stories – of Claremont and Harras reduced to communicating only by fax – may lead us to expect a comic in crisis and stories which can be read for their conflicting agendas. Is this apparent? Not obviously. There are some overly long fight scenes, marked by tall, narrow panels in which long-legged heroines throw themselves through the air; and where the *X-Men* stories of a decade earlier had taken from Japanese culture a concern with honour codes, now it was full of bladed weapons and the conspicuous wealth of local crime lords. All of this might be used to build a case for Claremont's loss of control over the book's direction and plotting, but there are many counter-examples. *X-Men* #274 (March 1991) is set in the Savage Land and largely narrated by a Magneto who is conflicted in the manner of so many of Claremont's characters:

> I wear red, the color of blood, in tribute to their lost lives. And the harder I try to cast it aside, to find a gentler path... the more irresistibly I'm drawn back. I should have died myself, with those I loved. Instead, I carted the bodies by the hundreds by the thousands... from the death house to the crematorium... and the ashes to the burial ground. Asking now what I could not then — why was I spared?!

While Magneto agonises in the Savage Land, the X-Men return, in #275, to the ruins of the X-mansion, finding that the underground sections are still usable and that Cable and the New Mutants reside there. What follows is an inevitable clash of values and while Cable does not doubt his, the X-Men, as ever, question themselves. 'Have you ever considered that he might be *right*?' asks Storm in #273. 'Are *we* fit caretakers any longer, for Xavier's school and his dream? Or has the time come to turn that role over to *others*?' Jean

Grey concludes, several pages later, that 'Cable is right, the times have never been more dangerous.' Faced with this challenge to the meaning of their team, Storm proposes that a vote be held, with the team to choose between three options: embracing Cable's world view and accepting his leadership (the New Right solution), to live in X-Factor's giant impregnable spaceship (the safe but unassimilated option) or to renew their faith in the values they have always sought to live by and to seek the reconstruction of the mansion to be used as a base for a team of mutant superheroes and trainees who seek integration into society. While *The New Mutants* may have been won over by Cable's hard charisma, this issue is a considered response, and a typical Claremontian one. Cable's arguments are a traditional threat to the X-Men's identity. Like Wolverine's berserker rages (in which he might be permanently lost to his animal impulses), the Marauders (who threatened to drag the team into a cycle of returning violence with more of the same) or any number of addictive powers which excite even as they corrupt, Cable presents an invitation to renounce heroic values and become less humane, less rational and less imaginative in one's response to the world's challenges. In typical Claremont style, the issue follows the team as they agonise over the issue and then, without requiring the formality of a vote, they affirm their commitment to not being dragged down to the level of their opponents. Issues like this could be acclaimed on the letters page upon the same terms of characterisation and the depiction of feeling for which Claremont had always been praised. 'Thank you, Chris, for the touching insight into the changing lives of the X-Men,' was one response to #273 (printed on the letters page of #277, June 1991). 'You brought Magneto's pain and what drives him so much to light for me,' explained another (in #279). Accounts of the comic during this period which declare that the art gave Claremont little space for his character reflections may underestimate his capacity to incorporate it.

Closer readers might argue that Claremont's dialogue acts as a subtle criticism of the artwork he was forced to work with. In #277, Storm despairs that 'Life devolved into an unending battle, so much effort spent on simple survival that we began losing sight of what we were surviving *for*.' Is that criticism of the comic's direction, or

simply classic Claremontian agonising? Professor Xavier's reflection in #279 (August 1991) that Colossus' armoured form is larger than he remembered might be a comment on the muscular way that male characters were being drawn by Lee. In #276, he had had two characters declare, 'We're baAack! Two bad, *beautiful* babes with *really big guns*!' Was he simply describing what he was given, or despairingly sideswiping at the new company norms, women dished up as physically active but without any of the rhetoric of empowerment which had always accompanied his own representation of powerful female characters?

Marvel probably didn't care how readers interpreted these polysemic moments, but deeper conflicts about the very premise of the comic were becoming apparent. With no fixed abode, a line-up only vaguely defined and major characters absent for months on end, *X-Men* no longer read like a traditional superhero team book. Reflecting on the period from a later perspective, editor Bob Harras would recall disagreements with Claremont over the form the narrative had taken:

> With the X-Men there are some things you can't get away from for too long: the school dynamics; Xavier [...] the book was becoming more like *Avengers*. The X-Men now had aliens and magically-powered characters on the team. I felt like we had to go back to what *X-Men* was all about and to me *X-Men* was Xavier and Scott and Jean and all the other classic characters. But Chris didn't want to do that kind of stuff anymore. He felt that he had done it already. My point was, 'sure, but *that's* the X-Men.'[13]

We needn't accept this at face value, though if events really were framed in these terms the outcome was never in doubt. Had Marvel ever backed change when the alternative was to restate the original premise? Claremont had seen off the putative 'X-Men West Coast' project by trumping it with *The New Mutants*, a return to first principles in its 'school for mutants' premise. He had lost the battle against *X-Factor* because the chance to bring back the original team was something Marvel couldn't resist. Harras' concerns, viewed generously, seek to retain what made *X-Men* distinct from other

comics on the market. More cynically, it constituted a conserva-
tive corporate aesthetic which was reluctant to change or advance
a product/format which provably worked in the marketplace. You
can read it all on the pages of the comic itself – not the ones where
the story was told, but the ones in between, the ones that carried
the advertisements. When Claremont had taken over *X-Men* in the
mid-1970s, Marvel Comics carried ads for pre-teen products –
sweet snacks, toys, tropical fish – and, oddly, bodybuilding courses.
In the small ads were to be found comic dealers who purchased
just enough space to print an address and details of how to obtain
their catalogue of back issues for sale. By the early 1980s, with the
rise of the fan market, the pre-teen toys were fading, replaced by
promotions by the emerging video games market and the larger
comic dealers who took out full-page or double-page ads listing
the prices of hundreds of issues. By the early 1990s, things were
changing again. In the comic dealers' ads actual comics mixed with
figurines, prints and other 'collectables'. *X-Men* T-shirts, action
figures, cards, calendars, badges, prints and portfolios were among
the items advertised in 1991. For a more immersive experience,
you could buy *Wolverine* on Nintendo or call a special telephone
number to 'battle the X-Men's deadliest enemies'. Fans didn't know
it then, but a cartoon series, usually referred to now as *X-Men: The
Animated Series*, was in development and would debut on Fox in
October 1992. It would run for five seasons, being a large success
on Saturday mornings. *The Uncanny X-Men* wasn't a comic any
more, it was a franchise.

The full exploitation of that franchise, however, demanded
that it be based around a consistent, easily understood premise.
Claremont's characters in 1990, disassociated from each other,
often amnesiac, dispersed around the world in apparently uncon-
nected plot lines, did not provide that. Thus, narrative events across
Marvel's comics in 1991 worked to rebuild the easily understood
central concept of the X-Men. In rapid succession, Storm was
returned to her proper age, Xavier was reunited with the X-Men
and Magneto broke with the team. In *X-Factor*, the characters
pondered their identities: did they, at heart, regard themselves as
X-Men? The answer was yes, and they too returned to Xavier's fold.

The New Mutants left, following Cable and his allies – characters called Warpath and Feral, the sort of names which Marvel used to give to villains – to form a new team, the more aggressive-sounding X-Force. Claremont's dream of a comic which changed line-up and format over time was dead. Once he himself was finally gone, Xavier had his mansion rebuilt, lost the use of his legs again and returned to the role of wheelchair-bound mentor. The traditional planks of the format were being reinstated, and what emerged was a high-concept format finely tuned for exploitation across multiple entertainment platforms. This is the *X-Men* as it is known – through cartoons and movies – to millions of people who have never read a Marvel comic.

As this marketable format was put in place, the end of the Claremont/Simonson era of *X-Men* hit quickly. *New Mutants* #97 (January 1991) was Louise Simonson's last issue. She left, dissatisfied with the new direction that Liefeld and Cable were taking the comic in. A month later, Claremont's last issue of *Excalibur* was released. In March, Simonson ended her connection with the mutant comics completely as her last *X-Factor* saw print, the same month that Jim Lee began to receive co-plotter credits – the credit which John Byrne had said Claremont was so resistant to giving to his artists – in *X-Men*. Claremont himself took over *X-Factor*, scripting dialogue to fit plots created by Lee and artist Whilce Portacio. He attempted to work in Simonson's style, but lasted only four months, leaving with the issue dated July 1991, only a month before his final issue of *The Uncanny X-Men* (#279) in August.

No one knew that Claremont was writing his final issues of *The Uncanny X-Men*, not even the man himself. The last issues contain a strange poignancy, therefore, because if a man were concluding a writing job in which he had immersed himself for a decade and a half, this is the story he might write. The X-Men, scattered across the world, reform as a core group, even to the point of joining Xavier in space. Upon their return to Earth, they travel not to the ruined mansion but to their other installation, the mutant research centre on Muir Island, run by Xavier's ex-lover Moira MacTaggert. Things have gone badly there, because Moira and others have been psychically possessed by the Shadow King, the new 'villainesque' name

for Amahl Farouk, the mutant crime lord with whom Xavier had fought his first ever psychic duel in postwar Cairo (*X-Men* #117 – see Chapter II), and whose evil example had led him to found the X-Men. For the Shadow King it is personal: he raises his dream of infinite corruption as a direct opposite of Xavier's vision, which he seeks to supplant. To that end, he has turned Muir Island into a dark inversion of the mansion, and mutants train in an arena. It is explicitly compared to the 'old Danger Room', but here aggression and violence are encouraged rather than teamwork skills. In the face of overwhelming odds, Xavier has one idea: the original X-Men – the team now calling themselves X-Factor – must join forces with the current team to defeat his oldest foe. As battle is joined, the characters throw off philosophical bon mots around favoured themes: 'No matter how much we grow. How *mature* we fancy ourselves... civilization ends up being no more than a veneer. Strip it away... we're all like *Wolverine* at heart' (#276, May 1991), and

> How easily, how eagerly, they *hate*! The excuse can be anything: color, religion, politics, sex, whatever comes to their inventive little minds [...] They have such a *creative* capacity for doing *ill* rather than good, you know -- one suspects it is almost inherent. (#278)

The Shadow King has thrown off almost all human traits now and become a monster given over to appetites ('my desires are insatiable' – #278) much like those monsters the X-Men fought in the 1970s. Claremont might have been growing disillusioned with life at Marvel as he scripted these issues, but they are his most characteristic work for years. If you want to read this as Claremont's conscious farewell, an epic with all the characters present and all the primary values restated one last time, then you are reading against the grain of the known history of the company. Bracketing that off for a moment, and reading the text in isolation, however, this reading actually works.

Xavier was uniting his mutant teams because Marvel was working towards the release of a new comic, one simply entitled *X-Men* which would run alongside *The Uncanny X-Men*. While *The New Mutants*, *X-Factor* and *Excalibur* had all been understood as spin-offs which

had responded to developments in the primary text of *The Uncanny X-Men*, the new comic would have equal parity at the centre of the X-universe. Though Claremont left *The Uncanny X-Men* with the issue cover dated August 1991, he was contracted to write the first three issues of the new *X-Men* title, and the first was released in August 1991 (though cover dated two months later).

In the escalating world of comics-as-investment, nothing was bigger than first issues. Todd McFarlane had written and drawn a new comic, simply called *Spider-Man*, and it sold a million copies. When *The New Mutants* was cancelled, the debut issue of its replacement, Rob Liefeld's reimagining of the team as *X-Force*, sold three or four times that (estimates vary) – an incredible figure which was swept away by *X-Men* #1's sales of eight million.

That figure did not constitute eight million individual customers, of course. It merely represented non-returnable sales of the issue to retailers and institutional investors who thought they had spotted a sure thing. At 500,000, *Uncanny X-Men*'s readership was a sixteenth of that, and although a number of people – those who would become fans in the future – might be assumed to need the comic in the future, the very act of stockpiling huge quantities created a situation where supply would always outstrip demand and the comic would, after the initial rush, be worth considerably less than its original cover price. Fans played their own part in the sales bonanza, since the issue came with a choice of five different covers and many thought that they needed to purchase them all. When the issue's sales were formally declared to be a world record many years later it was Claremont who would be presented with the official certificate. That accurately reflected whose name was most associated with *X-Men*, whose legacy had lasted, but surely he had ambiguous feelings about being retrospectively declared the king of exactly the moment when a 17-year commitment was falling apart.

In the story inside those three issues which Claremont wrote, Magneto has retreated into a space station, withdrawn from the world, but the world comes to him in the form of mutant refugees seeking his aid and sanctuary. They are pursued – not least because they stole a space shuttle to reach Magneto – by the US military. A reference by US shuttle pilots to 'Cheyenne Command' as an

American base evokes *Uncanny X-Men* #94 (August 1975), the first appearance of the new team, but it is #150 (October 1981) from which the story takes its bearings, even having Magneto raise, from the ocean's depths, the Soviet submarine which he had sunk in that issue. That had been the start of Magneto's redemption, and it had begun with his demands that the world's superpowers dismantle their atomic weaponry. Now he is just weary of human politics: 'I am rapidly losing interest in whatever you choose to do on the earth's surface -- despoil the environment, slaughter yourselves to the last child, I no longer care' (#1, October 1991). He is moved from weariness to rage, however, by a revelation about his past. Comparisons of his current DNA with a record made several years earlier show extensive modification.

During the early 1970s, while *X-Men* itself was just reprinting old stories, Magneto, appearing in other comics, had been temporarily regressed to infancy. During that time, it is now revealed, Xavier's long-time associate Moira MacTaggert had discovered that 'there were indications of an instability in your central nervous system, as though yuir body could'na quite handle the energies you were processing through it' (#2). Though Moira has sought to aid Magneto by adjusting the instability, he sees her work only as interference:

And who gave you the right to play *God* with my *soul*?! By the eternal, by tinkering with the foundation of my being, you took from me the dimensions of *moral choice*! Every decision I've made since my rebirth is now suspect.

Magneto had become a hero of the existential type in #150 when he chose to accept responsibility for his actions and not to be simply a symptom of his horrendous past. On those terms, he sought reconciliation with humanity and was handed stewardship of the school when Xavier left Earth. Now, however, he rejects those decisions and that whole self-understanding in favour of a determinism defined both in terms of Moira's genetic tampering and his own upbringing: 'My life was shaped by forces and events none of you can possibly understand' (#3). An existential hero denied the ability to choose has nowhere to go and, his space station exploding around

him, Magneto speaks like a man saying his farewells to the world: 'Perhaps it's best it end this way, Charles. Best for *my* dream to end in flames and glory, here far above Earth.'

The saddest reading we can make of this scene is that Magneto's farewell to the X-Men is Claremont's goodbye speech to Marvel, but apart from odd phrases – like the one I have just quoted, perhaps – it doesn't really bear that interpretation. This is, however, where Claremont's time on *X-Men* ended, at least for a while. If there is a sadness it lies not in forcing this speech to fit Claremont's mood but in the brutal curtailing of Magneto's choices. Claremont believed in people's capacities for change. His comics several times (*New Mutants* #40 in June 1986, for example) quote the adage about leopards being unable to change their spots only for other characters to point out that humans, by contrast, can. It is a theme we have followed throughout this book. If Claremont's writing had hit a corporate wall it could not scale (or smash through, Colossus-style), there could be no more sombre register of that failure in the text itself than to find the comic's foremost existentialist hero forced into a corner where he had no choices to make. No one, neither the readers nor the comics professionals, expected Magneto's demise to be permanent, but it reads as if it will be – and if you wish to regard the *X-Men* comics after Claremont's departure as not really canonical (and effectively I do in as much as I take no real notice of them) I suppose that he finally does die, burnt up, going out spectacularly in a fireball in space.

With Claremont's departure, Marvel's immediate need was to demonstrate continuity between the era just ending and *X-Men*'s future. A decade after he'd left the book, John Byrne's was still the name which shone second only to Claremont's in the *X-Men* firmament, so Harras hired him to write dialogue for both *X-Men* comics over the pencilled plots of Jim Lee and Whilce Portacio. As an artist himself, Byrne might have had sympathy with the graphic revolution, but he was also a writer in the traditional Marvel mode. Whatever differences he may have had with Claremont all those years earlier, Byrne shared the same zeal for long-term planning so that issues could be written to build story arcs and character development over time remained consistent. That was not, however,

how the new stars of the X-universe worked. The artists, he later explained,

> would send me the plot, and then they'd send me three pages of pencils. I'd script those because they had to be scripted right away [...] then I'd get one more and the one page didn't match the first three pages because they'd taken off at a tangent, and they were both doing this [...] It was a nightmare.[14]

Despairing of the endless rewriting as plot lines changed without warning, he completed only two issues of *X-Men* and six of *Uncanny X-Men*. None of this had any detrimental impact on sales of the comics, which continued to rise.

Not everything which Claremont had built was dispensed with upon his departure; some of it would be central to the franchise which Marvel was building. In *Uncanny X-Men* #294 (November 1992) the gay reading which Claremont had been happy to acknowledge when others would not, and which he had inserted into the comic in a variety of coded forms, fully rose to the surface of the comic when Xavier addressed a crowd in New York thus:

> No amount of words -- of *derision*, distrust, or *disinformation* -- can change the truth that each of us... *man*, woman, black, Hispanic, Jew, Native American, homosexual, mutant, everyone... underneath all the '*words*'... we are related. We are all family.

The sequence provoked one outraged response on the letters page a few issues later, with the correspondent in question despairing that 'political correctness' had entered Marvel generally and that Xavier was confusing genuine genetic determinants with the 'learned cultural traits' of homosexuality. Though the magazine gave nearly an entire page to this letter and an editorial response, the correspondent was fighting a losing battle. The following year the comic began a lengthy story arc about the Legacy Virus, a disease targeted at mutants and a clear AIDS metaphor. Victims included Pyro, the evil mutant who had been coded as gay ever since his first appearance in 'Days of Future Past'.[15]

Claremont had proven company-loyal. That's a fact which we should be careful not to romanticise (he had, after all, done very well out of his time at Marvel), but it remains a fact. The same could not be said for the incoming generation of writers/artists who understood that their value in the comics industry far exceeded what Marvel was paying them. They formed a new comics company. Image Comics would be a place where the creators retained full rights to the characters which they created and no one interfered with the creative vision. It took a few months to come together, but in the first half of 1992 Marvel's most bankable artists – Todd McFarlane, Jim Lee, Erik Larsen, Jim Valentino, Marc Silvestri and Rob Liefeld, many of them people who'd made their reputation on *X-Men*-related comics – left the company, causing the value of Marvel stock to crash. Claremont made an effort to work at Image, with his name linked to a project called *The Huntsman*, but nothing came of it.

Freed from the demands of Marvel and its editorial structures, the auteurs of Image frequently missed deadlines, their comics often failing to appear on time. In addition, not everyone's comics proved successful outside of the safety net provided by the Marvel Universe and brand name. The travails of this new company, however, were as nothing to the sales slump which hit the entire industry in 1993, then again the following year, as the comics market entered a sustained contraction from which it has never recovered. Marvel Comics itself, now owned by Wall Street giants and funded by overvalued junk bonds, saw its corporate debt soar past $600 million. The company declared bankruptcy in the mid-1990s amidst a series of financial manoeuvres so Byzantine that even those of us educated in the Claremont school of complex plotting across multiple comics are unable to understand it fully.[16]

Upon leaving Marvel, Louise Simonson crossed town to DC, where she spent much of the 1990s working on another huge franchise: *Superman*. She wrote collaboratively with other workers on big events in the Man of Steel's life such as the 'Death of Superman' storyline, which extended across multiple comics in 1992, and the one-off *Superman: The Wedding Album* (1996), in which Clark Kent finally ties the knot with long-time love interest Lois Lane.

The former was a high-profile event which brought DC worldwide media coverage. *Superman* #75 (January 1993), the issue in which the Man of Steel died, became another early 1990s bestselling issue, purchased in large quantities by those who thought they saw an investment opportunity. To no fan's surprise, the character was resurrected less than a year later.

Claremont found no such regular berth, splitting his time between writing novels and comics. As befits someone of his success and reputation, he was interested in creator-owned projects. From 1995–8 he wrote *Sovereign Seven* for DC, the first creator-owned characters to feature as part of the mainstream DC universe. Running for 36 issues, *Sovereign* sought to blend Claremont's own themes and style with the bladed weapons and long-thighed women of the Image artists. He returned to Marvel in 1998, as an editorial director, where he soon began writing *Fantastic Four* and eventually a number of *X-Men* projects. Some of these stories are very good, I think, but they were written within a strong editorial structure which sharply defined what was creatively possible. Did Claremont dream of that mid-1970s Marvel where a single editor struggled to oversee more than 40 monthly comics and creative teams were necessarily left largely to their own devices? He found more freedom in projects such as *X-Men Forever* (first issue: 2009), which allowed him to pick up his story after *X-Men* 3, ignoring anything written since. Another project, *GeNext*, asked what the children of the Claremont-era X-Men would be doing now if comics characters aged in real time. They would, it transpires, be playing out the familiar tropes. In this alternative timeline, Storm has a daughter, Rebecca, conceived in the Savage Land to an undisclosed father. She has inherited her mother's weather-control skills, but when she manifests them her fingernails sharpen into claws, her teeth become fanged and markings (warpaint? Aggressive tattoos?) appear on her face. Long-term Claremont watchers could enjoy – as I do – some very familiar soul-searching: 'I've got to calm down, get back in control of myself... Please, Oli, please -- I need help. But suppose when he sees me as I really am -- he sees a monster?' (*GeNext #1*, July 2008). These projects were branded as alternate realities, one step removed from the mainstream Marvel Universe, but no other

writers have been gifted such idiosyncratic projects, and their existence points up how notions of Claremont as *X-Men*'s auteur author persisted 20 years after his original departure.

One of his jobs as an executive was to oversee Marvel's interest in Twentieth Century Fox's plans for X-Men films. The first of these was released in 2000, a prelude to the deluge of superhero films which would hit cinema screens once Marvel Entertainment was purchased by Walt Disney in 2009. Whenever creative staff left, Marvel's response was always the same: writers and artists come and go, but the characters are the true stars and they remain. If that sometimes sounded desperate, as it did following the Image exodus, it has been fully vindicated in the twenty-first century. *The Avengers, Iron Man, Guardians of the Galaxy* – as I write this, Marvel characters dominate the contemporary box office in a way which they cannot possibly sustain infinitely, but which will build fan bases for the future. The X-Men films have never been as big as these mega-franchises, but there are ten of them so far, and no end is in sight. One currently in development is *Gambit*, which, as I write this, will feature a script written by Joshua Zetumer from a screen story by one Christopher S. Claremont.

*

A quarter of a century after Chris left *The Uncanny X-Men*, his work is still read and is published in a range of formats. In Britain, Panini publishes the stories under the 'Pocketbooks' subtitle, cheap editions whose perceived readership includes younger comic fans (as suggested by their deletion of the word 'bastards' from 'God Loves, Man Kills'). At the other end of the scale, Marvel's hardback *Omnibus* series presents the series in a larger format than previously seen – eleven by seven inches – and on the best-quality paper they have ever seen. Both series begin with the formation of the new team and work relentlessly forward through the Claremont years. Particularly acclaimed stories such as 'Dark Phoenix', 'Days of Future Past' and others can be found in various editions at different price points. A series of reprints under the banner 'New Mutants Classic' contain only Claremont's stories for that comic. His are

not the only X-Men stories which can be purchased in this way, of course, but they do remain constantly in print as others come and go around them. The X-Men, as he envisaged them, are a group of (mostly) young people besieged by a range of addictions, weaknesses, corruptions and other internal challenges but who nevertheless choose to act for the common good. They do this not because it is what makes them heroes (though that point is sometimes made) nor because it makes them mutants, but because it is what makes them – and us – human. As long as there are people willing to entertain this provocative assertion, there will be readers for the work of Chris Claremont.

APPENDIX

SALES FIGURES OF UNCANNY X-MEN DURING THE CLAREMONT ERA

During the period covered by this book, Marvel was obliged to publish annual circulation figures for their comics, and these were printed annually on the letters page. In this table, the first column lists the issue where this data was published and the second the date to which the figures were calculated.

Issue no/ cover date	Filing date	Print run (average over previous 12 months)	Total paid circulation (average over previous 12 months)	Percentage of print run sold
098 / Apr 1976	22 Sept 1975	266,255	118,544	44.5%
104 / Apr 1977	20 Sept 1976	248,507	116,992	47.1%
111 / Feb 1978	20 Sept 1977	260,598	123,725	47.5%
120 / Apr 1979	25 Sept 1978	282,634	115,260	40.8%
131 / Mar 1980	1 Oct 1979	327,387	171,091	52.3%
144 / Apr 1981	1 Oct 1980	345,288	191,927	55.6%
156 / Apr 1982	1 Oct 1981	450,926	289,525	64.2%
169 / May 1983	11 Oct 1982	524,923	313,225	59.7%
182 / Jun 1984	5 Oct 1983	546,070	336,824	61.7%
196 / Aug 1985	28 Sept 1984	560,666	378,135	67.4%
205 / May 1986	1 Oct 1985	652,150	448,870	68.82%
222 / Oct 1987	6 Oct 1986	630,020	417, 350	66.2%
229 / May 1988	02745372*	684,758	461,011	67.32%
246 / Jul 1989	1 Oct 1988	633,760	432,745	68.3%
261 / May 1990	1 Nov 1989	592,965	408,925	69.0%
274 / May 1991	1 Oct 1990	599,839	415,961	69.3%
286 / Mar 1992	1 Oct 1991	735,600	460,625	62.6%
298 / Mar 1993	1 Oct 1992	863,058	460,625	84.74%

This gibberish is presumably a misprint in the relevant comic. Other Marvels published that month give a filing date of 6 October 1987.

NOTES

ACKNOWLEDGEMENTS AND HOUSEKEEPING

1 Grant Morrison, *Supergods: Our World in the Age of the Superhero* (London: Jonathan Cape, 2011).
2 Sean Howe, *Marvel Comics: The Untold Story* (New York: HarperCollins, 2012); Gerard Jones and Will Jacobs, *The Comic Book Heroes: The First History of Modern Comic Books from the Silver Age to the Present*, 2nd ed. (Rocklin, CA: Prima Publishing, 1997).

INTRODUCTION

1 *The Comics Journal* 152 (August 1992). The cover copy read 'The deposed *X-Men* writer talks about his turbulent career'.
2 Peter Sanderson, 'The Secret of X-Appeal', *The Comics Journal* 74 (August 1982), p. 65.
3 Heidi MacDonald, 'Alas, poor Claremont, I knew him Wolverine...', in *The Comics Journal* 99 (June 1985), p. 53.
4 *Marvel Team-Up* was a monthly comic in which Spider-Man would join forces with a different Marvel hero every issue to fight a villain. Since all meaningful developments in the life of Spider-Man himself took place in his own comic and the other character was different each month, it was impossible to make any substantial evolution in theme or character. Claremont's use of those Marvel characters related to espionage (Nick Fury, The Black Widow, Shang-Chi) to tell one long spy story across #82 to #85 (June to September 1979) was a sign of his finding ways to develop the comic away from its inherent limitations. Like other writers assigned to the title, however, his best work was done when the guest stars were drawn from comics he happened to be writing at the time, thus allowing him greater freedom with their characters and actions. A number of notable *X-Men* firsts do occur during Claremont's time on the comic: Captain Britain, a character Claremont had created for Marvel's UK operation, and who would later appear in *X-Men*-related titles, made his American comic-book debut in #65 (January 1978), which also saw the first appearance of the villain Arcade, who would subsequently menace the X-Men on numerous occasions. For #100 (December 1980), Claremont created Karma, who would subsequently become a regular part of *The New Mutants*, the first *X-Men* spin-off comic. Another notable *X-Men* crossover occurred prior to Claremont's time on the title: John Byrne, later

the artist on *X-Men*, first drew the characters in #53 (January 1977). *Spider-Woman* was created by Marvel in 1977 to stop any other company trading on *Spider-Man*'s popularity by creating a female equivalent. It was never a bestselling comic, and its quality was frequently derided in the fan press. In 1981, beginning with #34, Claremont was assigned to write the comic, working with artist Steve Leialoha. Although the consensus was that quality improved substantially, sales did not pick up sufficiently to avoid cancellation in 1983. Some reports suggest that sales did rise in specialist comic shops (where customers were older and paid keen attention to shifts in writer or artist assignments), but not on the news stands, where buyers were younger and more focused on characters than authors. For many readers, inevitably, the highlight of Claremont's period on this comic is the X-Men's guest appearance in #37 and #38 (September and October 1975).

5 'An interview with Rick Marschall', *The Comics Journal* 52 (December 1979), p. 65. Marschall also suggests that in the late 1970s, senior Marvel editors were less than impressed with Claremont's writing: 'in my job interview, Jim Shooter gave me this big lecture about how Chris Claremont was *the* writer at Marvel who needs lecturing and teaching and shepherding and he's so awful and everything' (p. 67).

6 Established in 1954, the Comics Code Authority monitored the content of American comics, viewing all publications. Its seal of approval was printed discreetly on the front cover of all publications which it approved. Prior to the establishment of specialist comic shops, stores would routinely only stock comics with Code approval.

7 The company we now call DC was officially known at the time as National Periodical Publications. DC – derived from *Detective Comics*, the magazine where Batman debuted – was an informal but widely used name only officially adopted in 1977.

8 The general practice of the American comics industry has been to have two people responsible for each page of art. The term *artist* – sometimes known as a *penciller* – generally denotes the work of a person who, working from a script or plot line, produced artwork done in pencil which showed the characters and action. This was then handed to an *inker*, who went over the lines in the black ink required by the traditional printing processes which comics used (and which could not reproduce something as relatively faint as pencil). Variations on the process can be found; for example, some artists began to ink their own work. While some inkers were more acclaimed than others and exhibited a distinct style of their own, fan acclaim has generally been for pencil artists. Pencil artists are often regarded as closer to a story's origins and more likely to have been present at meetings when writers and editors discussed individual plot lines or the longer-term aims of the comic (as ever, there are always exceptions). Pencilling is regarded as the more narrative part of the process, as a pencil artist decides on the layout of pages and the composition of panels, thus directly narrating the story.

9 Claremont wrote the college into the periphery of *X-Men* continuity. The quote is from #136, which establishes that Jean Grey's family home was in the town. *Bizarre Adventures* #27 (July 1981) adds that her father is a professor of history at the college, and *X-Men* #145 (May 1981) says that he has taught there for fifteen years, meaning he was there when Claremont

was a student. #175 (November 1983) establishes that after Jean's death in #137 (September 1980) a headstone was raised to her in the cemetery of the college's chapel, though there was no body to bury. (The actual funeral sequence in #138 had been more circumspect and merely stated that the funeral was 'miles' north of the X-mansion.) *X-Men Annual* #6 (1982) has Rachel Van Helsing, world-renowned anthropologist and vampire hunter, on a temporary teaching position there. As I write this, the entry on Xavier on marvel.com, the company's official website, asserts that Professor Xavier himself did his undergraduate work at Bard, though this contradicts references in the comic itself, which clearly state that his initial degree was taken at Harvard.

10 Peter Sanderson, *The X-Men Companion I* (Stamford, CT: Fantagraphics Books, 1982), p. 96.

11 Margaret Connell and Gary Groth, 'Chris Claremont' (interview), *The Comics Journal* 50 (October 1979), pp. 67–8.

12 Heidi MacDonald, 'Chris Claremont' (interview), *The Comics Journal* 100, (July 1985), pp. 80–1.

13 Chris Claremont, 'Introduction' (to a trade paperback reprint of *God Loves, Man Kills*). Reprinted in *The Uncanny X-Men Omnibus* vol. 3 (New York: Marvel Worldwide Inc., 2015), p. 1011.

14 Though often repeated, the origin of the pithy epithet 'with great power comes great responsibility' is debated. Winston Churchill and Theodore Roosevelt both used variations on the phrase, but similar sentiments may be found at the time of the French Revolution, and thematic similarities have been found in biblical verses.

15 Superegos and moral qualms also serve in comics to fend off those moments which would bring the ongoing narrative to an end. For reasons of conscience, superheroes never kill their arch-enemies, which only ensures that they will return again later. Similarly, supervillains never resort to shooting the heroes in the back. The degree to which these manifestations of moral issues are parodied within other parts of popular culture tells us how ingrained they have become as generic conventions.

16 Len Wein, quoted in Peter Sanderson, 'Wolverine: the evolution of a character', *The Incredible Hulk And Wolverine* #1 (October 1988). This comic reprints Wolverine's pre-*X-Men* appearance in *The Incredible Hulk* #180 and #181 (October and November 1974) with Sanderson's essay.

I. CLAREMONT'S CHARACTERS

1 The shift in Wolverine's character from a young man who wears gloves with claws in them to an older man with an adamantium skeleton and a healing factor has been discussed frequently (see, for instance, Sanderson, 'Wolverine: evolution'). It is clear that Claremont took his time rewriting the character. Traces of preliminary conceptions for Wolverine can be found in early issues of *X-Men*. The Marvel staffer who wrote the letters page (it reads like Claremont) for #97 stated that Wolverine had the same powers as Thunderbird, suggesting that the character was still being thought of in terms of strength. When he is scanned by advanced medical equipment in

#98, Wolverine returns unusual readings, causing the scientists involved to wonder if he really is a mutant, and this sequence would seem to relate to the idea, posited at early stages, that the character is an actual wolverine animal which has been super-evolved by alien technology.

2 Peter Sanderson, *The X-Men Companion I* (Stamford, CT: Fantagraphics Books, 1982), p. 70.

3 Jean's makeover in terms of her Farrah Fawcett haircut and her new dress sense is discussed in Mike Madrid, *The Supergirls: Fashion, Feminism Fantasy, and the History of Comic Book Heroines* (Minneapolis, MN: Exterminating Angel Press, 2009), pp. 171–4.

4 Duffy's contributions to *X-Men*'s own letters page had been blatantly flirtatious. 'Dear Chris and Dave, I love you both. I love your pencils and your typewriter. I love your armadillo.' Once employed at Marvel, she would consistently write about *X-Men* characters in the 1970s and early 1980s (before it became popular for them to guest star in other comics as a way of boosting circulation). Taking over the writing of *Power Man and Iron Fist* (the two comics had been merged in the hope of saving the characters from outright cancellation), she took control of Colleen Wing and Misty Knight, thus curtailing Claremont's plans to use them in *X-Men*, and the X-Men themselves appear in *Power Man and Iron Fist* #57. She wrote stories about Iceman and Nightcrawler for *Bizarre Adventures* #27 (July 1981, 'Secret Lives of the X-Men') and an X-Men prose story for an anthology when Marvel was looking to develop a line of novels. In all of this work, the tone of her writing was substantially more light-hearted than that of the Marvel norm, let alone the intensity that Claremont often aimed for. It may be more than a coincidence that when she announced plans to self-publish in 2008 the company she incorporated was called Armin Armadillo Publishers.

5 Even as the sexual politics of X-Men changes during the 1980s and 1990s, it is a recurrent motif that a female character who turns villain or is possessed will become highly sexualised in the process. In addition to Jean Grey, see Madelyne Pryor/The Goblin Queen in 1988–9 and Moira MacTaggert in 1991. This is one of the many representational issues discussed in Joseph J. Darowski, *X-Men and the Mutant Metaphor: Race and Gender in the Comic Books* (Lanham, MD: Rowman and Littlefield, 2007).

6 Sanderson, *Companion I*, p. 103.

7 The *Journal*'s publisher and guiding light Gary Groth had, with Mike Catron, acquired the magazine, then called *The Nostalgia Journal*, in 1976. It became *The New Nostalgia Journal* with issue 27 (July 1976) and *The Comics Journal* with issue 32 (January 1977), shifting to a magazine format with issue 37. Throughout this period, Groth was developing his argument about comics' parity with other art forms, and the magazine gradually shed its earlier interest in science-fiction novels and cinema. The magazine had a sense of mission towards a community which, it felt, needed it: '*The Comics Journal* is published every six weeks for comics fandom' read the inside page, as if it were a gift or a public service.

8 Marilyn Bethke, 'And beneath all this glitter and tinsel…more glitter and tinsel', *The Comics Journal* 45 (March 1979), p. 30.

9 Sanderson, *Companion I*, p. 70.

10 Ibid., p. 96.

11 Ibid., pp. 99–100.

12 Byrne outlines the events at length in a convention appearance transcribed in *The Comics Journal* 76 (October 1982), pp. 70–5. Analysis of the page in question bears him out: the picture as drawn reflects his stated intentions rather than the prose which Claremont added to it.

13 Paul Levitz, 'These stories weren't meant to be collected' (introduction), *Legion of Super-Heroes: The Great Darkness Saga* (New York: DC Comics, 2010), p. 4.

II. HISTORY AND FUTURES PAST

1 Byrne discusses the origins of Kitty in Peter Sanderson, *The X-Men Companion II* (Stamford, CT: Fantagraphics Books, 1982), pp. 71–8.

2 I have quoted this line accurately. The switch from using numerals (13) to the written form of numbers ('fourteen') in a single sentence is extremely unusual.

3 Of course, the Inner Circle of the Hellfire Club are themselves mutants who have somehow bypassed Cerebro's detection system – but the comic doesn't want you to notice that.

4 Sanderson, *Companion II*, p. 111.

5 This is a deceptively throwaway moment. It hardly constitutes a fitting climax to the story of Sauron. The curing occurs over the final page and a half of a four-issue story told in the anthology title *Marvel Fanfare*. The battle over, Lykos says despairingly, 'I'm deadly as ever. I need to absorb life essences to survive, yet taking too much transforms me into Sauron. No matter how hard I resist, I will take too much…kill me.' When Wolverine offers his services as a painless executioner, Storm restrains him ('We are not executioners, Wolverine, even for the most noble of reasons'), and the prospect of a cure is suddenly offered and enacted on the next (final) page. Lykos lies on his back and is bombarded with rays from a hi-tech device above him, just as Jean did in the original, unused conclusion to 'Dark Phoenix'. Claremont was never one to let a good ending go to waste, and clearly reused what had been discarded, but is it too mischievous to see a self-reflexive reading here with the story arguing that the death sentence forced upon Jean Grey was not the correct moral answer?

6 This was subsequently amended: his consciousness survived and later found a way back to the physical plane – see Chapter IV.

7 Sanderson, *Companion II*, p. 32.

8 Tom DeFalco, *Comic Creators on X-Men* (London: Titan Books, 2006), p. 186.

9 'Blood and thunder' (letters page), *The Comics Journal* 60 (November 1980), p. 32.

10 Interviewed in *The Comics Journal* 57 (Summer 1980), p. 82.

11 Sean Howe, *Marvel Comics: The Untold Story* (New York: HarperCollins, 2012), p. 286. The sexualised imagery which did make it into Claremont's mutant comics is discussed by Sigrid Ellis in her essay 'Kitty queer' in Lynne M. Thomas and Sigrid Ellis (eds), *Chicks Dig Comics* (Des Moines, IA: Mad Norwegian Press, 2012), pp. 104–10.

12 Sanderson, *Companion II*, p. 32.

13 Cockrum, interviewed in Sanderson, *Companion I*, p.57.

14 Sanderson, *Companion I*, p. 114.

15 The *Elfquest* allusions are clear, and people are meant to recognise them. The S'ym references are more subtle and slightly odd. S'ym, who became a recurrent minor villain in the spin-off comic *New Mutants*, is often stated by those reviewing the issues as looking like Cerebus, but his visual appearance is actually very different. The pig-like aardvark has a snout and S'ym doesn't, for instance – except on the cover of *New Mutants* #52, where artist Walt Simonson does seem to be aiming for a Cerebus likeness. A one-off *X-Men/Cerebus* crossover was announced, to be jointly written by Claremont and Sim, in which the mutants would be transported to the aardvark's world, but it never appeared. Given that *Cerebus* started life as a parody of Marvel's *Conan the Barbarian* comic before shifting to pointed social satire, it is hard to imagine what it would have been like ('Newswatch', *The Comics Journal* 84 (September 1983), p. 16). Beyond the independents was the avant-garde 'graphix magazine' *RAW*, an anthology of European and American comic-strip work. *RAW* was too concerned with formal issues to break into the mainstream, and often lacked human content, save for its stand-out work, Art Spiegelman's 'Maus', a cartoon retelling of his father's war experience where the Germans were portrayed as cats, their victims as mice. For the most highbrow fans, *RAW* was everything a Marvel comic wasn't. In this respect, it is somewhat ironic that thirty years on 'Maus' and *X-Men* are frequently discussed together in books on Jewish themes in comics.

16 Trust the *X-Men* to be different. The 22-page format didn't debut in *X-Men* until the following month (#138, October 1980) because September's issue had already been planned as a double-sized (old-sized) issue running to 35 pages of story for 75 cents.

17 John Byrne claims to be the man who put his foot down on Proteus' parentage. DeFalco, *Comic Creators*, p. 108.

18 Harry Broetjes, 'Jim Shooter interview', *The X-Men Chronicles* 1 (July 1981), p. 10.

19 *The Comics Journal* gives a transcript of a discussion with Claremont, Frank Miller and Josef Rubinstein at an unidentified convention. Having tantalised fans with talk of the body count in the upcoming *Wolverine* mini-series, they note Shooter's entrance halfway through, acknowledging him with 'Hi Jim, every head turns. No, Wolverine does not kill,' to laughter and applause ('Wolverine', *The Comics Journal* 78 (December 1982), p. 85).

20 Kim Thompson, 'Comics in 1981: Waiting for the fruit salad', *The Comics Journal* 71 (March 1982), p. 39.

21 Interviewed in *The Comics Journal* 57 (Summer 1980), p. 61.

22 'Newswatch', *The Comics Journal* 60 (November 1980), p. 11.

23 Compare their interviews with Peter Sanderson in 1981, for instance. Cockrum (interviews in Sanderson, *Companion I*) does not insist upon discussing his plotting input, though it is clear he has some. Byrne, interviewed in the second volume, does.

24 The reviews in question are Dwight R. Decker, 'Phoenix one mo' time', *The Comics Journal* 69 (December 1981), p. 55 and Jan Strnad, 'The view

from the curb', *The Comics Journal* 71 (April 1982), p. 33. Cockrum's response was on the letters page of issue 78 (December 1982), p. 23.

To further underline his point, Cockrum would create, write and draw a four-issue *Nightcrawler* mini-series in 1985 continuing the playful fantasy. He was still fighting to be recognised as the author of this part of the book's tone. Claremont's later attempt to replicate the humorous approach – #181, based on Japanese monster movies, where the joke is that Tokyo has been attacked by so many Godzilla-style dinosaurs that the local schoolkids have spotters' guides – was less successful.

25 'Marv Wolfman' (interview), *The Comics Journal* 100 (July 1985), p. 171.

26 Details of the plan as reported in *The Comics Journal* 70 (January 1982), pp. 10–11.

27 Sanderson, *Companion II*, p. 51.

III. BRINGING IT ALL BACK HOME

1 Chris Claremont, *First Flight* (New York: Ace Books, 1987).

2 The initial report was in 'Newswatch', *The Comics Journal* 81 (May 1983), p. 9. The retraction occurred in the following issue ('Newswatch', *The Comics Journal* 82, July 1983), p. 17.

3 Peter Sanderson, *The X-Men Companion I* (Stamford, CT: Fantagraphics Books, 1982), p. 114.

4 We now use 'graphic novel' to refer to any sort of comic story packaged in book format. Much of what is sold in that format is simply seven or eight consecutive issues of an ongoing comic. The original usage of the term 'graphic novel', however, did not refer to such compilations but to an original work, complete in itself and often of greater aesthetic aspiration (hence 'novel').

5 Sean Howe, *Marvel Comics: The Untold Story* (New York: HarperCollins, 2012), p. 286.

6 Heidi MacDonald, 'Alas, poor Claremont, I knew him Wolverine...', *The Comics Journal* 99 (June 1985), p. 55.

7 Gerard Jones and Will Jacobs, *The Comic Book Heroes: The First History of Modern Comic Books from the Silver Age to the Present*, 2nd ed. (Rocklin, CA: Prima Publishing, 1997), p. 291. Orzechowski remained Claremont's letterer of choice even when working for DC in the 1990s. His entry on Wikipedia claims that he has lettered approximately 6,000 pages of Claremont's comics.

8 Tom DeFalco, *Comic Creators on X-Men* (London: Titan Books, 2006), p. 69.

9 By some glitch in the colouring process, Maddy is actually given blonde hair in the panel where she walks down the aisle.

10 Interviewed in Peter Sanderson, *The X-Men Companion II* (Stamford, CT: Fantagraphics Books, 1982), p. 79.

11 Howe, *Marvel Comics*, pp. 287–8. Many other sources retell the same events.

12 Les Daniels, *Marvel: Five Fabulous Decades of the World's Greatest Comics* (London: Virgin Books, 1993), p. 194.

13 DeFalco, *Comic Creators*, p. 144.

14 Simonson, interviewed in James Van Hise, 'Marvel's mutant universe', *Comics Feature* 55 (May 1987), pp. 31–2.

15 Launched with a September 1986 cover date, *Classic X-Men* would run for 110 issues. When Claremont's writing load became too great, other writers took over the scripting of the backup stories, and with #46 the title was renamed *X-Men Classic* and the inclusion of new material abandoned.

IV. EXISTENTIAL X-MEN: *THE NEW MUTANTS*

1 The initial idea had been that the character would be a Muslim from Iran, but this was changed when it was decided that the black hair of such a character would make her look too much like another character, Psyche. We shall never know how such a character would have played out through the rise of Islamism and the War on Terror.

2 Heidi MacDonald, 'This is it? (Or: what nice paper you have!)', *The Comics Journal* 79 (January 1983), p. 54.

3 The adventures of a subsequent group of young mutants, *Generation X*, was first published in 1994. The term had a long history in sociology, referring to that generation born after the baby boomers (with birthdates ranging from the early 1960s to the mid-1980s, though it appears to have been coined by photographer Robert Capa when he used it as the title of a 1953 photoessay concerning the lives of those growing up immediately after World War II. It gained popular currency with the publication of Douglas Coupland's 1991 debut novel *Generation X: Tales For an Accelerated Culture*. The *X-Men* spin-offs seem to be unique among comics in turning to sociological journalism for their titles.

4 The letters page of #19 (September 1984) acknowledged that the attempt to show the integration of the two societies was 'only partially realized'.

5 Claremont here reuses a narrative strategy which had worked effectively in 1979–80. During the Hellfire Club story, the fact that stylish villain Jason Wyngarde was camouflage for the more familiar villain Mastermind could be deduced from subtle clues dropped into the story several issues before the full revelation. Similar clues are drip-fed in *New Mutants* about Farouk's presence.

6 Farouk is clearly named for Farouk I of Egypt. The last Egyptian monarch, Farouk was deposed in 1952 in a CIA-backed coup. His administration was famously corrupt, his weight once ballooned to three hundred pounds and upon leaving Egypt for exile, he left behind what is widely regarded as the largest collection of pornography ever assembled (at least prior to the invention of the internet).

7 The details of what Moonstar did are unclear. Her powers manifested themselves and revealed Patrick's deepest thoughts, but what those were are never explained. An obvious implication from the first half of the story is that his desire for her was what was shown – but it presumably wasn't, because it is a surprise when this happens later in the story. Unless I'm missing something, the story gives no other clues as to what the event was, which is narratively unusual for 1980s Marvel.

8 The solipsism discussed in the previous chapter reaches its apex in this sequence. Rachel reflects that because she has not destroyed the universe with the Beyonder inside it, he will himself destroy it from outside (and thus survive). 'That infinite cost will be upon his conscience,' soothes a comforting Storm, as if the question of whose soul becomes stained were the only issue involved in the destruction of all creation.

V. THE HARDER THEY COME...

1 Susan Jeffords, *Hard Bodies: Hollywood Masculinity in the Reagan Era* (New Brunswick, NJ: Rutgers University Press, 1994).
2 Louise Simonson, quoted in Tom DeFalco, *Comic Creators on X-Men* (London: Titan Books, 2006), p. 144.
3 Sabretooth was originally created by Claremont and John Byrne to battle Iron Fist before that artist was assigned to *X-Men*. Claremont initially intended Sabretooth to be Wolverine's father. This is only hinted at in print. Sabretooth calls Logan (among other things) 'boy' and 'old son', but this was sufficiently ambiguous that later writers and editors did not feel bound by it.
4 Quoted in DeFalco, *Comic Creators*, p. 146.
5 Peter Sanderson, 'Wolverine unleashed', *Marvel Age* 67 (October 1998). Article reproduced in *Wolverine: Madripoor Nights* (New York: Marvel Worldwide Inc., 2014), pp. 484–5.
6 From #26 (October 1988), the back-up strips in *Classic X-Men* were written by Ann Nocenti – one of Claremont's favourite ex-editors – and Jo Duffy, the fan-turned-pro whose letters to Marvel in the 1970s had praised Claremont's characterisation of women. They were not writers to go off-message from the Claremont vision.
7 Lance Parkin, *Magic Words: The Extraordinary Life of Alan Moore* (London: Aurum Press, 2013), p. 116.
8 Chris Claremont, 'Introduction', *Captain Britain* (London: Marvel Entertainment Group, 1989), p. 7.
9 Gerard Jones and Will Jacobs, *The Comic Book Heroes: The First History of Modern Comic Books from the Silver Age to the Present*, 2nd ed. (Rocklin, CA: Prima Publishing, 1997), p. 329.
10 Gareb S. Shamus, 'A letter from our PUBLISHER', *Wizard* i/15 (November 1992), p. 3.
11 'This month's number ONES', ibid., p. 100.
12 Sean Howe, *Marvel Comics: The Untold Story* (New York: HarperCollins, 2012), p. 328; Jones and Jacobs, *Comic Book Heroes*, p. 344.
13 Quoted in DeFalco, *Comic Creators*, p. 178.
14 Quoted ibid., p. 116.
15 Claremont's penultimate issue of *The Uncanny X-Men* in July 1991 had skirted around the subject. The issue begins with a long speech on humanity's capacity for prejudice and fear of the other. The art clearly shows an anti-gay rally (in that the placards waved read 'No Perverts Allowed' and 'AIDS is God's Punishment'), but the dialogue talks only of ethnic and religious divides.

16 The definitive account of Marvel's legal and financial problems in the 1990s is Dan Raviv, *Comic Wars: How Two Tycoons Battled over the Marvel Comics Empire...And Both Lost* (NewYork: Broadway Books, 2002), but this is dense financial journalism and not for the faint-hearted.

BIBLIOGRAPHY

Beasley, Valeria, 'Letter', *The Comics Journal* 60 (November 1980), p. 32.

Bethke, Marilyn, 'And beneath all this glitter and tinsel…more glitter and tinsel', *The Comics Journal* 45 (March 1979), p. 30.

Broetjes, Harry, 'Jim Shooter interview', *The X-Men Chronicles*, vol. 1 (Albany, NY: FantaCo Enterprises, July 1981).

Byrne, John, 'Interview', *The Comics Journal* 57 (Summer 1980).

Byrne, John, 'Convention appearance', *The Comics Journal* 76 (October 1982).

Claremont, Chris, *First Flight* (New York: Ace Books, 1987).

——— *Captain Britain* (London: Marvel Entertainment Group, 1989).

Claremont, Chris, Frank Miller and Josef Rubenstein, 'Wolverine' (transcript of a convention panel), *The Comics Journal* 78 (December 1982).

Cockrum, Dave, 'Letter', *The Comics Journal* 78 (December 1982).

Connell, Margaret and Gary Groth, 'Chris Claremont' (interview), *The Comics Journal* 50 (October 1979).

Daniels, Les, *Marvel: Five Fabulous Decades of the World's Greatest Comics* (London: Virgin Books, 1993).

Darowski, Joseph J., *X-Men and the Mutant Metaphor: Race and Gender in the Comic Books* (Lanham, MD: Rowman and Littlefield, 2007).

Decker, Dwight R., 'Phoenix one mo' time', *The Comics Journal* 69 (December 1981).

DeFalco, Tom, *Comic Creators on X-Men* (London: Titan Books, 2007).

Flynn, Thomas R., *Existentialism: A Very Short Introduction* (Oxford: Oxford University Press, 2006).

Freitag, Steve and Kim Thompson, 'Newswatch', *The Comics Journal* 84 (September 1983).

Howe, Sean, *Marvel Comics: The Untold Story* (New York: HarperCollins, 2012).

Jeffords, Susan, *Hard Bodies: Hollywood Masculinity in the Reagan Era* (New Brunswick, NJ: Rutgers University Press, 1994).

Jones, Gerard and Will Jacobs, *The Comic Book Heroes: The First History of Modern Comic Books from the Silver Age to the Present*, 2nd edition (Rocklin, CA: Prima Publishing, 1997).

Levitz, Paul, 'These stories weren't meant to be collected' (introduction), *Legion of Super-Heroes: The Great Darkness Saga* (New York: DC Comics, 2010).

MacDonald, Heidi, 'This is it? (Or: what nice paper you have!)', *The Comics Journal* 79 (January 1983), pp. 53–5.

——— 'Alas, Poor Claremont, I Knew Him Wolverine…', *The Comics Journal* 99 (June 1985).

———— 'Chris Claremont' (interview), *The Comics Journal* 100 (July 1985).

———— 'Marv Wolfman' (interview), *The Comics Journal* 101 (July 1985).

———— 'The deposed X-Men writer talks about his turbulent career', *The Comics Journal* 152 (August 1992).

Madrid, Mike, *The Supergirls: Fashion, Feminism Fantasy, and the History of Comic Book Heroines* (Minneapolis, MN: Exterminating Angel Press, 2009).

Marschall, Rick, 'Interview', *The Comics Journal* 52 (December 1979).

Morrison, Grant, *Supergods: Our World In The Age of The Superhero* (London: Jonathan Cape, 2011).

Parkin, Lance, *Magic Words: The Extraordinary Life of Alan Moore* (London: Aurum Press, 2013).

Raviv, Dan, *Comic Wars: How Two Tycoons Battled over the Marvel Comics Empire…And Both Lost* (New York: Broadway Books, 2002).

Sanderson, Peter, *The X-Men Companion I* (Stamford, CT: Fantagraphics Books, 1982).

———— *The X-Men Companion II* (Stamford, CT: Fantagraphics Books, 1982).

———— 'Wolverine: The evolution of a character', *The Incredible Hulk And Wolverine* 1 (October 1988).

———— 'Wolverine unleashed', *Marvel Age* 67 (October 1998). Article reproduced in *Wolverine: Madripoor Nights* (New York: Marvel Worldwide Inc., 2014).

Shamus, Gareb S., 'A letter from our PUBLISHER', *Wizard* i/15 (November 1992).

Strnad, Jan, 'The view from the curb', *The Comics Journal* 71 (April 1982).

Thomas, Lynne M. and Sigrid Ellis (eds), *Chicks Dig Comics* (Des Moines, IA: Mad Norwegian Press, 2012).

Thompson, Kim, 'Newswatch', *The Comics Journal* 60 (November 1980).

———— 'Comics in 1981: waiting for the fruit salad', *The Comics Journal* 71 (March 1982).

Thompson, Kim and Dwight R. Decker, 'Newswatch', *The Comics Journal* 70 (January 1982).

———— 'Newswatch', *The Comics Journal* 81 (May 1983).

———— 'Newswatch', *The Comics Journal* 82 (July 1983).

Thompson, Kim and Steve Freitag, 'Newswatch', *The Comics Journal* 84 (September 1983).

Van Hise, James, 'Marvel's mutant universe', *Comics Feature* 55 (May 1987).

INDEX

Adams, Art 166, 171
Adams, Neal 6–7, 89, 128
addiction/drug,
 as metaphor 33, 38, 130
Alien (film, 1979) 76
Alpha Flight 25, 28, 45–6,
 114
Amazing Fantasy 4, 15
Angel/Warren Worthington
 III 36, 72, 87, 117
Ani-mates 143
Apocalypse 116, 118
Arcade 11, 70
Arkon the Annihilator 28
Auschwitz 53, 59–60
Austin, Terry 82
auteur theory 2
Avengers, The 5, 20, 25, 73, 94,
 99, 117, 171, 178, 188

ballet 23
Banshee/Sean Cassidy 21, 23,
 29, 47, 106, 110, 161
Bard College 6, 7, 84,
 194–5n9
Batman 23
Beast/Hank McCoy 19, 31, 36,
 47, 49, 50
Beauty and the Beast 129–30
Belasco 133–4, 148
Beyonder 112, 136, 138–9,
 140, 141, 200n9
Black Dragon, The 161
Black Tom Cassidy 25, 79
Bodine, Larry 58, 117
body horror 104–6
Bolton, John 119, 133
Bonecrusher 156
Brood, the 70–1, 76, 104, 108,
 162
Brotherhood of Evil
 Mutants 54, 58, 63, 84, 87
Buscema, Sal 121

Byrne, John 7–8, 19, 20, 22,
 27, 28, 30, 36, 43, 44, 45,
 50–1, 52, 53, 55, 67–8, 71,
 78–9, 82, 89, 97, 99, 106,
 113, 114, 116, 143, 168,
 180, 184–5, 193n4, 197n12,
 201n3

Cable 173–4, 176–7, 180, 180
Cahiers du Cinema 82
Caliban 5887
Callisto 87–8, 92
cancer, as metaphor 134
Cannonball/Sam Guthrie 121,
 123, 145
Captain America 5, 79, 155
Captain Britain/Brian
 Braddock 166–7, 168,
 193n4
Carlin, Mike 115
Carter, President James 154,
 173
Casablanca (film) 62
Cerebro 57
Cerebus the *Aardvark* 74,
 198n15
Christianity 13–14, 17, 39, 65,
 76, 94, 97–8, 123, 125, 135,
 142, 144–51, 161; *see also*
 soul, the
Christmas 24
Claremont, Chris
 as auteur 1, 2, 9–17, 79–83,
 94, 110, 153, 175–6, 189
 becomes writer on *X-Men* 9,
 21
 departure from Marvel 1,
 178–84
 depicted as Dark
 Phoenix 106
 female characters 17, 37–8,
 178; *see also* individual
 entries